For Kids Only

Introduction by Charles F. Reasoner
Professor, Elementary Education, New York University

Delacorte Press/New York

Originally published in Switzerland by Reich Publishing Co., Ltd.

Copyright © 1975 by JESPER HØM & SVEN GRØNLYKKE.
Copyright © 1976 für die deutschsprachige Ausgabe by REICH VERLAG AG,
Lucerne, Switzerland.

Introduction copyright © 1977 by Dell Publishing Co., Inc.

Manufactured in the United States of America

First U.S.A. printing

Library of Congress Cataloging in Publication Data

Høm, Jesper.
For kids only.

By Jesper Høm and Sven Grønlykke.
First published under title: Kinderbilderbuch.

SUMMARY: Approximately 500 photographs of people,
animals, and objects arranged to tell very brief stories
without any words.

1. Photography, Artistic. 2. Picture-books for
children. [1. Photography—Collections. 2. Picture
books] I. Grønlykke, Sven, joint author. II. Title.
TR654.H6713 779′.092′2 76-28183

ISBN: 0-440-02690-3 PPR

ISBN: 0-440-02738-1 TR

Introduction

This book is an adventure in reading without words. For too long, adults have equated a child's ability to read with skill in reproducing speech sounds from printed words. The assumption is that once words are decoded meaning will follow. But as reading experts are beginning to realize, the ability to decode printed words is based on a wide range of prior experiences and abilities: experience in perceiving signs as symbols, which in association with each other and in the context in which they occur can be understood as having meaning. This is reading, and this is a basic and ever-present human experience, of which decoding printed words is only a small part.

What adult hasn't observed an infant's cries, movements, and facial expressions, and through them read the infant's needs? Or read the unverbalized moods and feelings of a friend through tone of voice or body language? Who has not read the colors and forms of a painting, the sequence of movements and gestures in ballet or mime, the series of images of a film? And who hasn't watched a pre-print child laugh while reading the Sunday funnies? Even though the printed words in the balloons are skipped over, the youngster is nonetheless reading the meaning encoded nonverbally in a series of pictures. We read, in the widest sense, for survival, for communication, for pleasure, and for fun.

All children can and do read. By the time they first reach school, they are fluent in nonverbal signs and signals. All too often the teaching of print reading fails to capitalize on the kinds of reading children are already able to do. Instead, the exclusive

goal is word recognition and performance of skills designed to promote it. If a child is not yet proficient in pre-print reading skills, or simply not yet mature enough in eye-hand coordination, or lacks the visual and auditory acuity needed to distinguish between different speech sounds, that youngster may be turned off reading for life. Reading, instead of being an extension of something already mastered, becomes something totally alien and impossible to do. As a result, the child may *never* be able to approach reading with any confidence or pleasure. Even the child who is able to recognize printed words, and is thus "ready to read," may be robbed of much potential reading pleasure by being trained through tedious repetition and rote recall of words divorced from meaning.

That is where this book comes in. *For Kids Only* is a series of stories-in-pictures that children can read without the pressure of having to recognize words—there are none. Instead, there are nearly 500 photographs of people, animals, and objects, arranged in coherent sequences designed to claim a child's attention and encourage associations. Youngsters will be able to expand their ability to differentiate relationships, to recognize and create order and meaning from a series of symbols, and to extend symbols through imagination—that is, without words, to read. Because the pictures portray ordinary things and events from daily life, children will feel a sense of achievement from expanding their existing knowledge and may even be amazed by how much they have already learned. And, perhaps even more important, *For Kids Only* is pure, un-"adult"-erated, kid-rated fun.

Charles F. Reasoner
Professor of Elementary Education
New York University

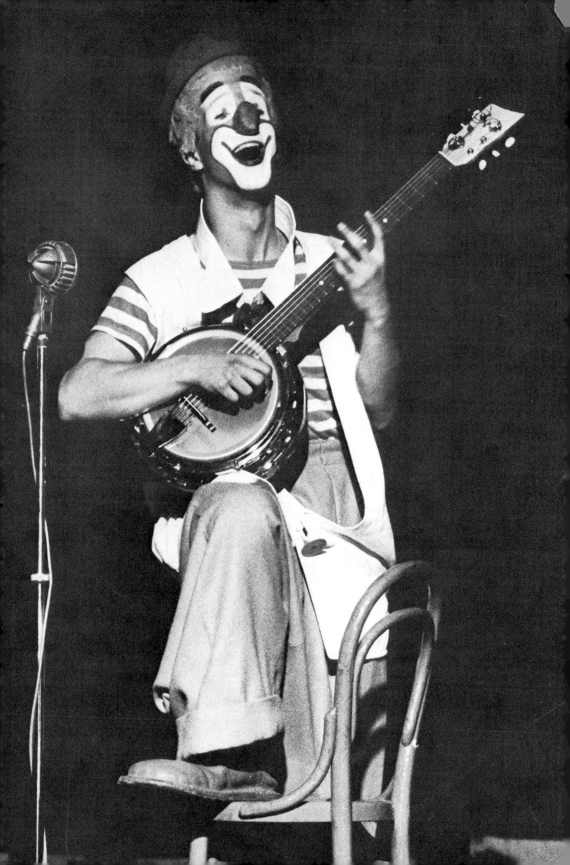

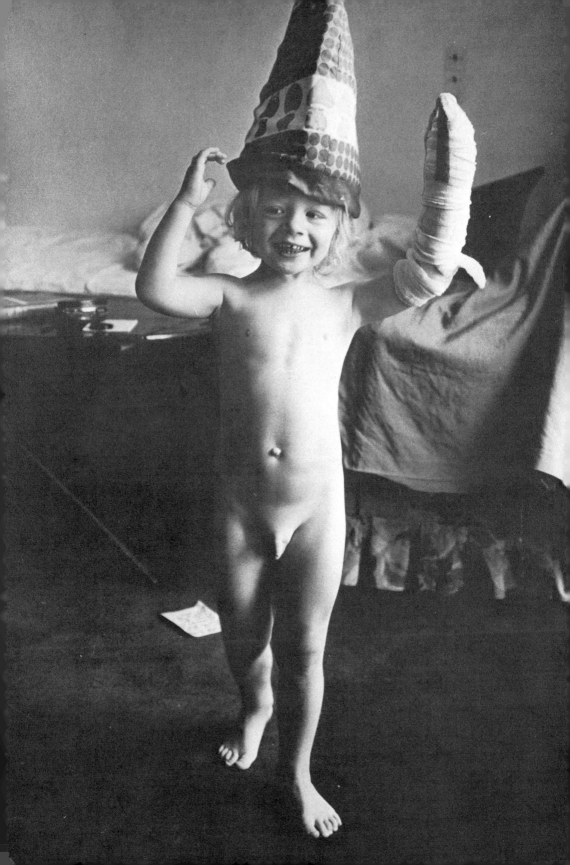

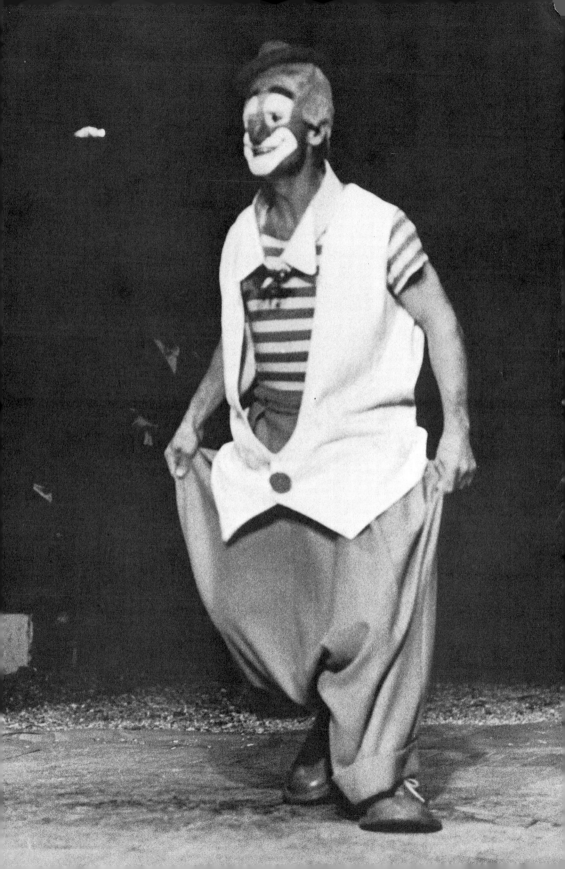

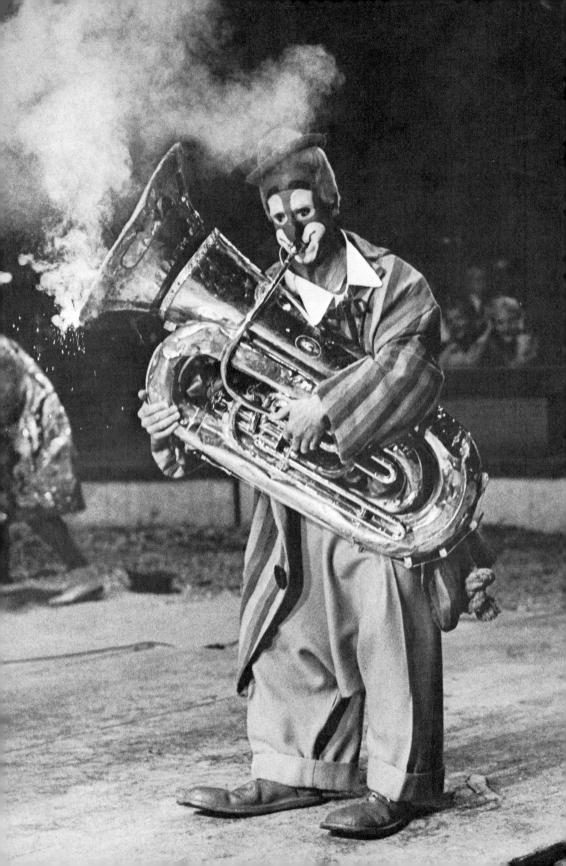

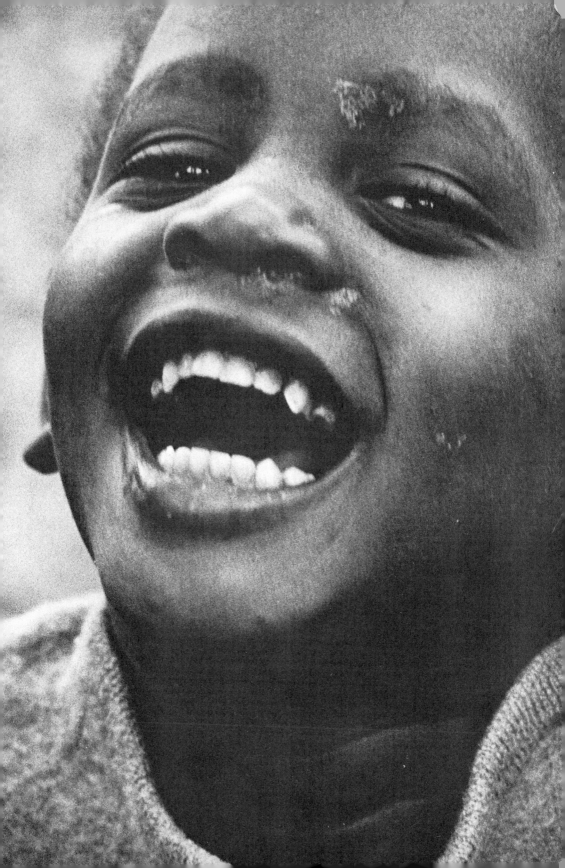

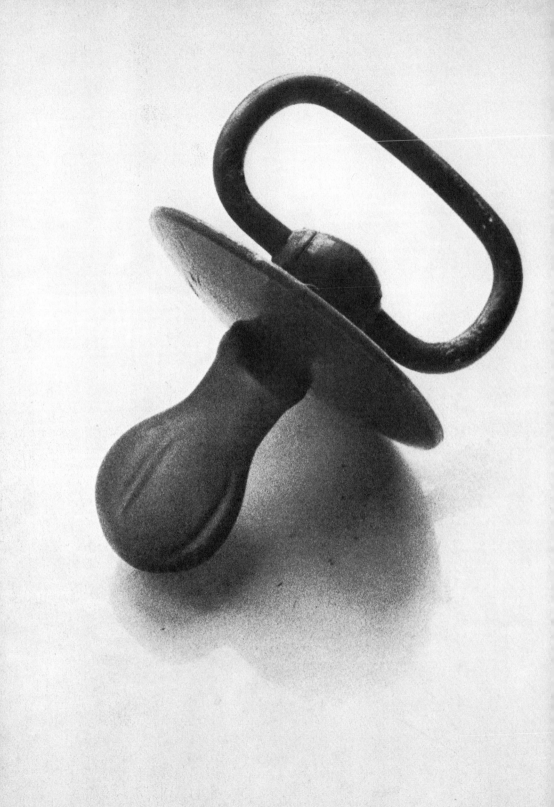

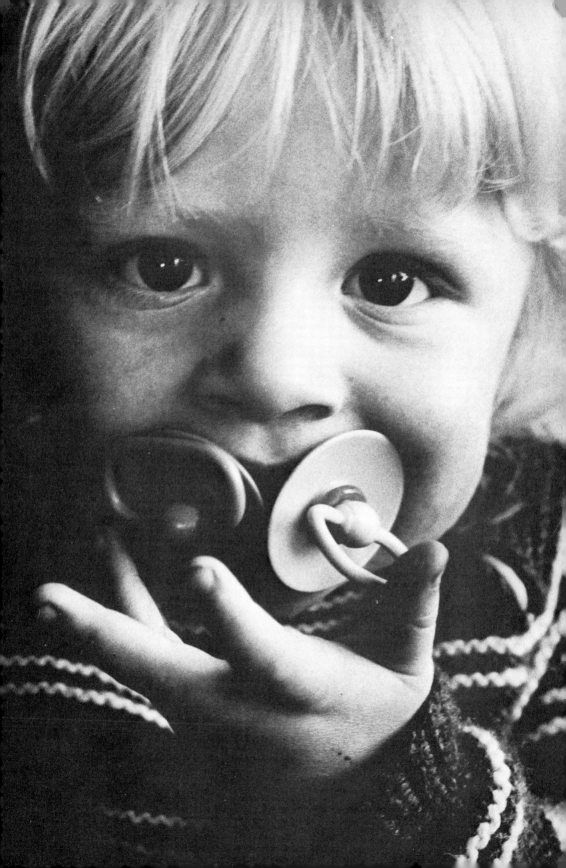

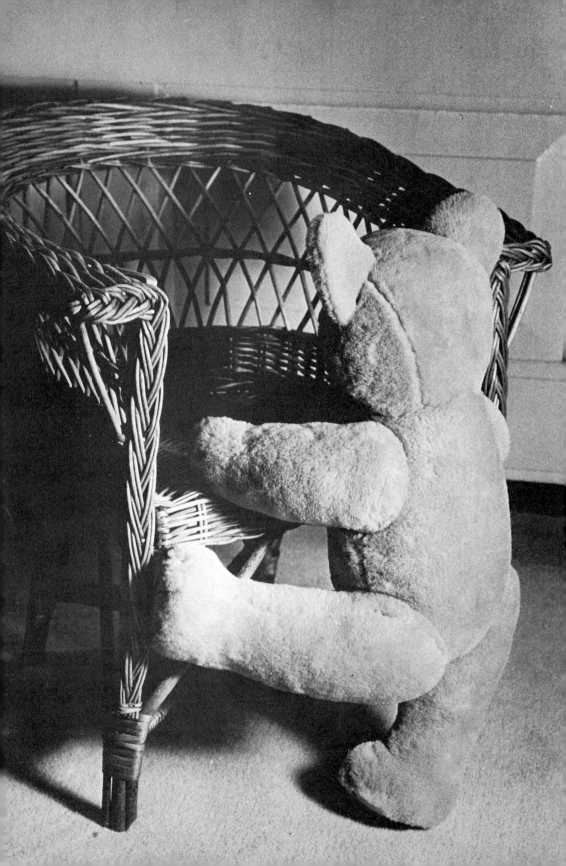

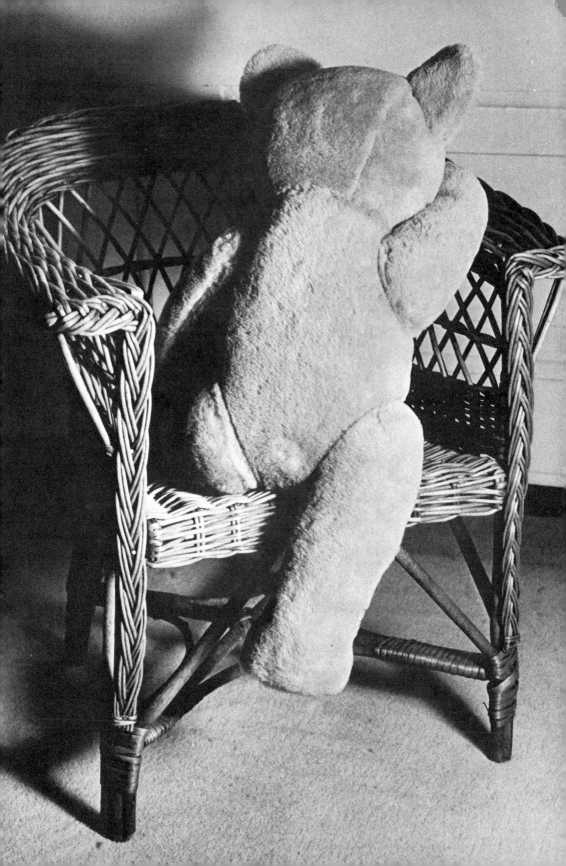

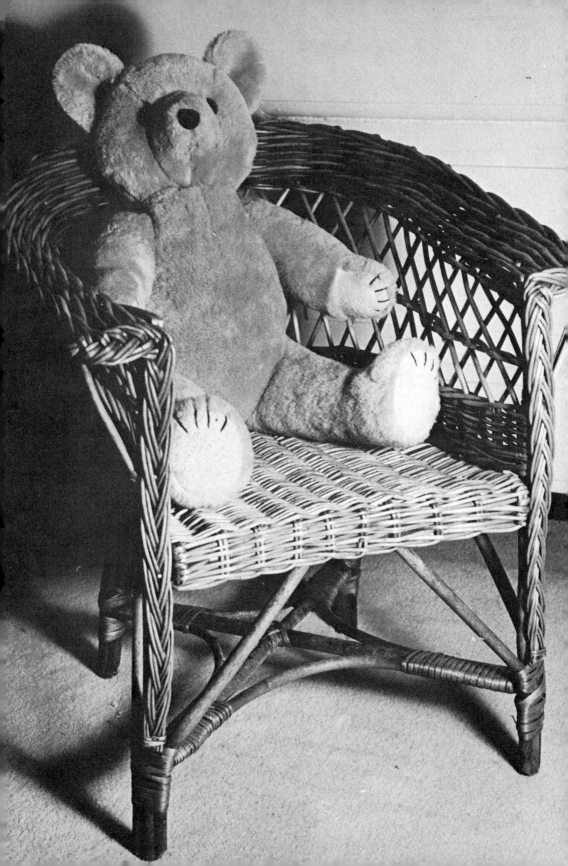

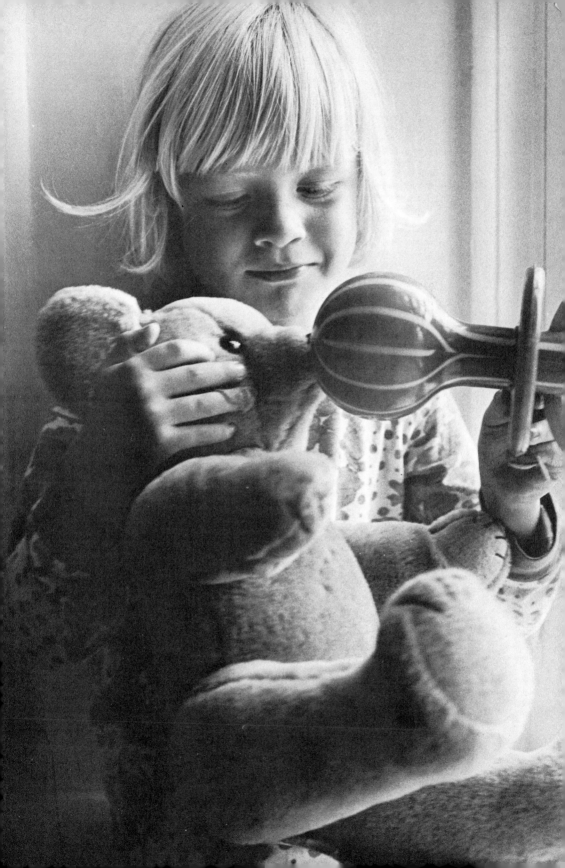

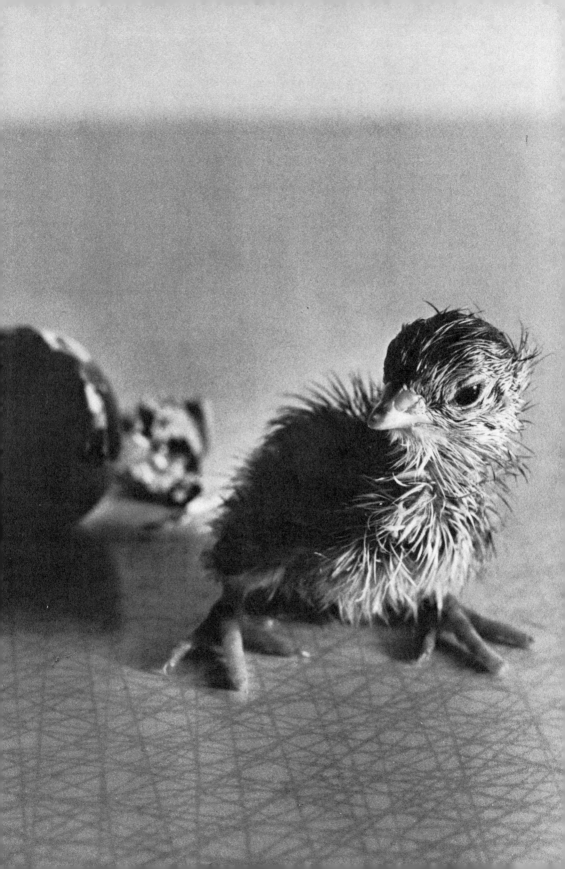

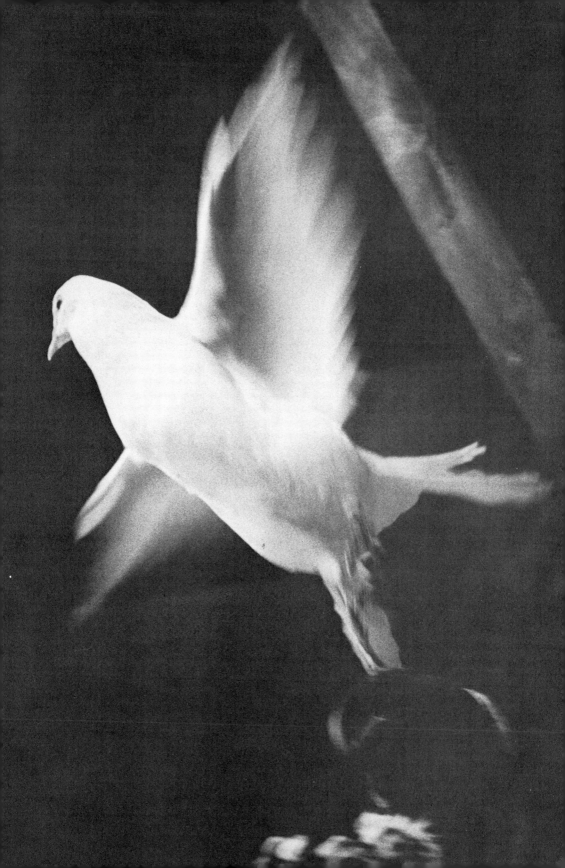

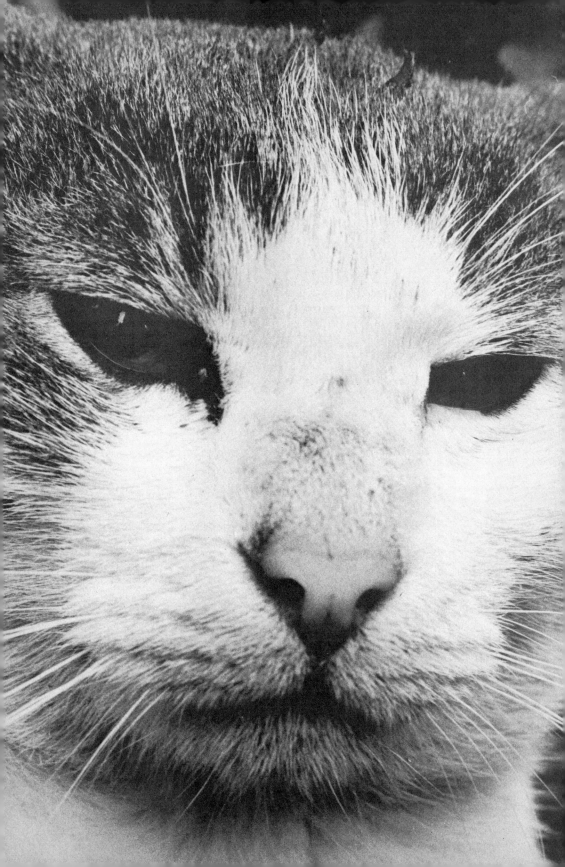

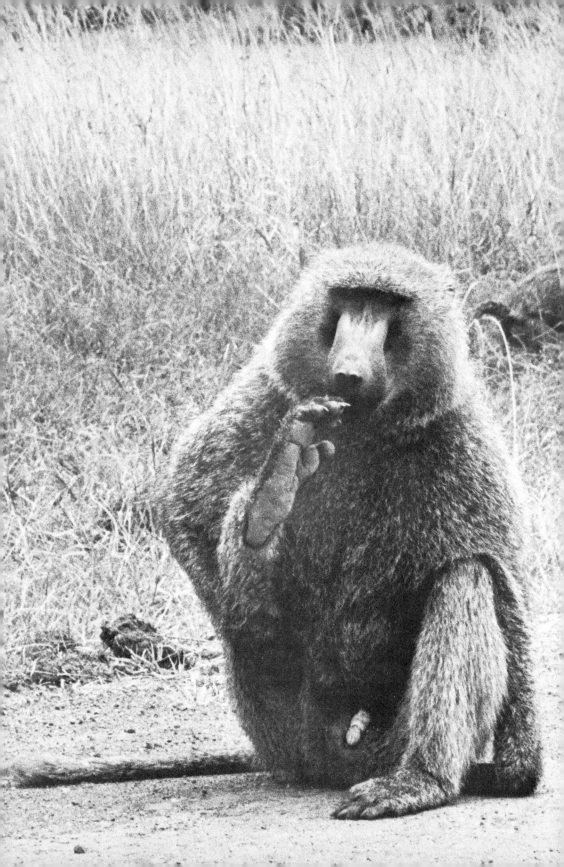

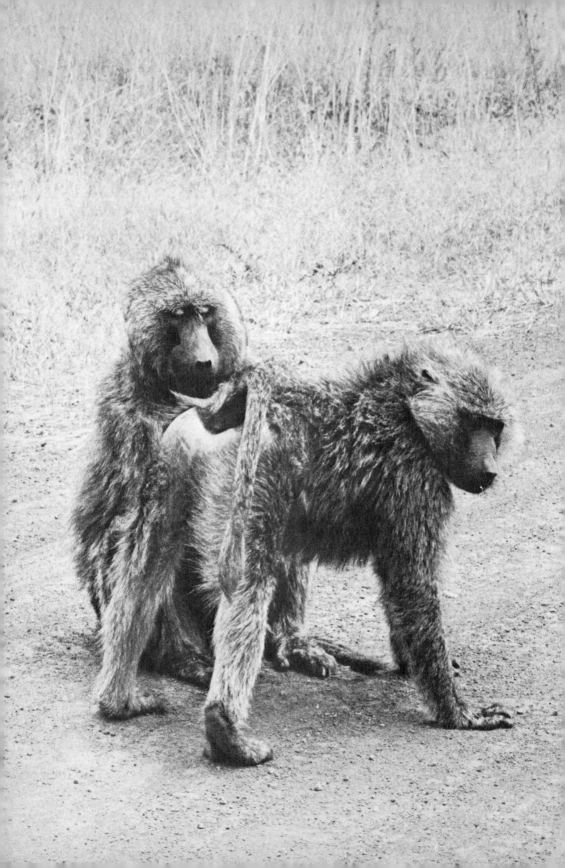

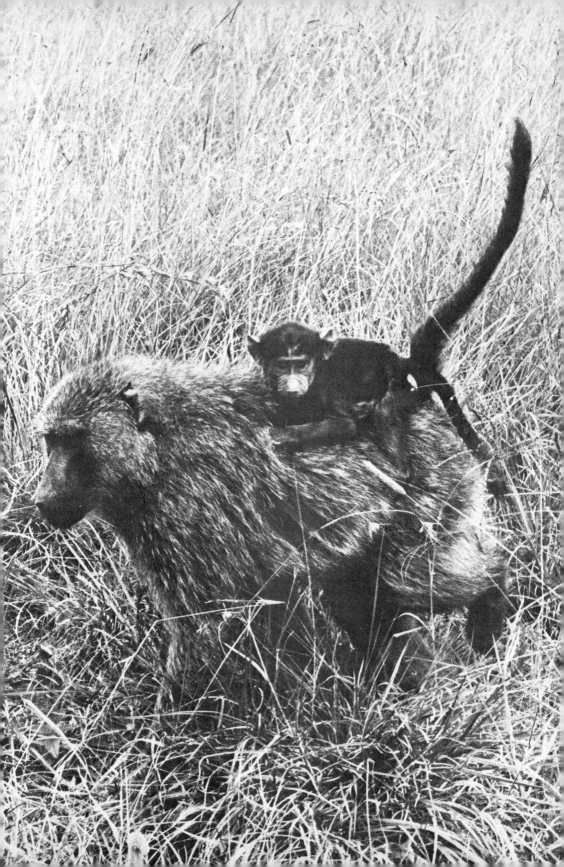

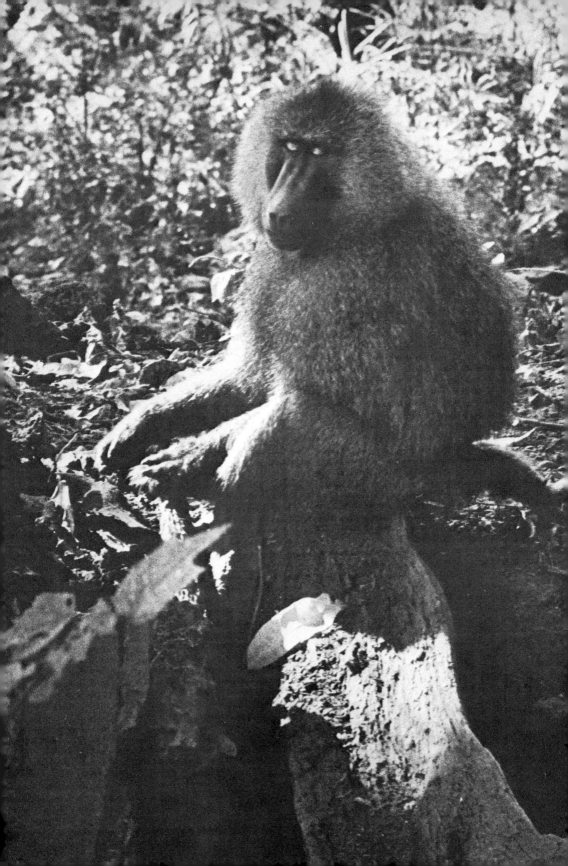

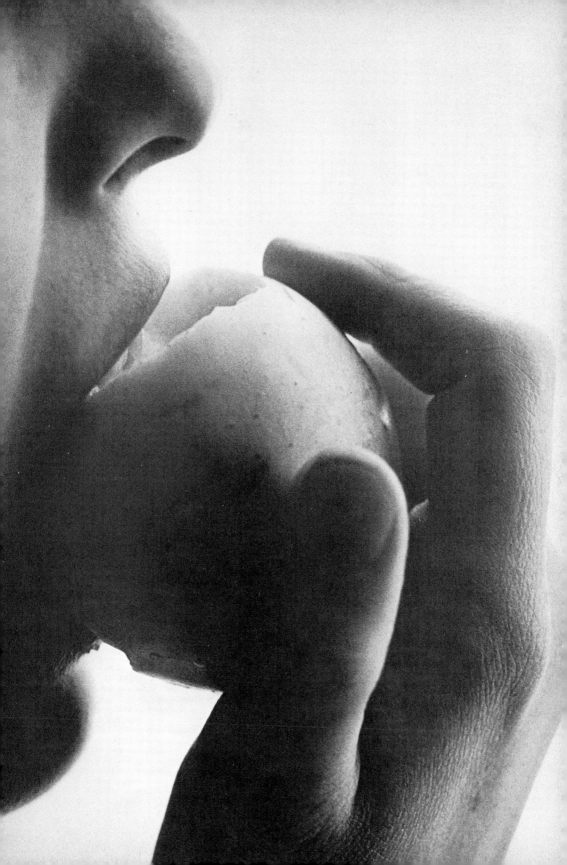

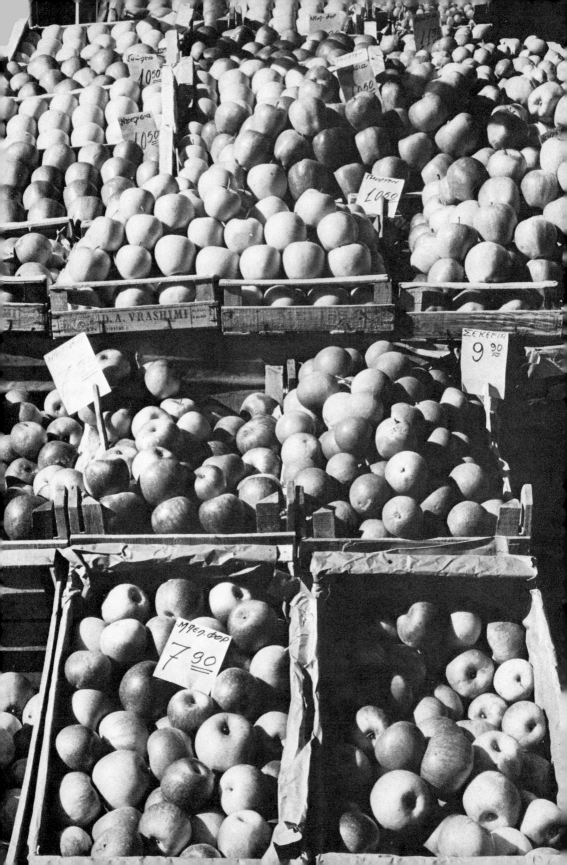

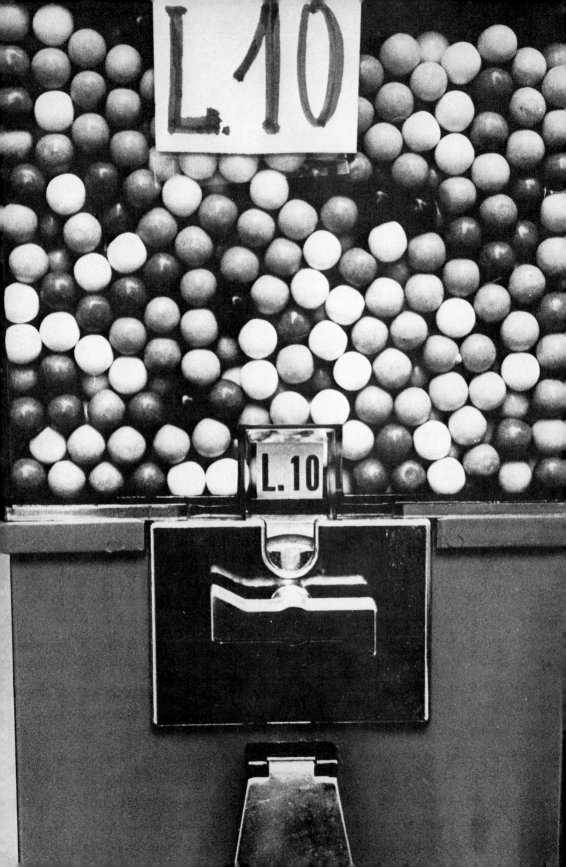

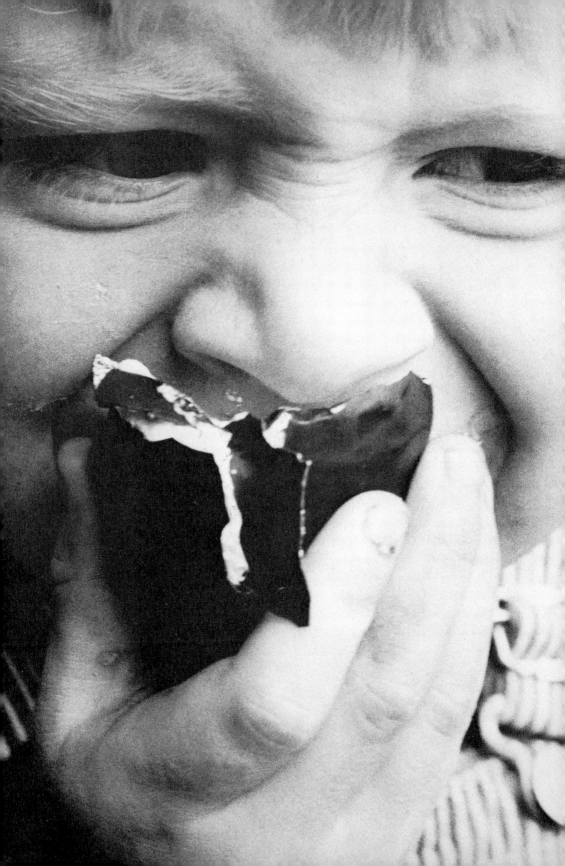

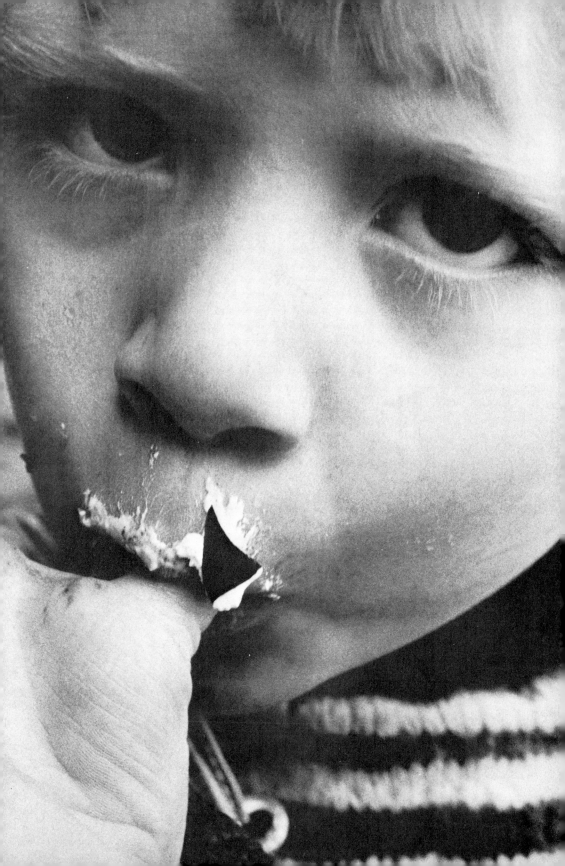

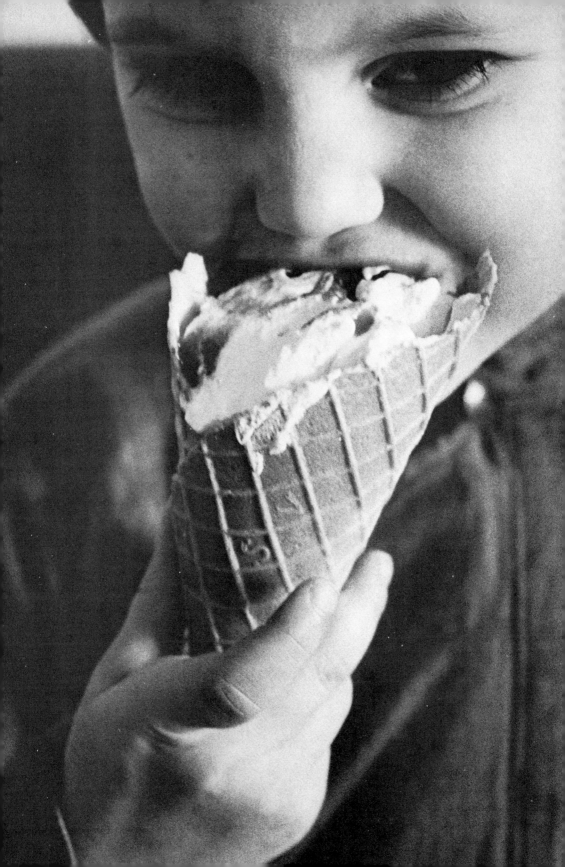

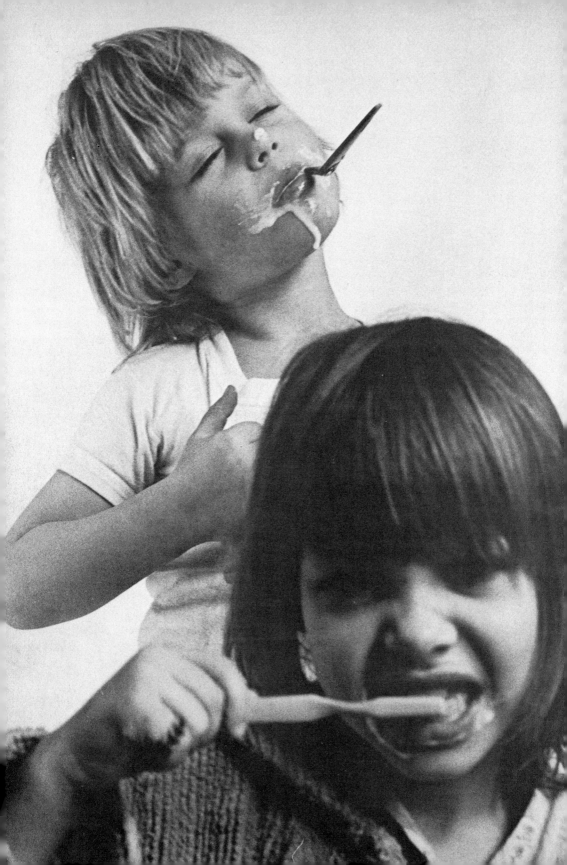

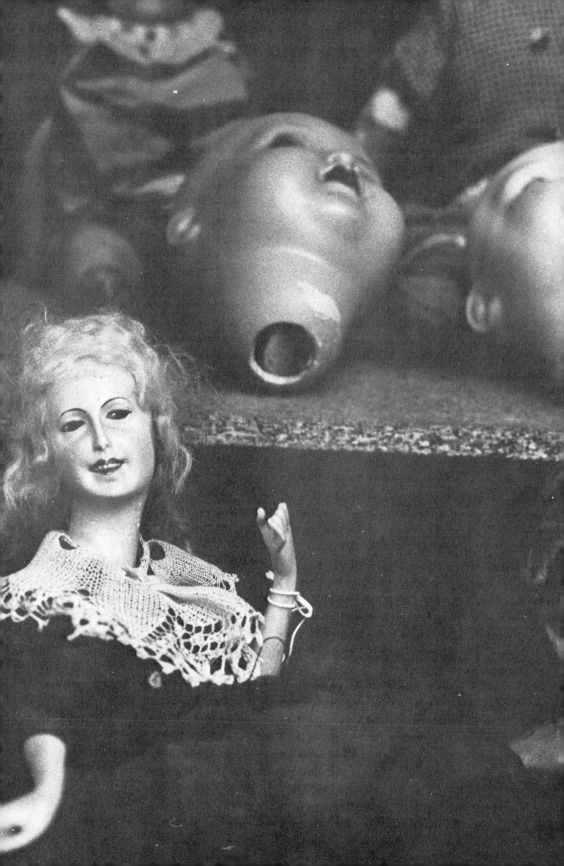

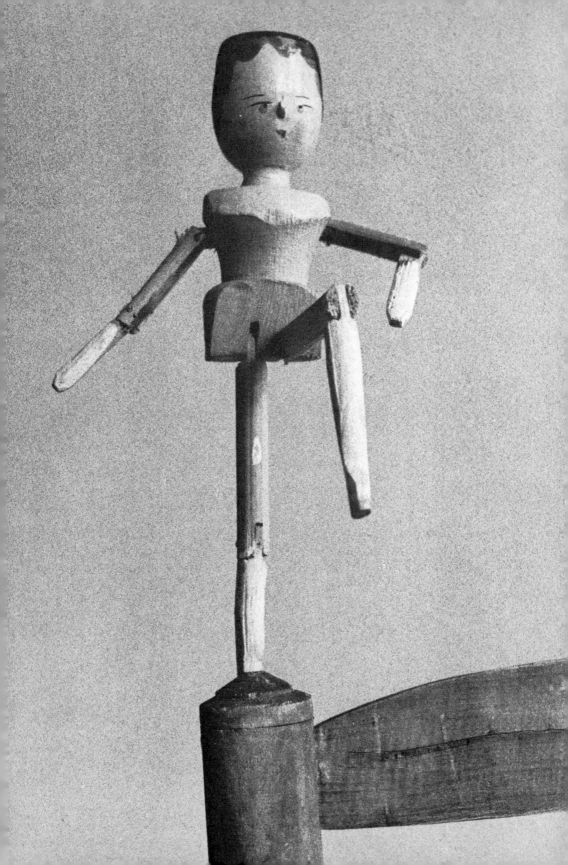

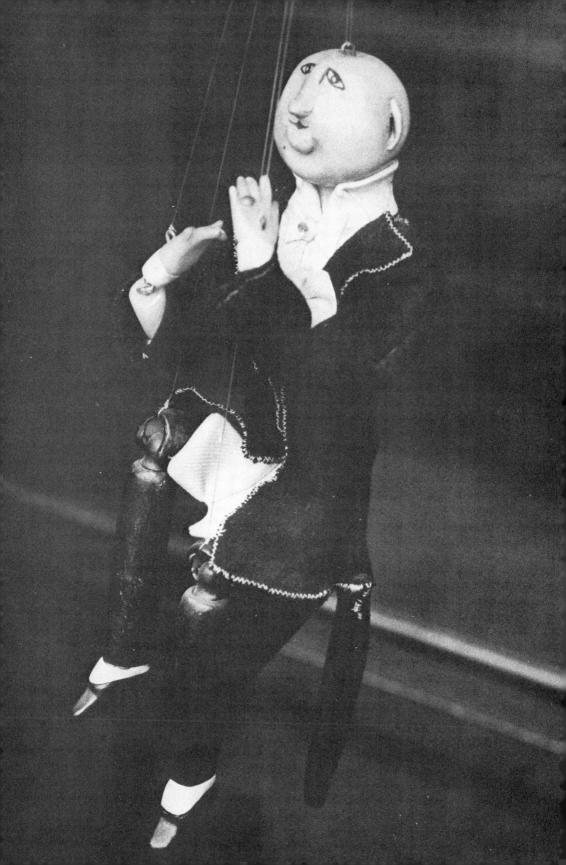

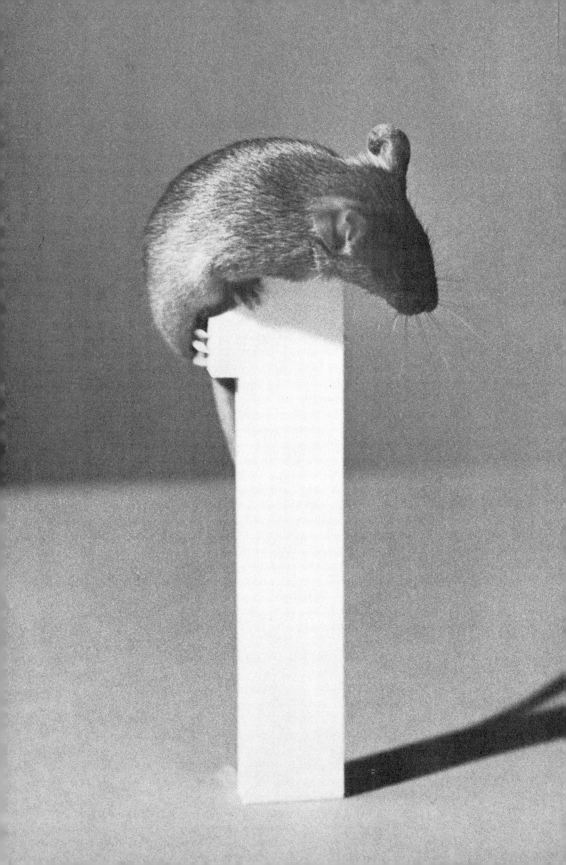

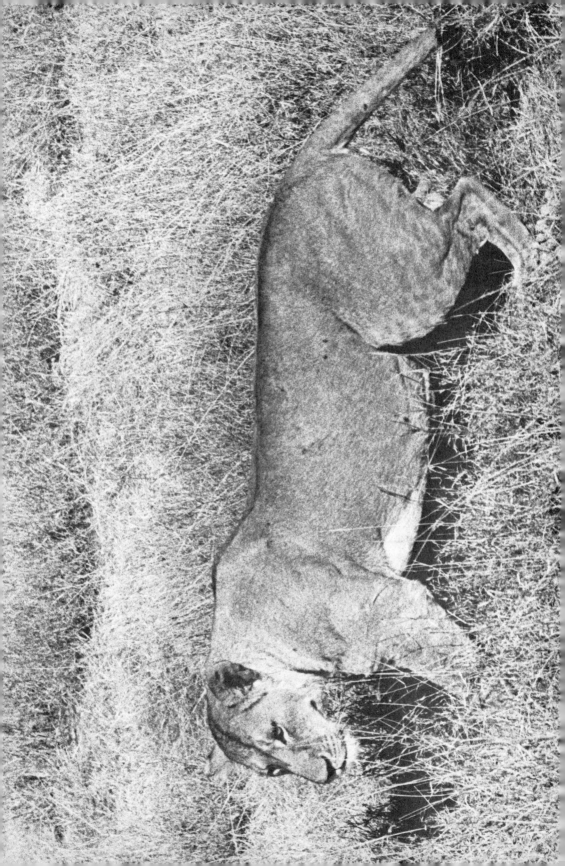

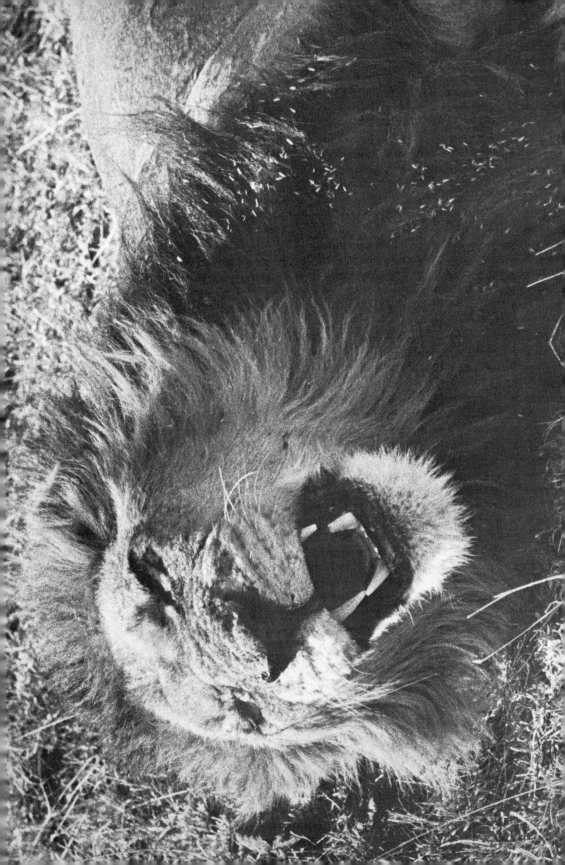

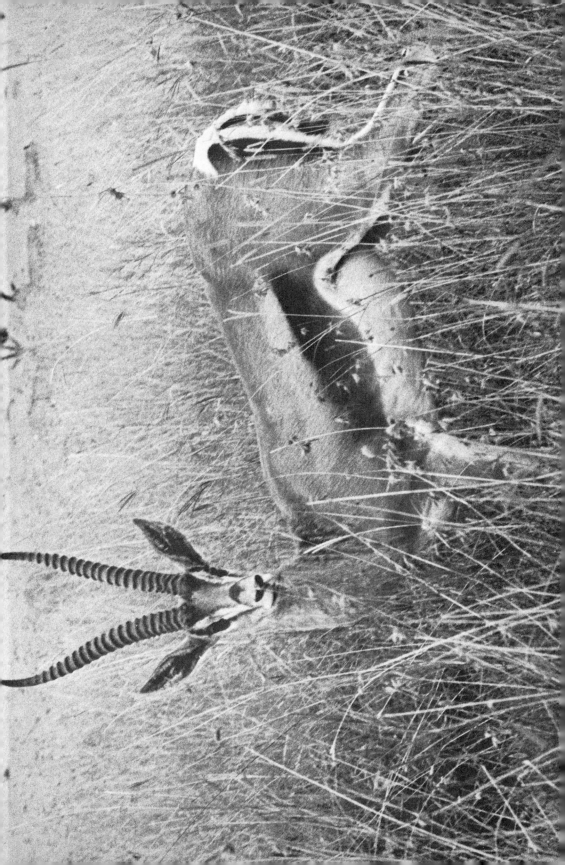

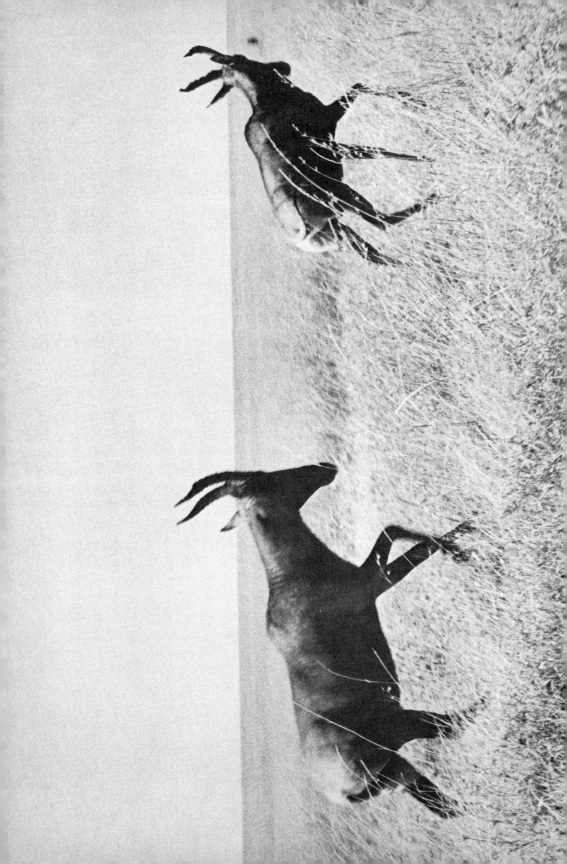

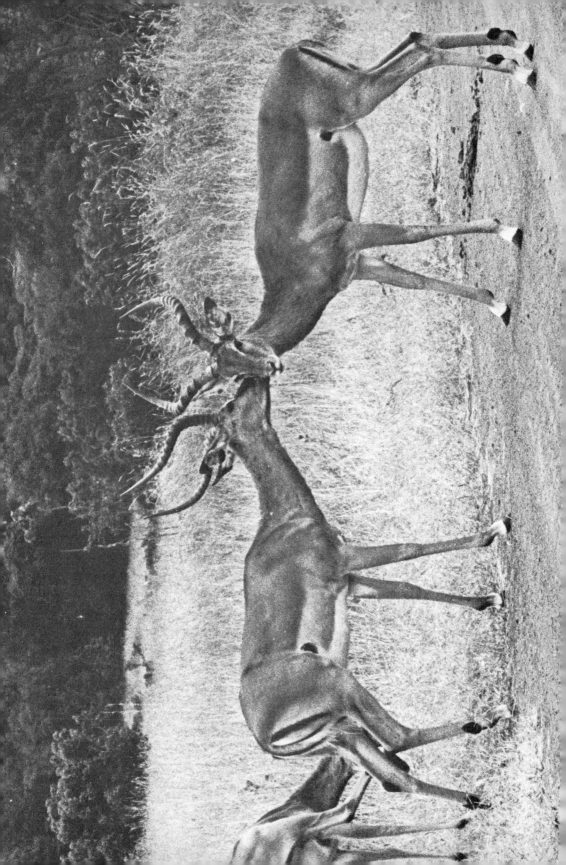

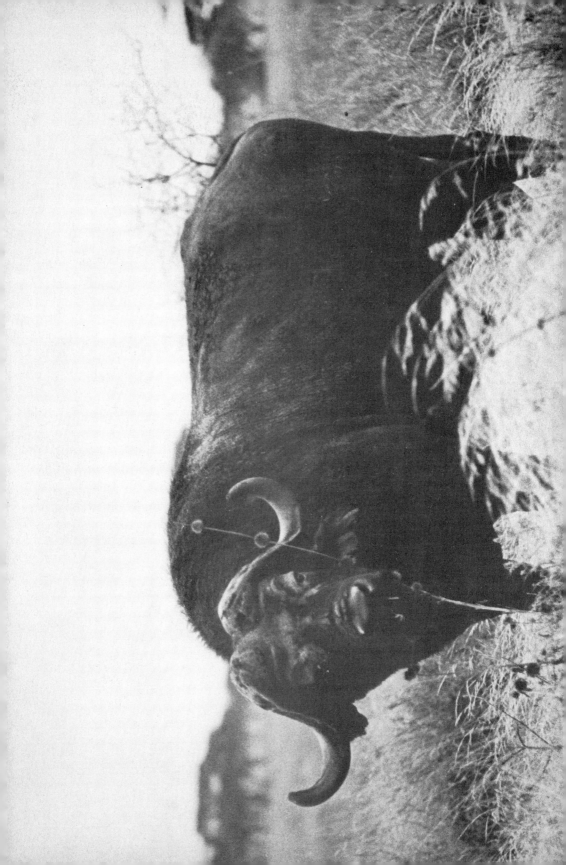

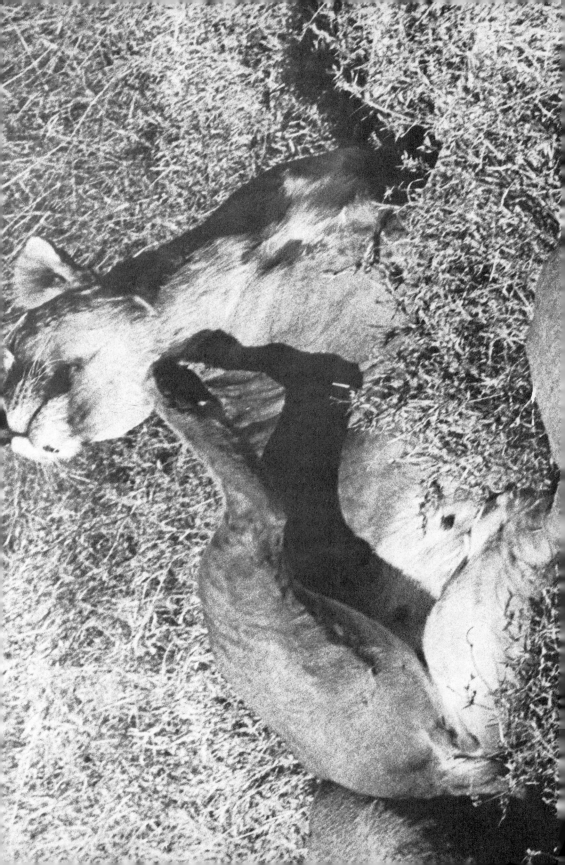

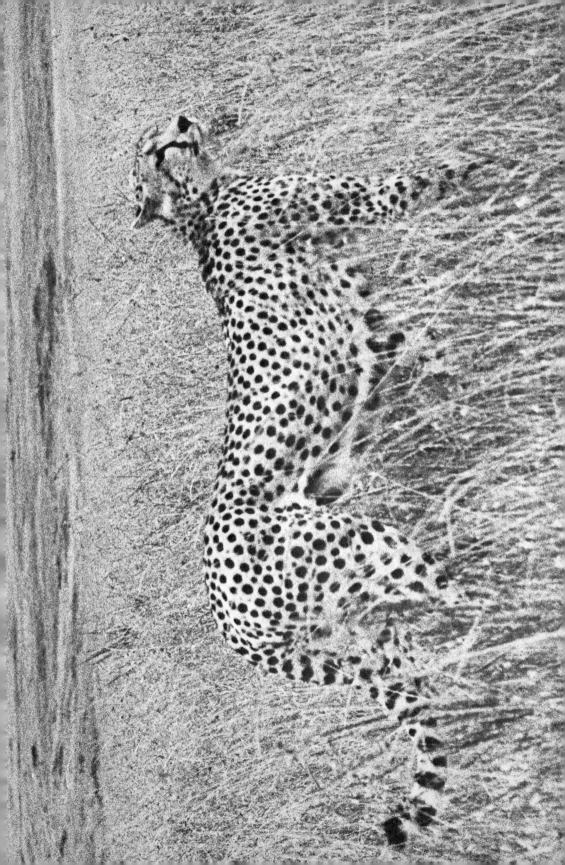

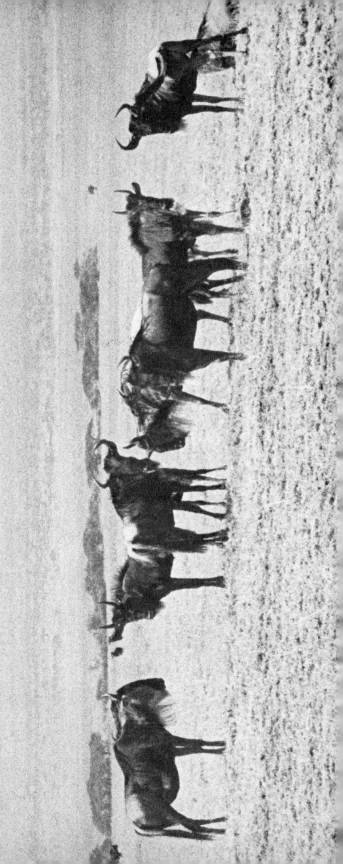

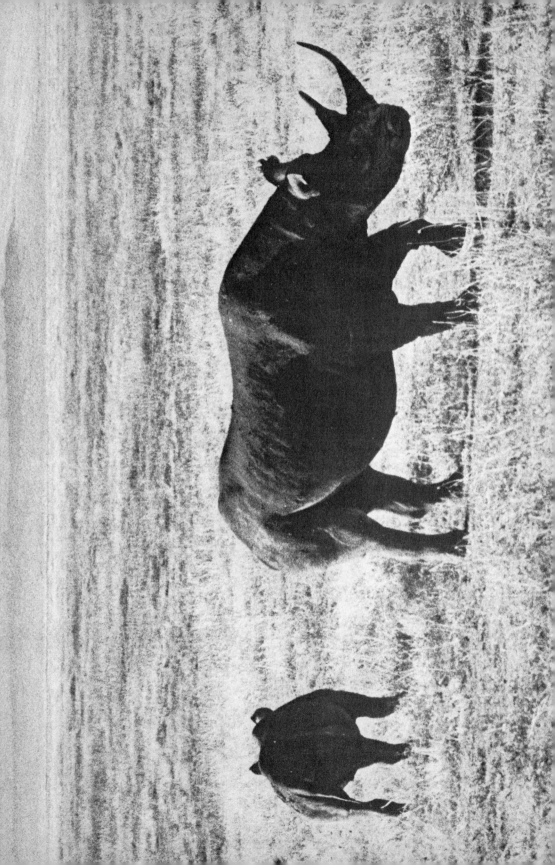

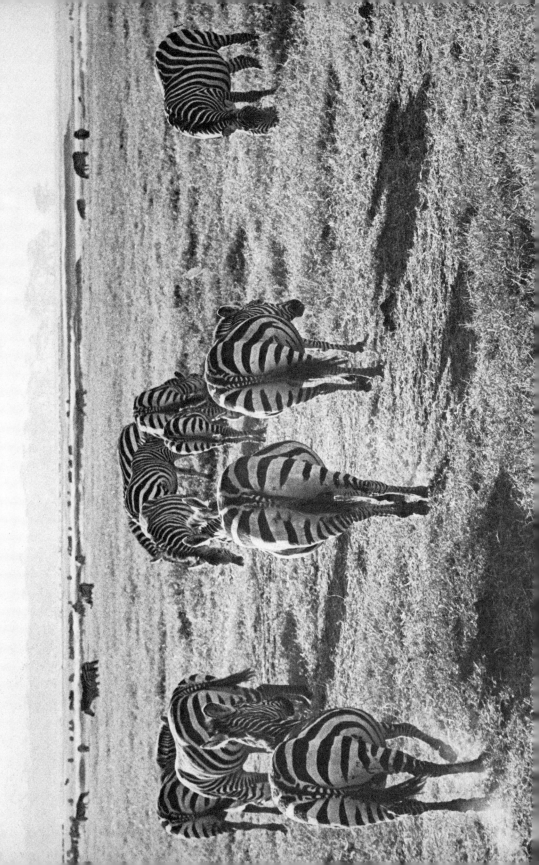

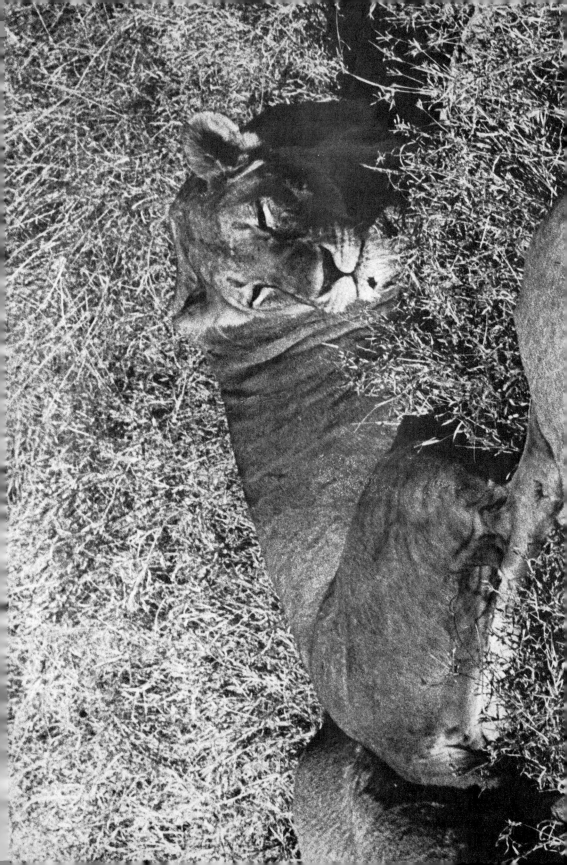

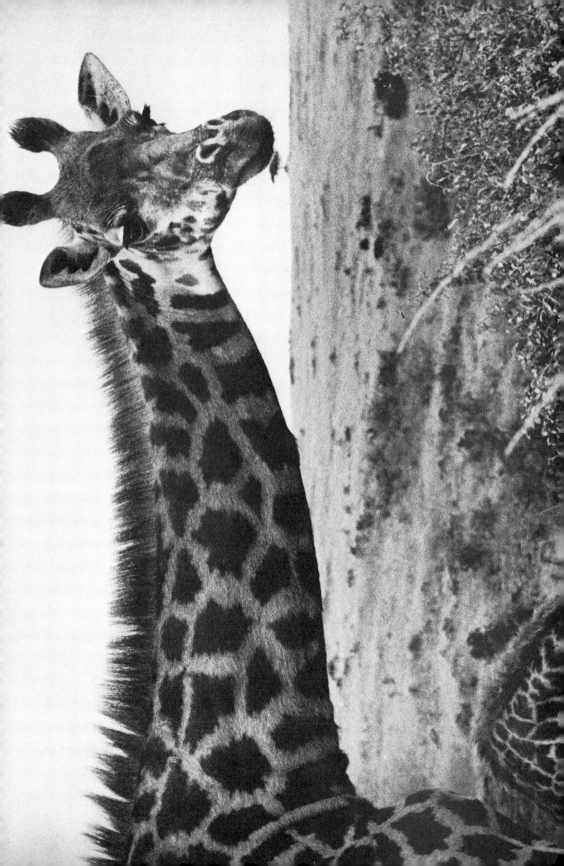

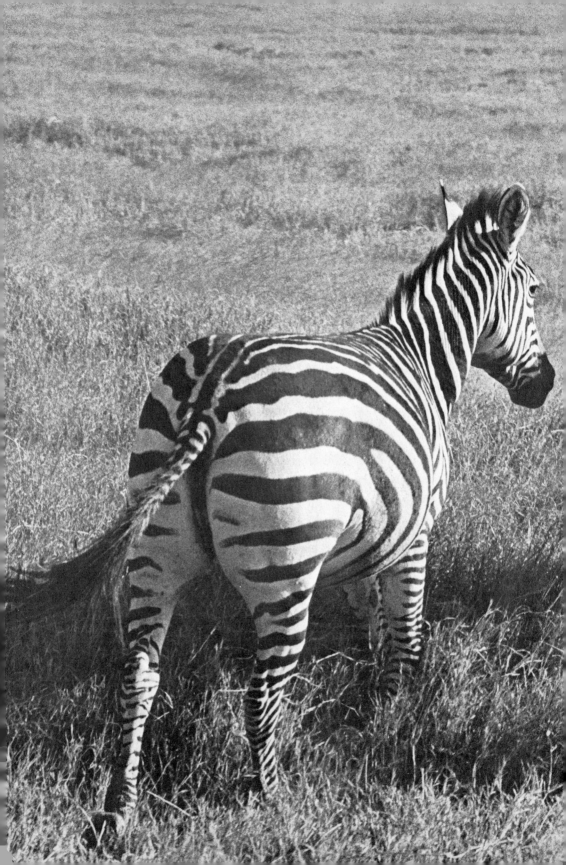

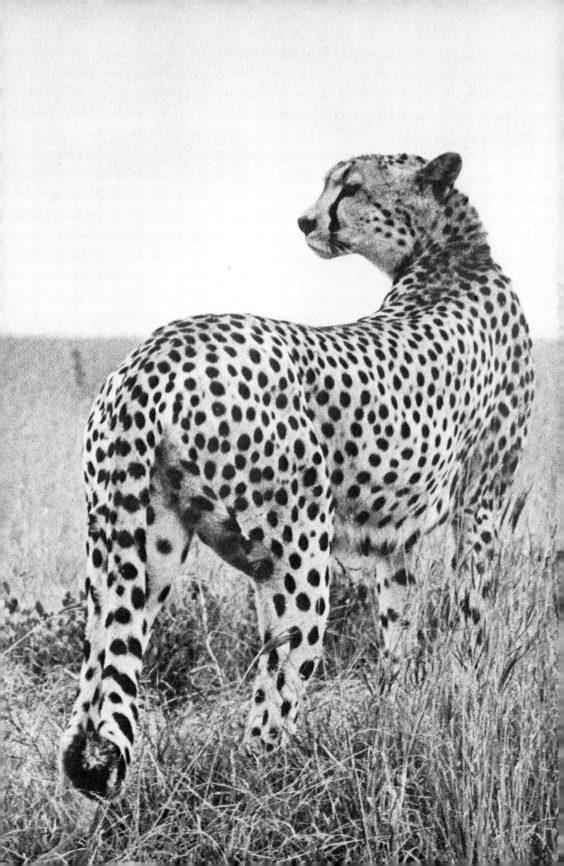

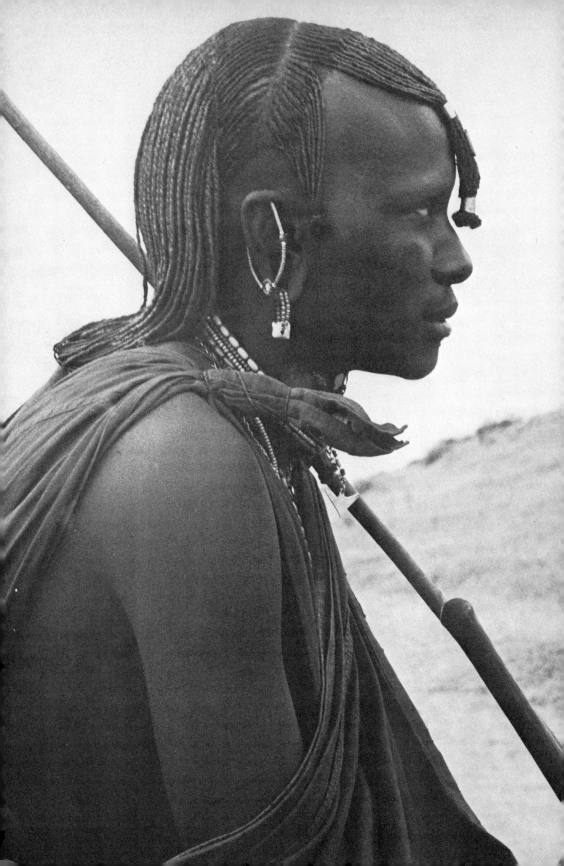

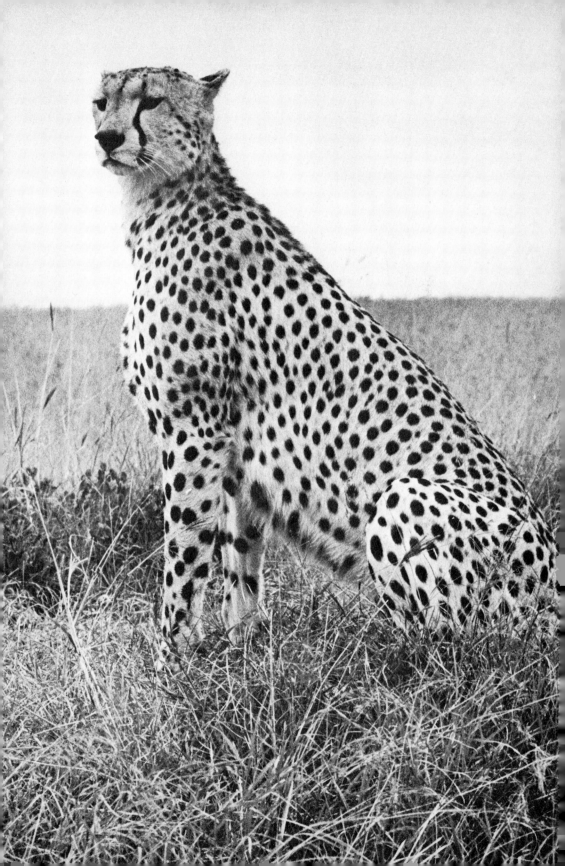

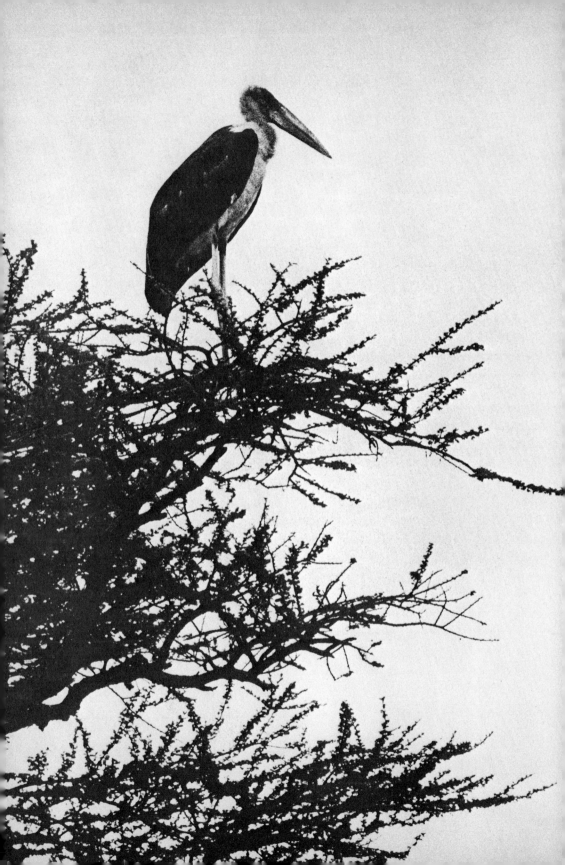

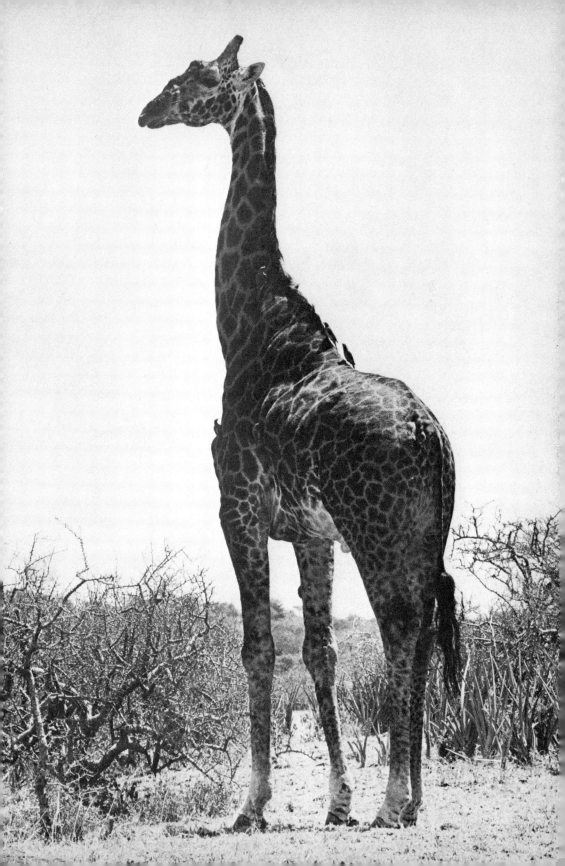

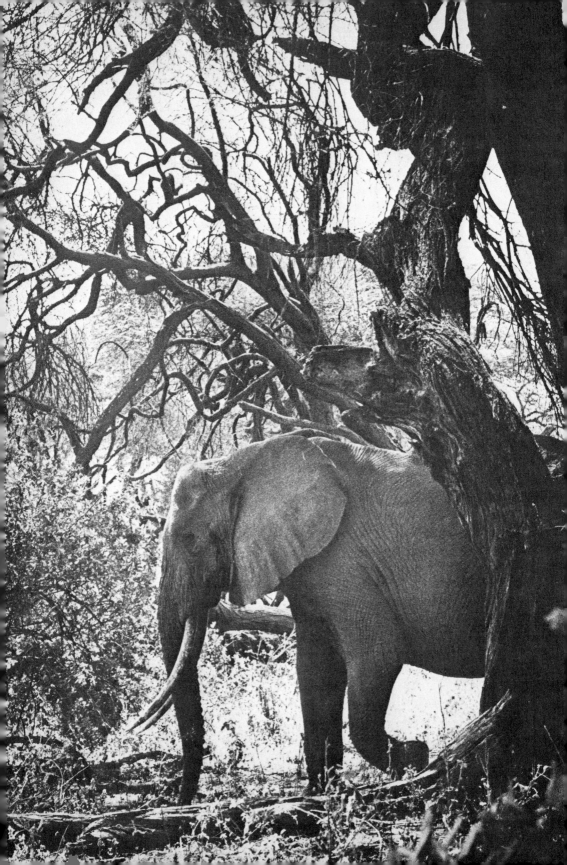

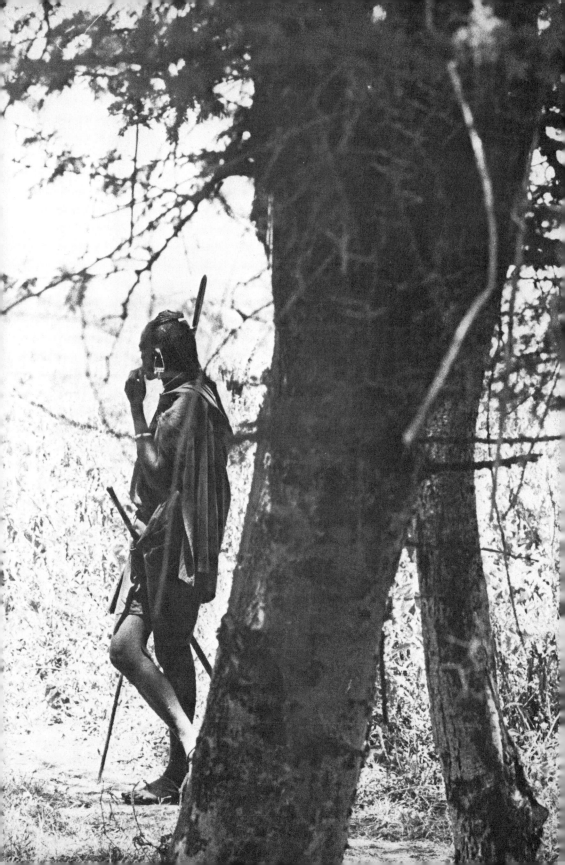

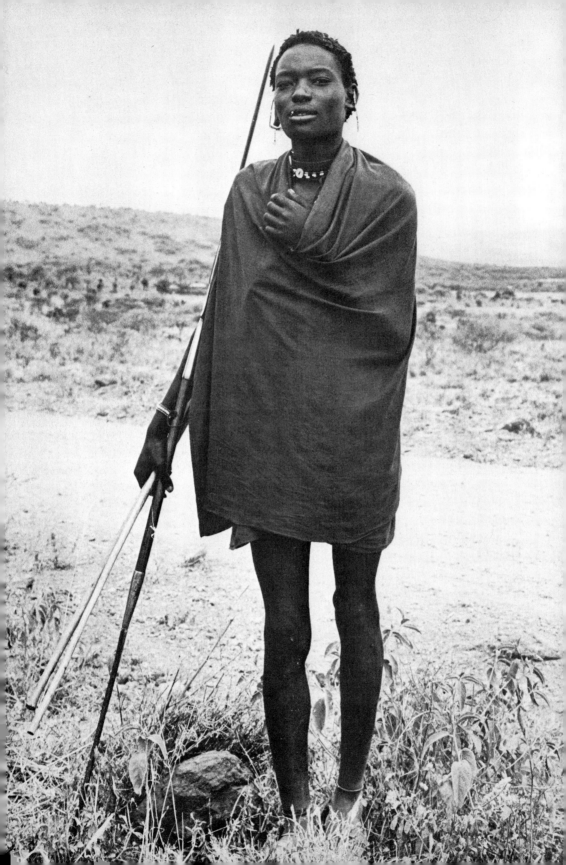

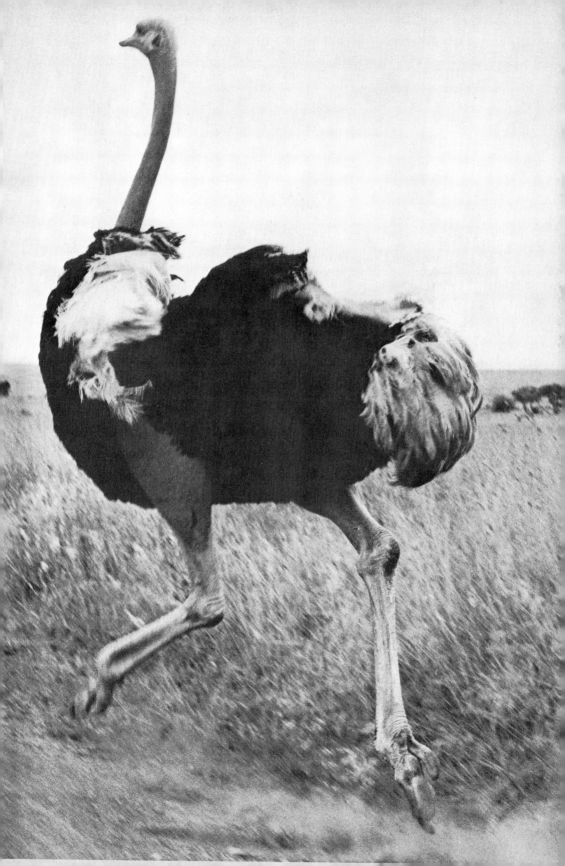

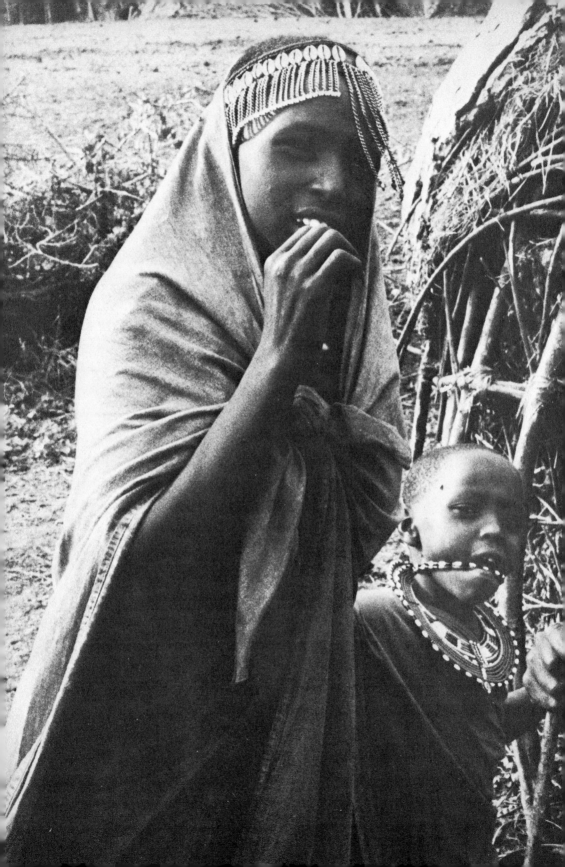

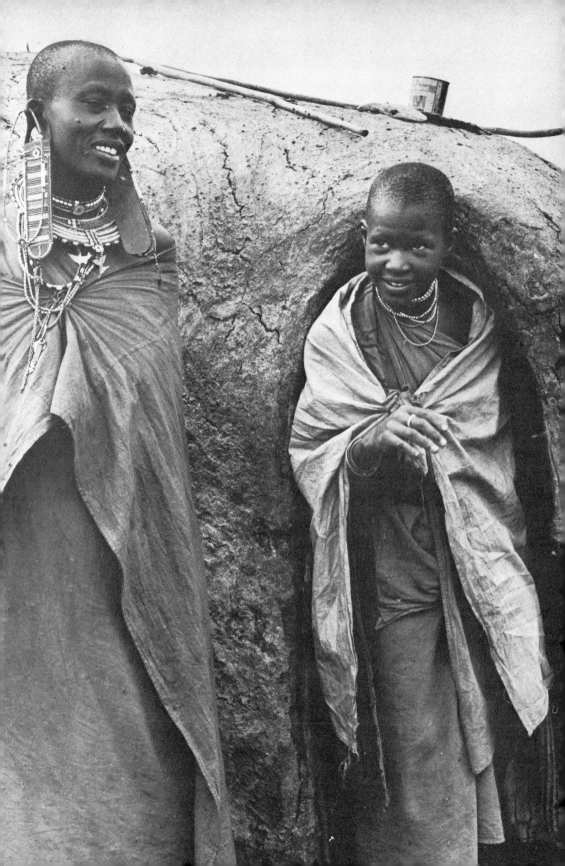

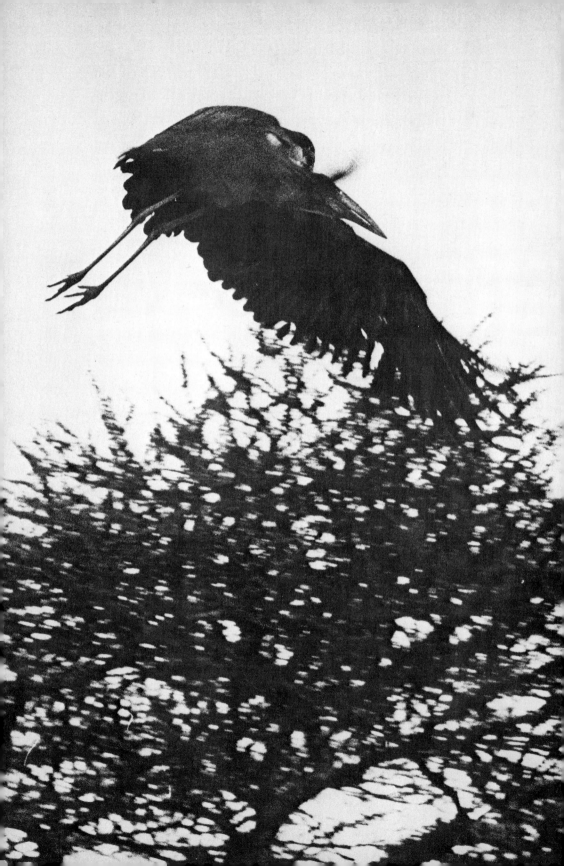

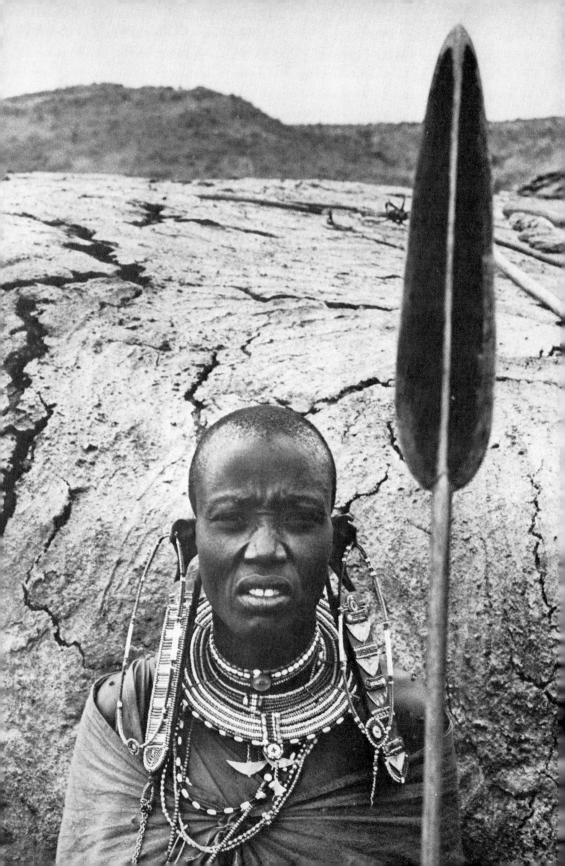

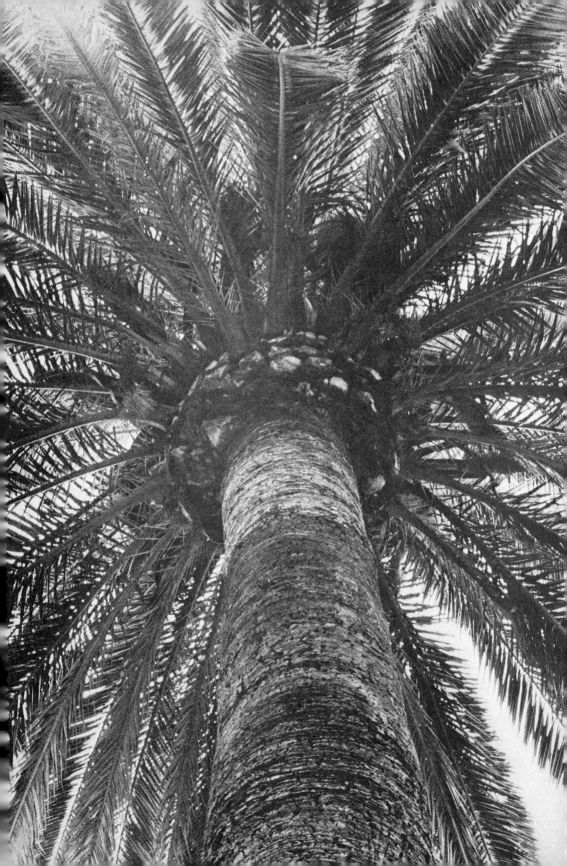

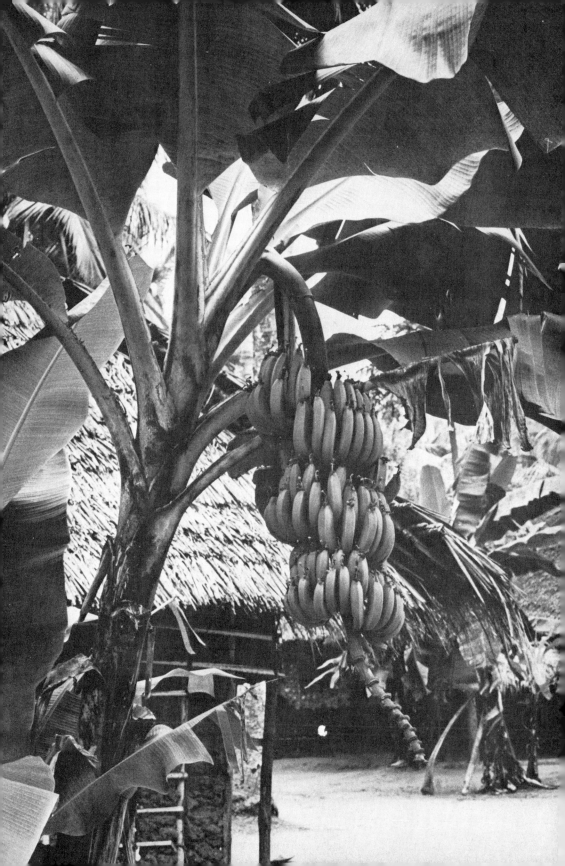

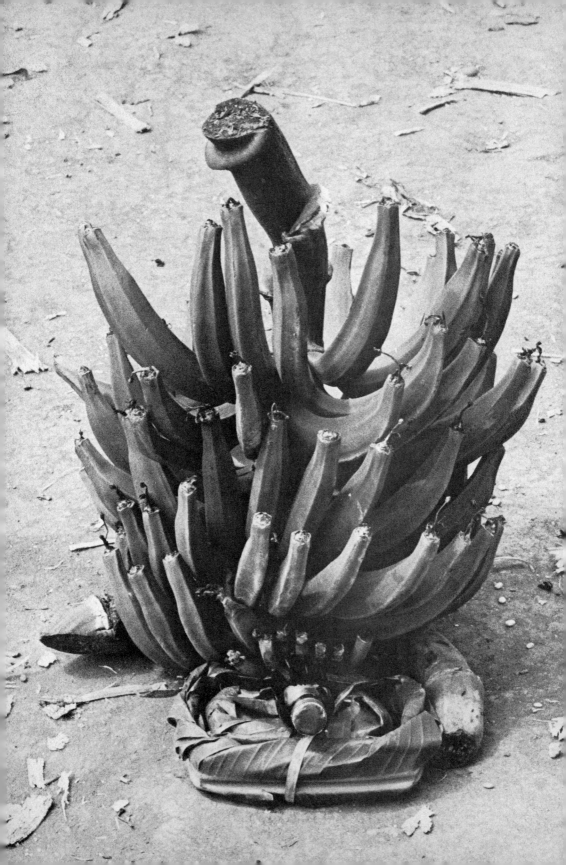

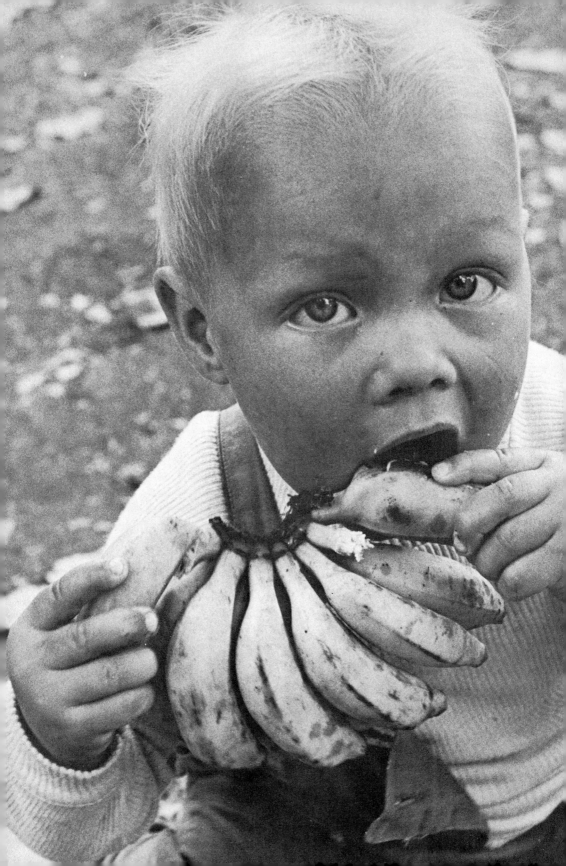

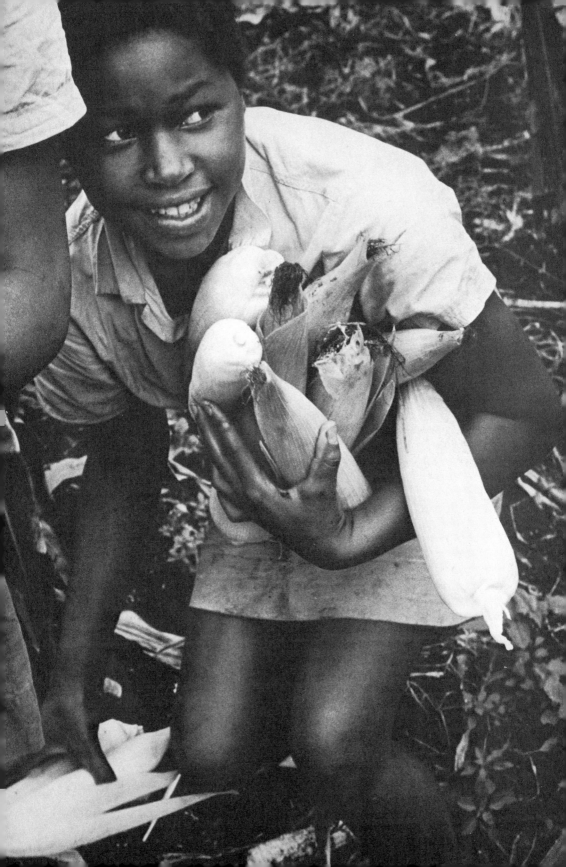

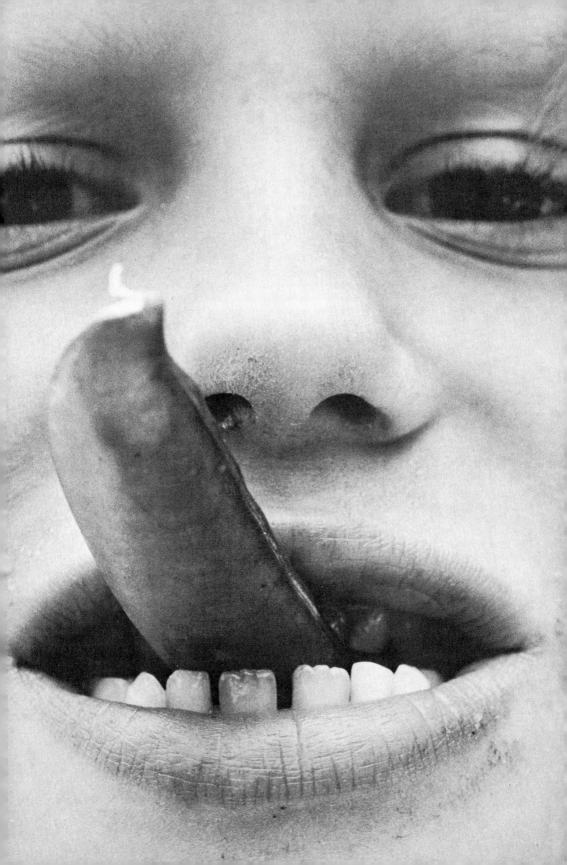

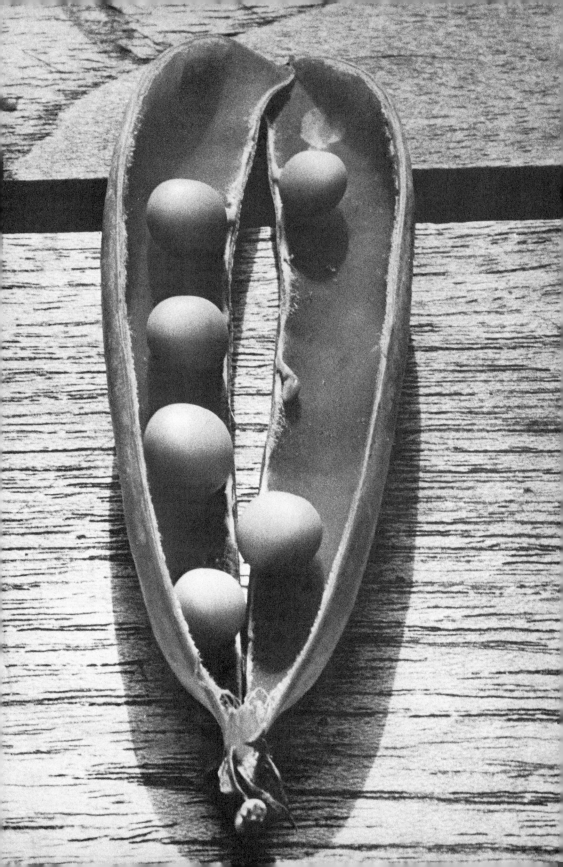

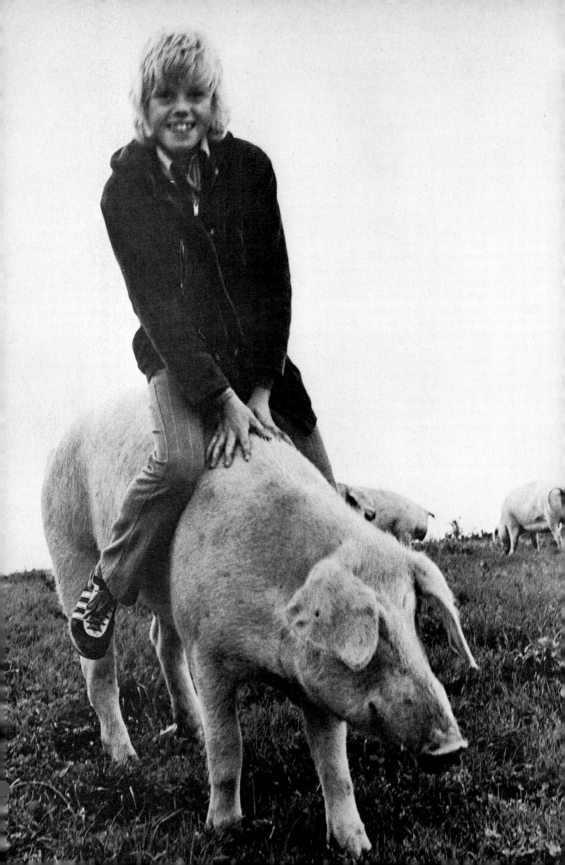

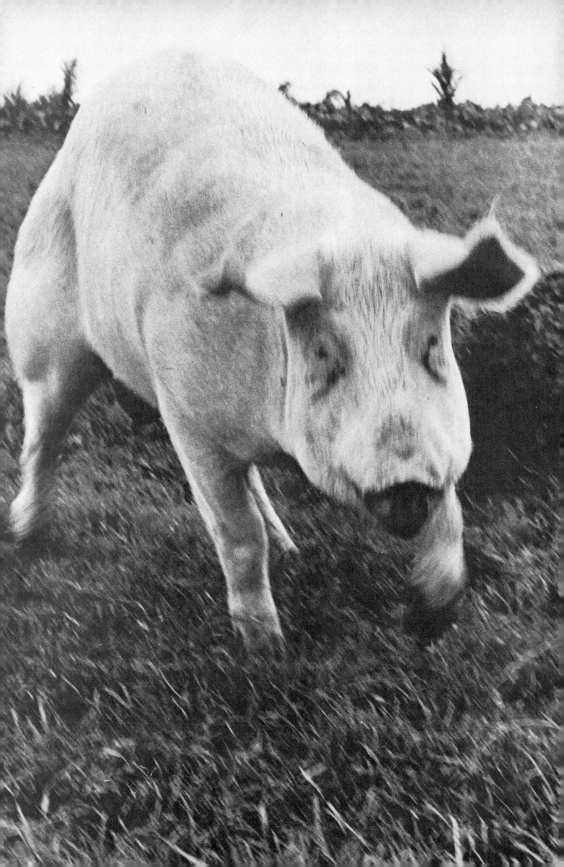

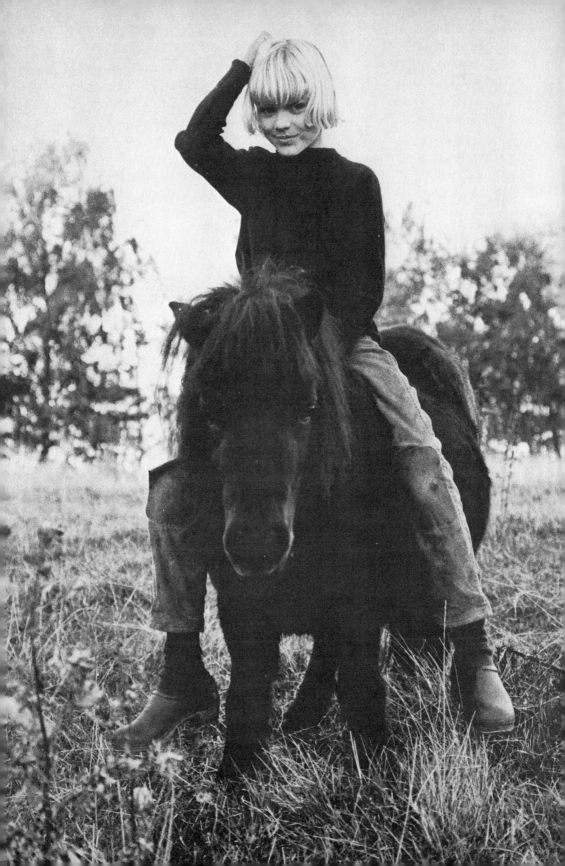

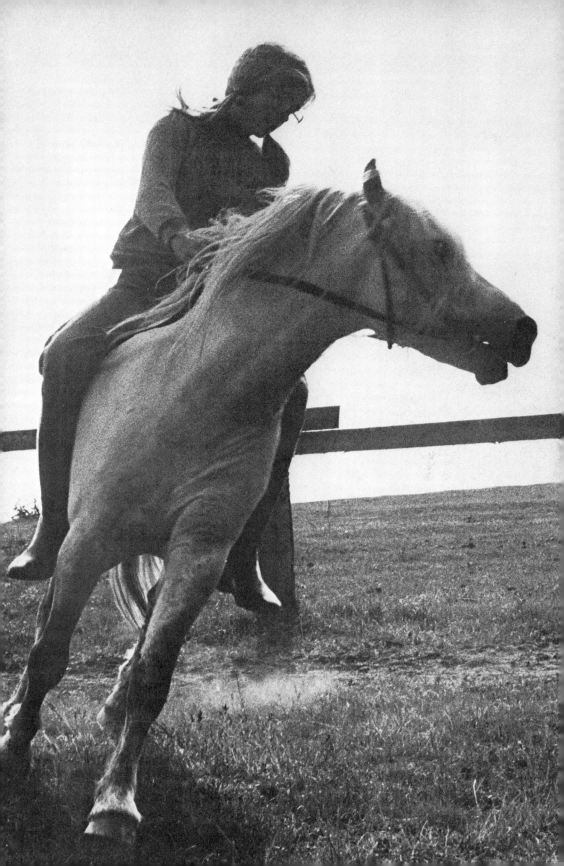

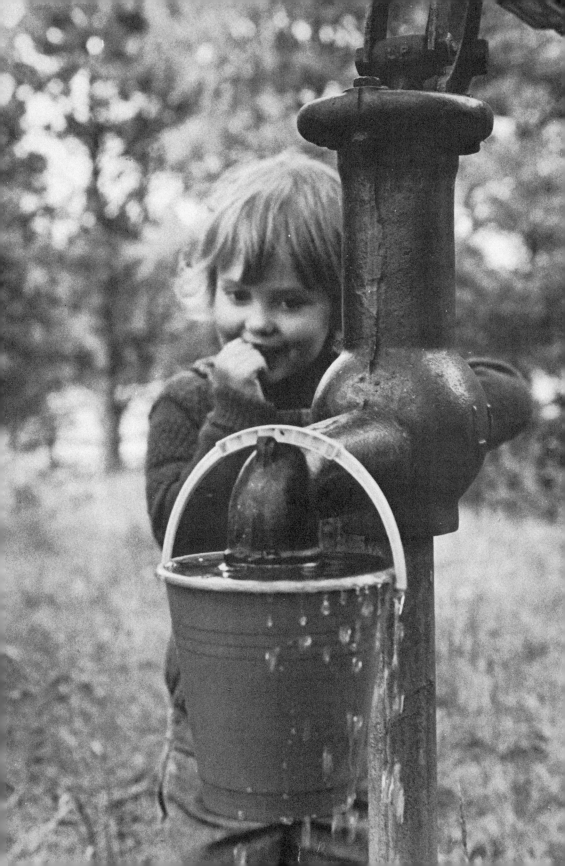

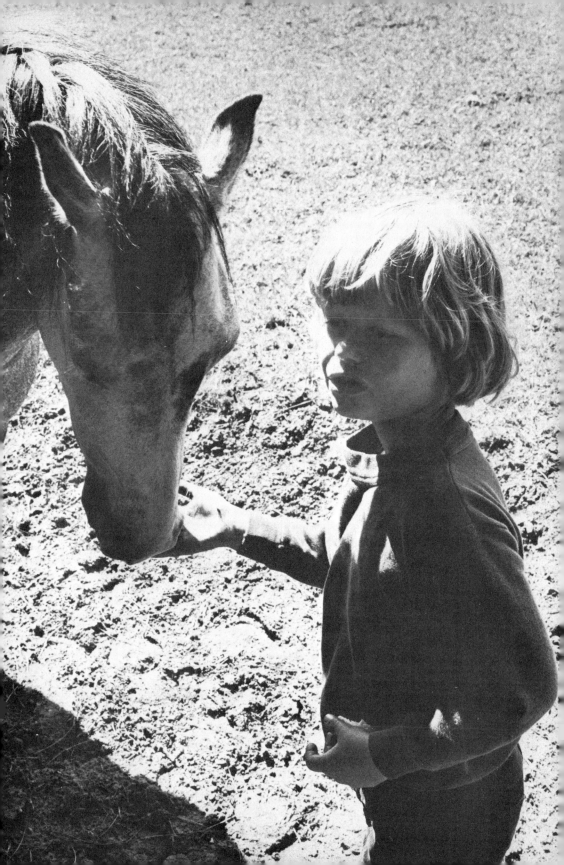

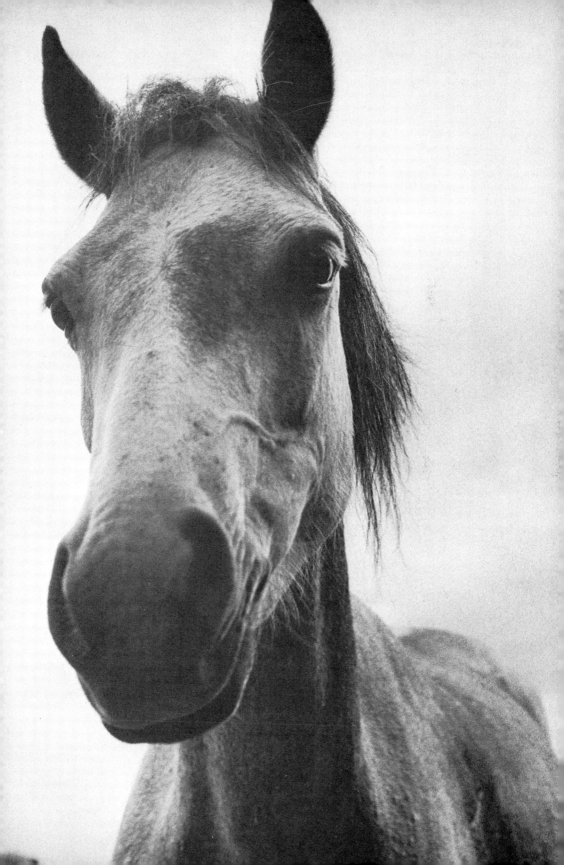

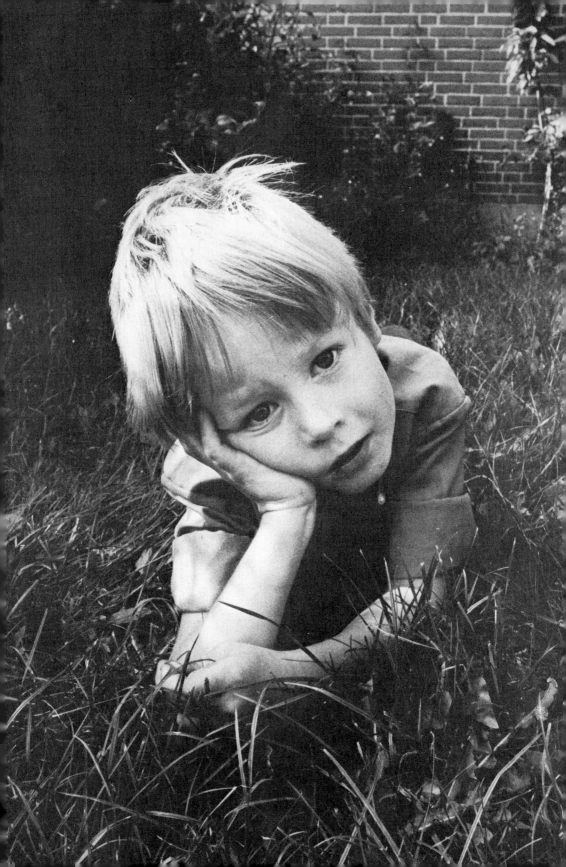

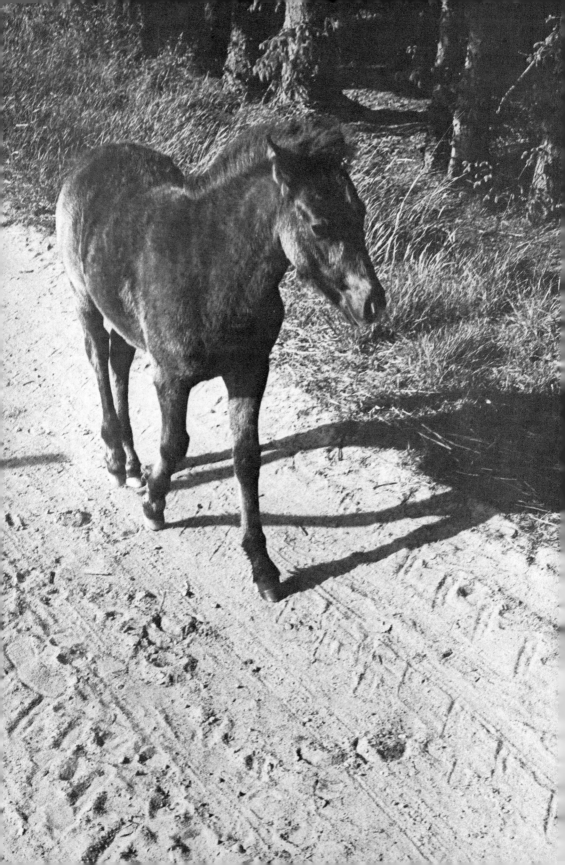

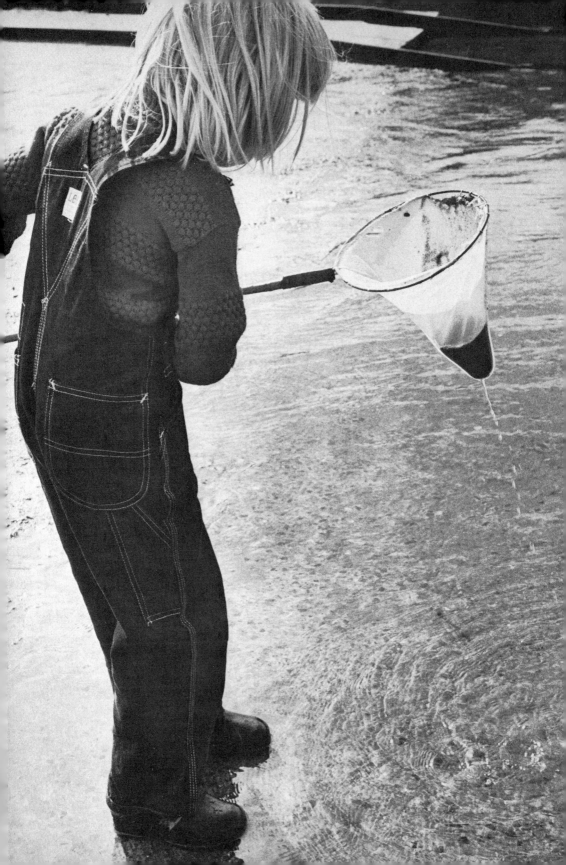

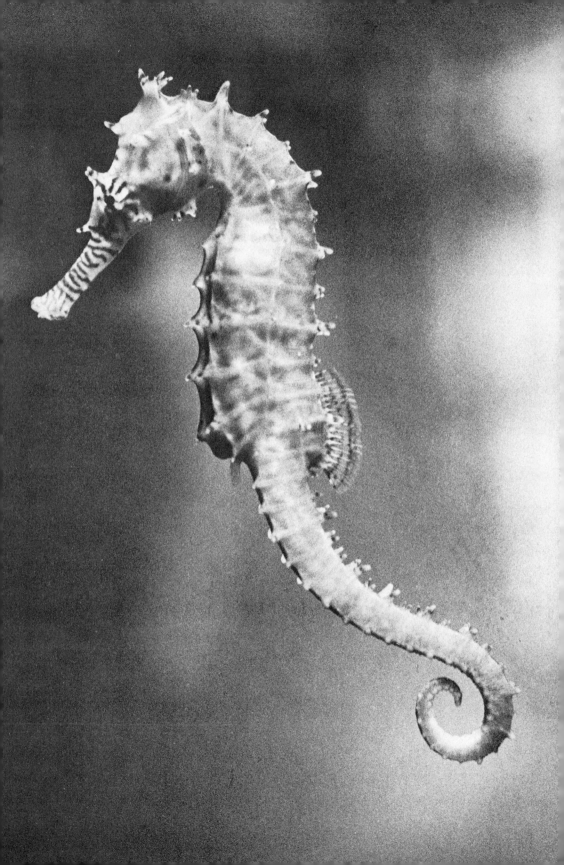

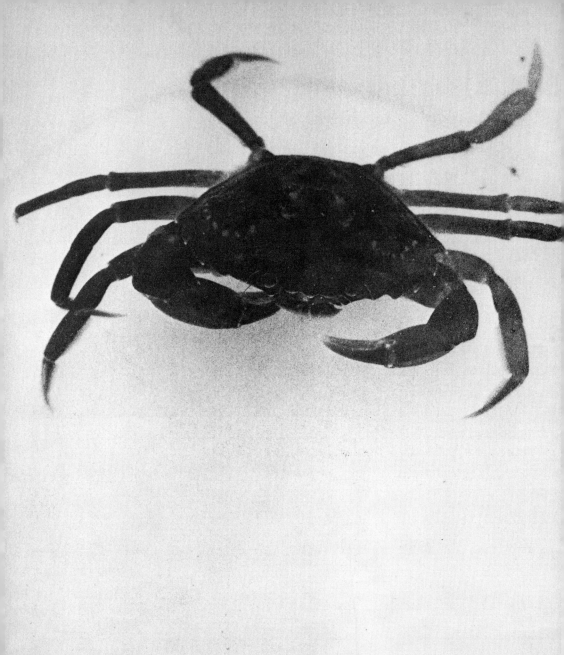

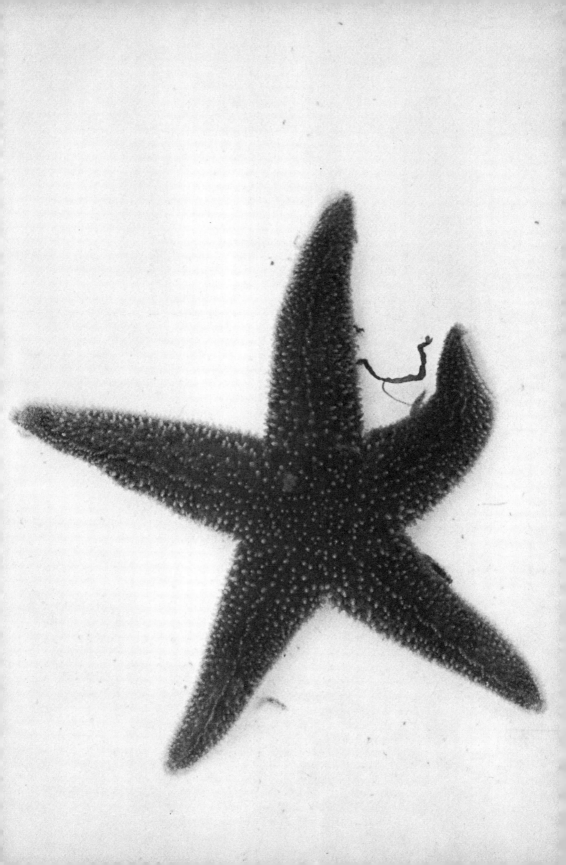

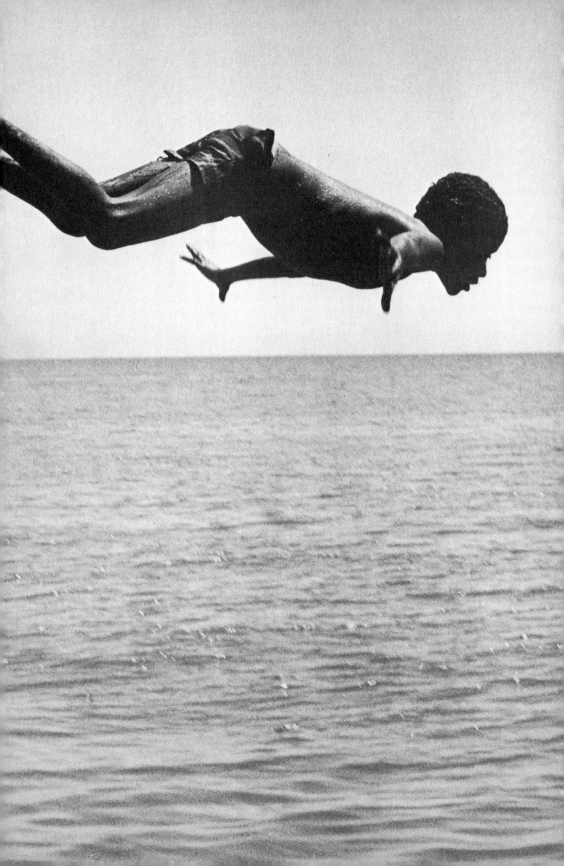

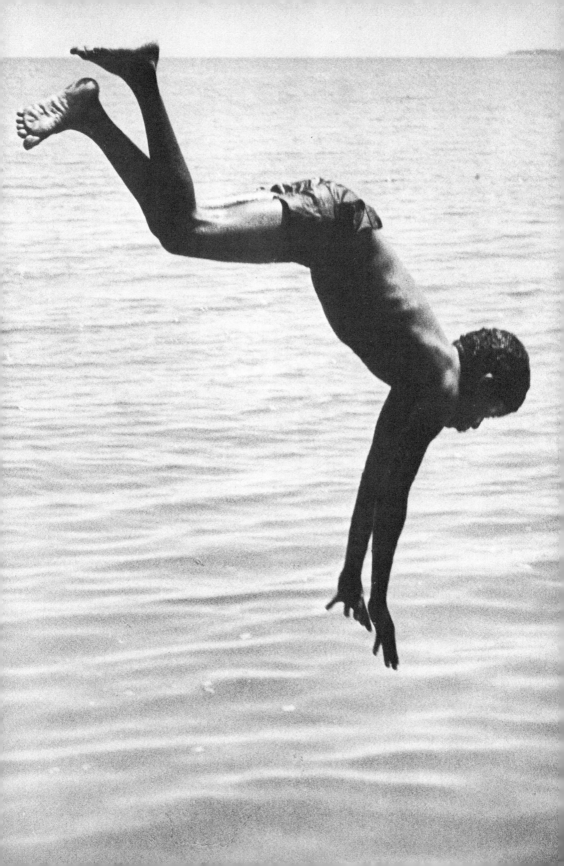

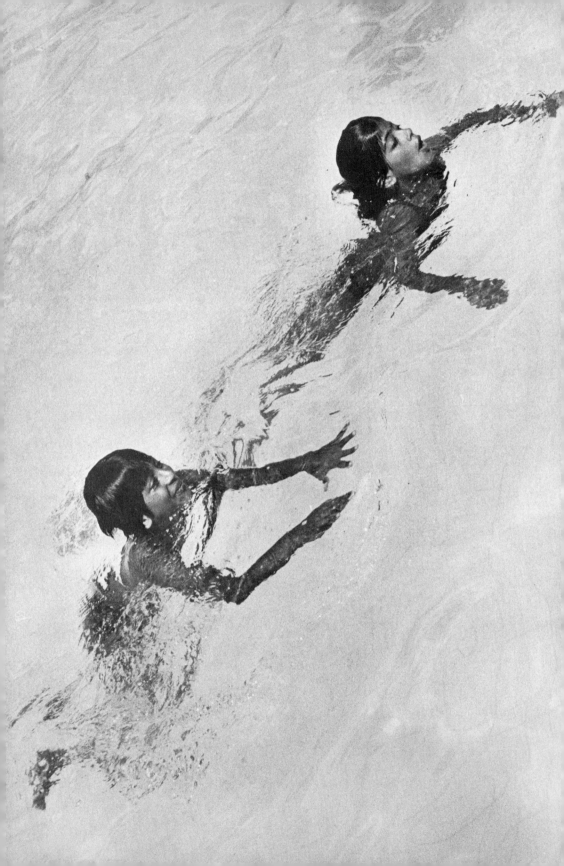

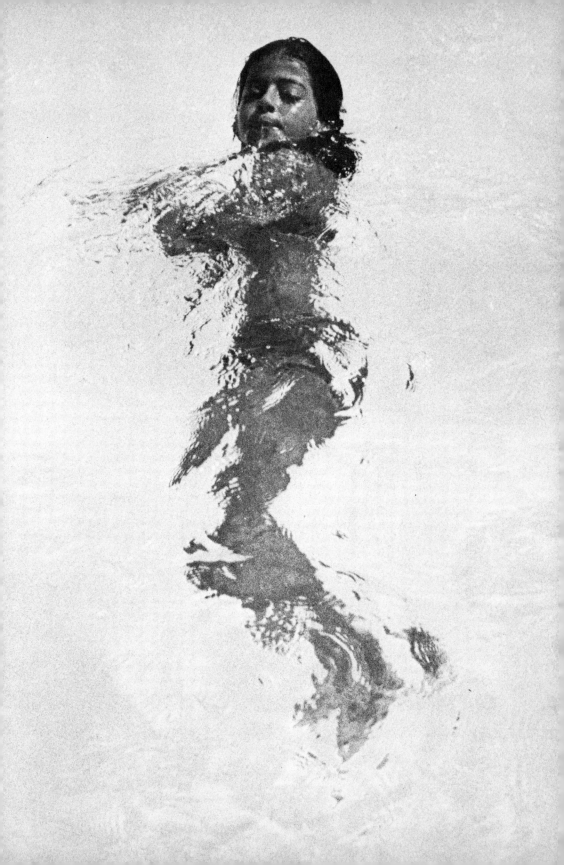

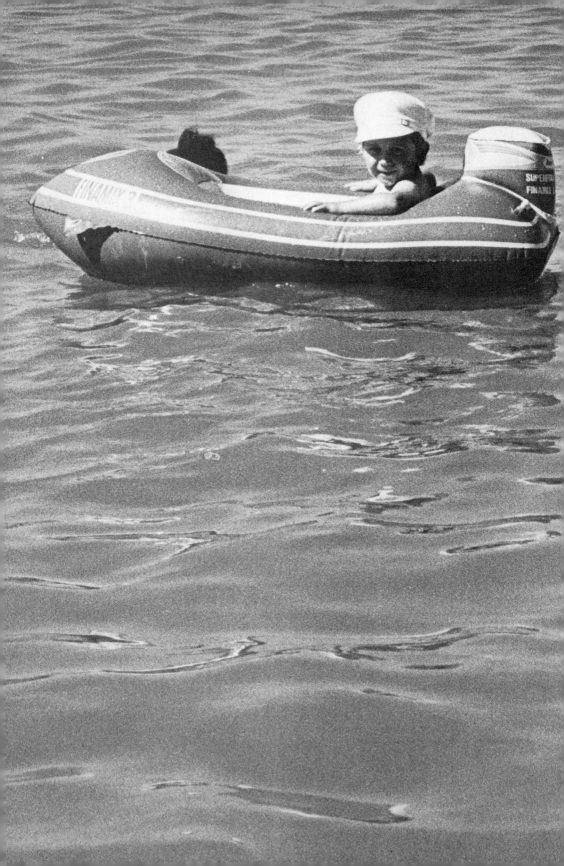

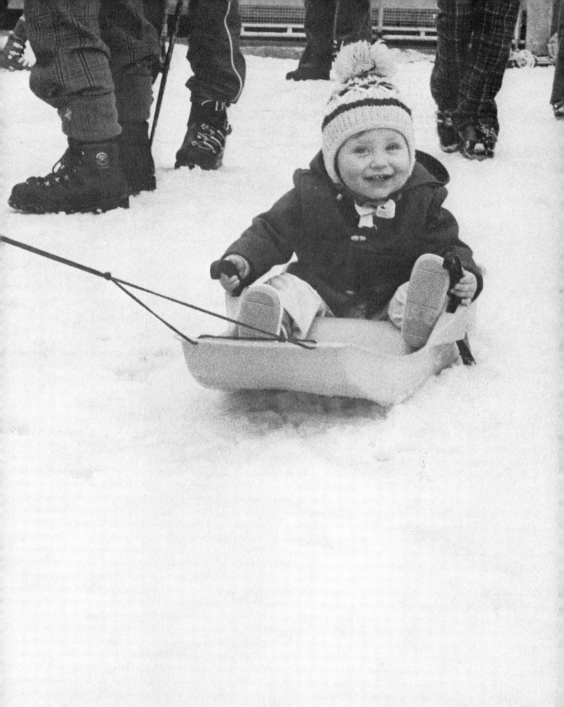

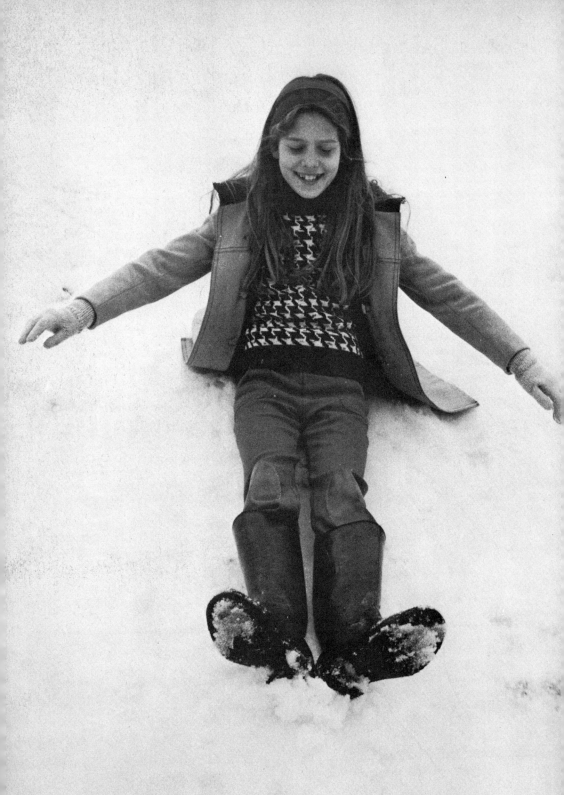

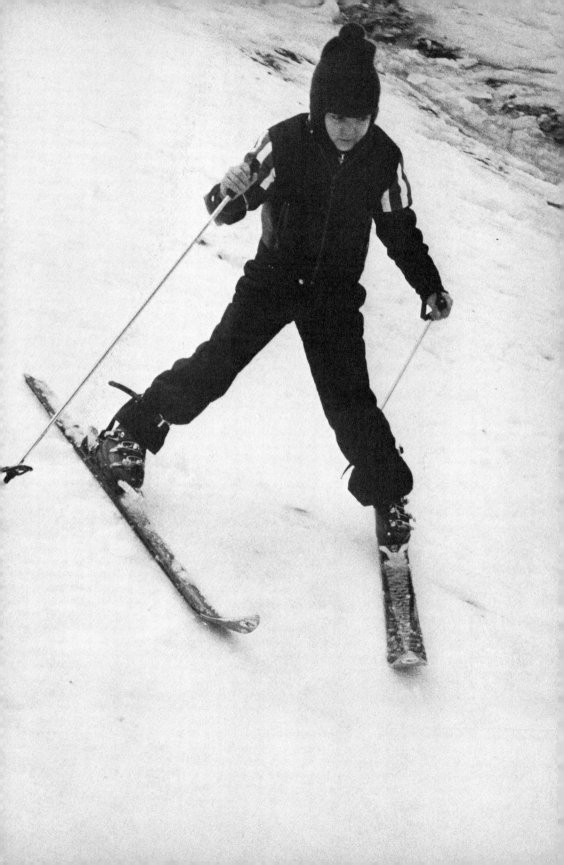

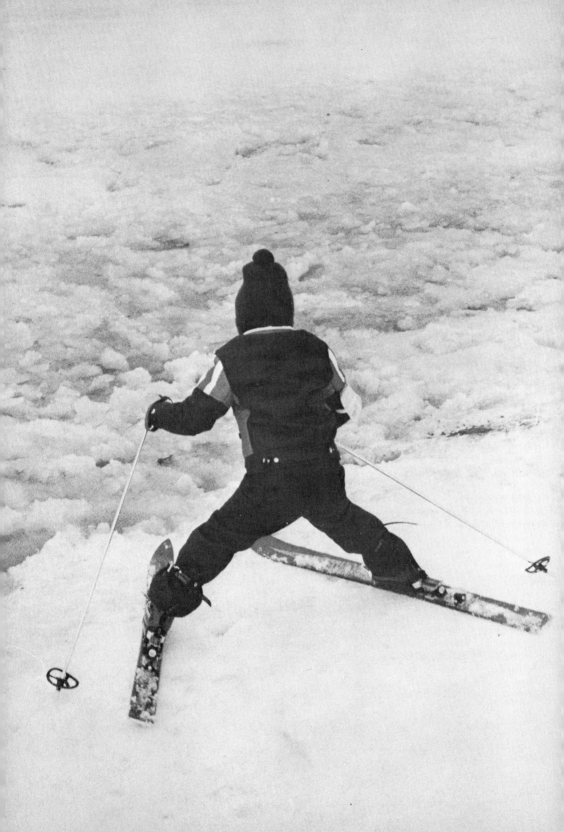

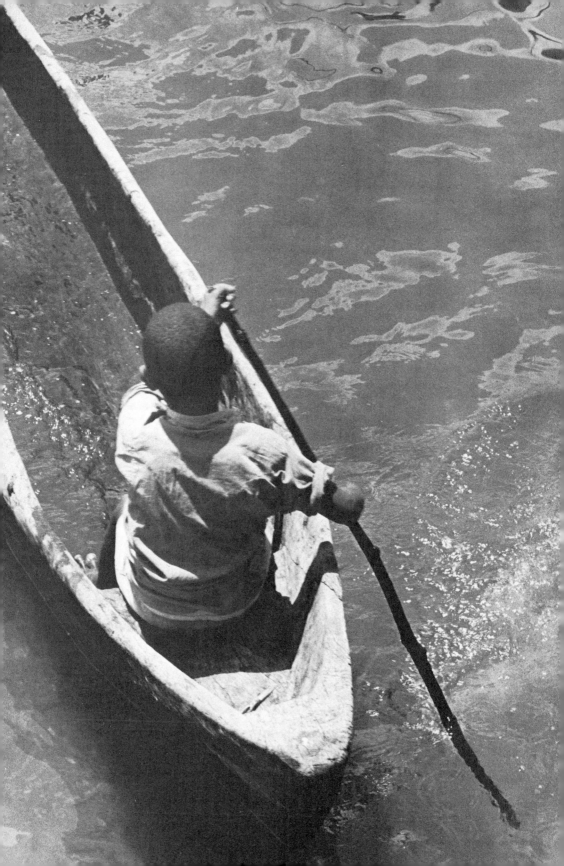

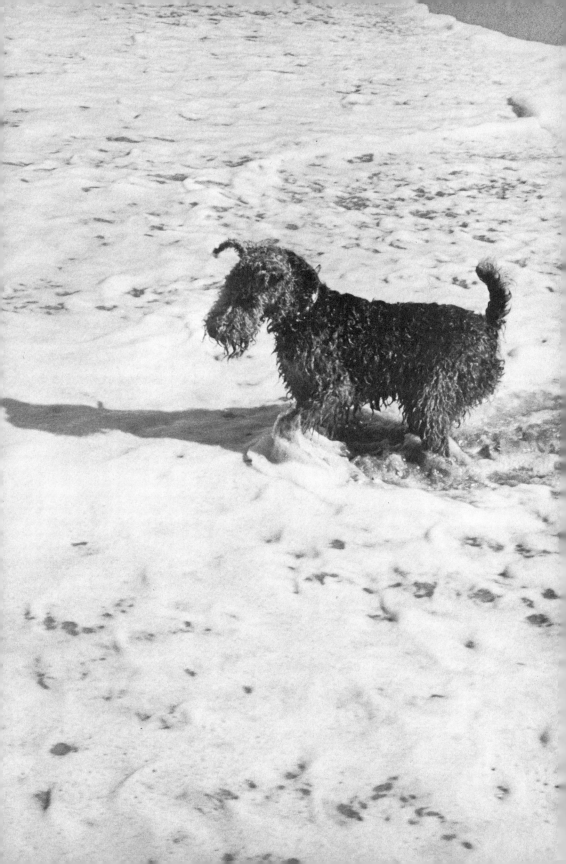

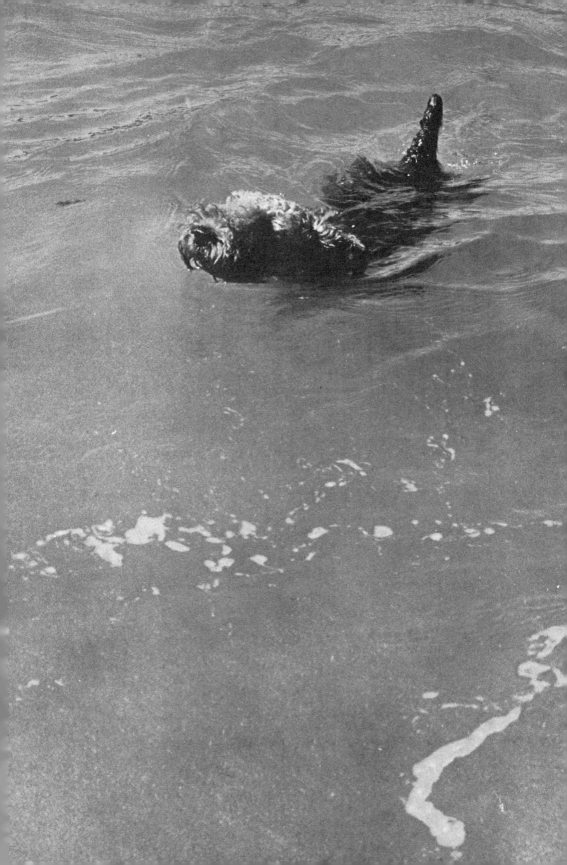

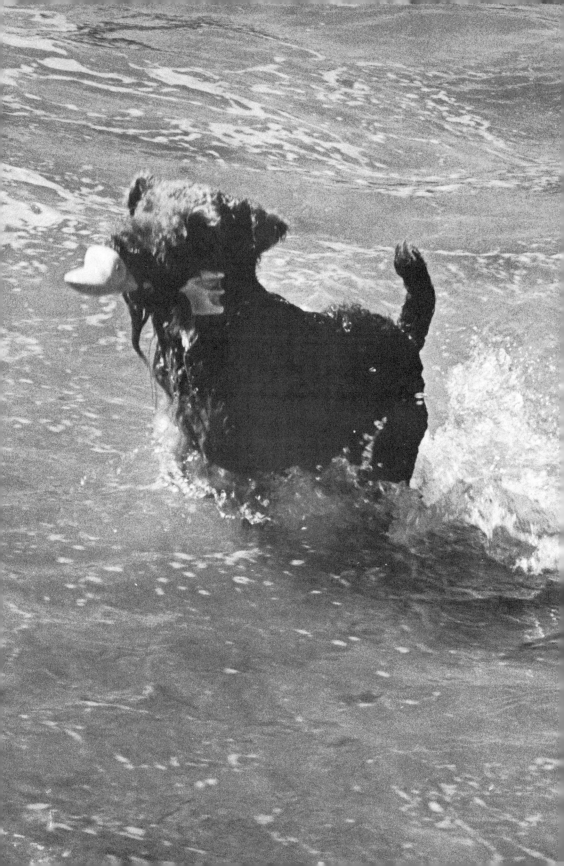

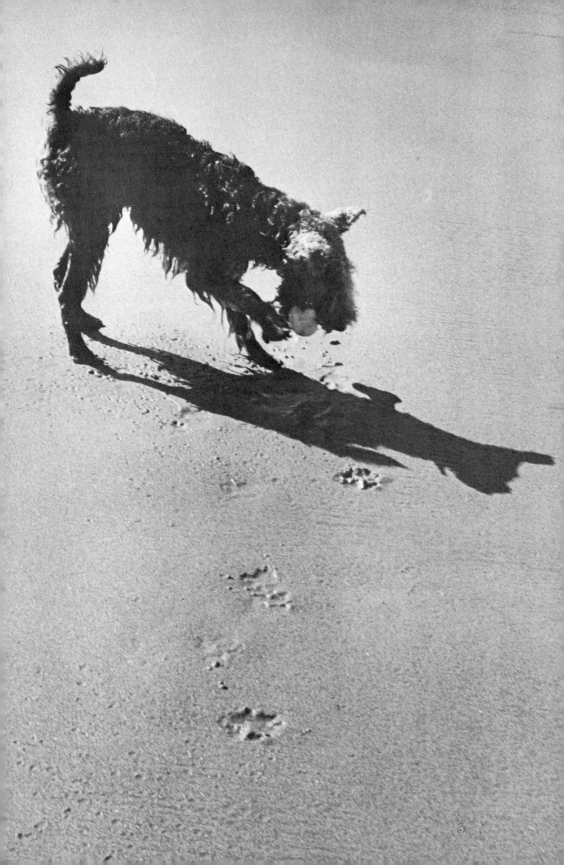

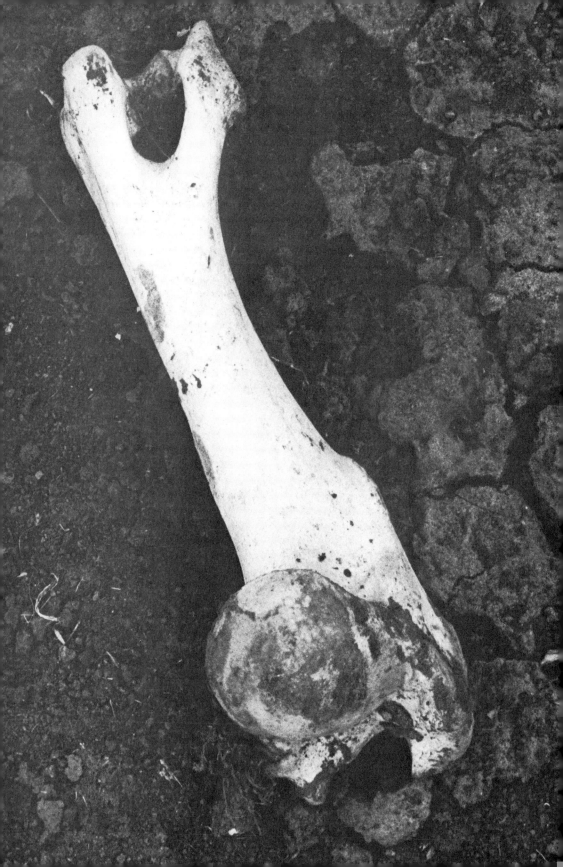

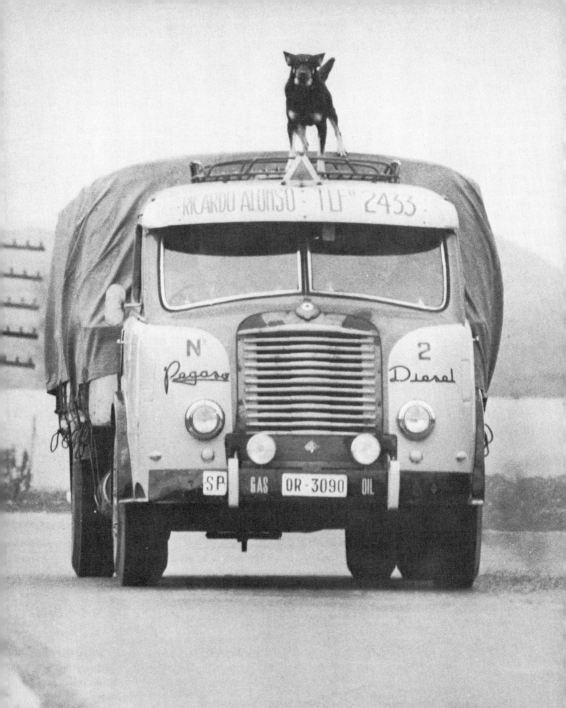

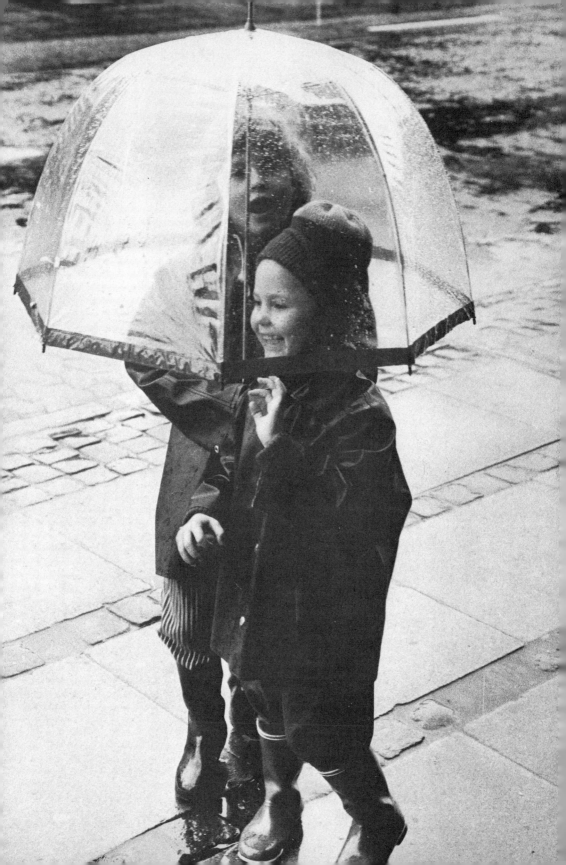

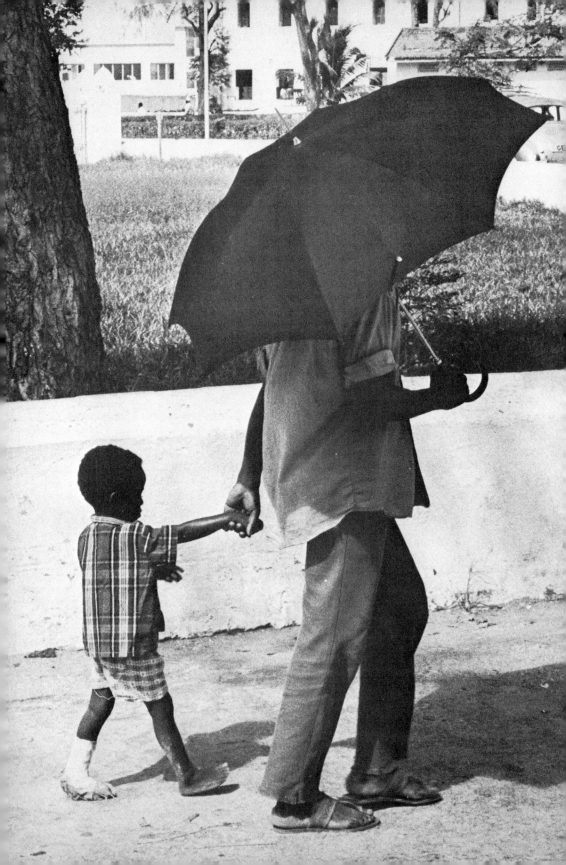

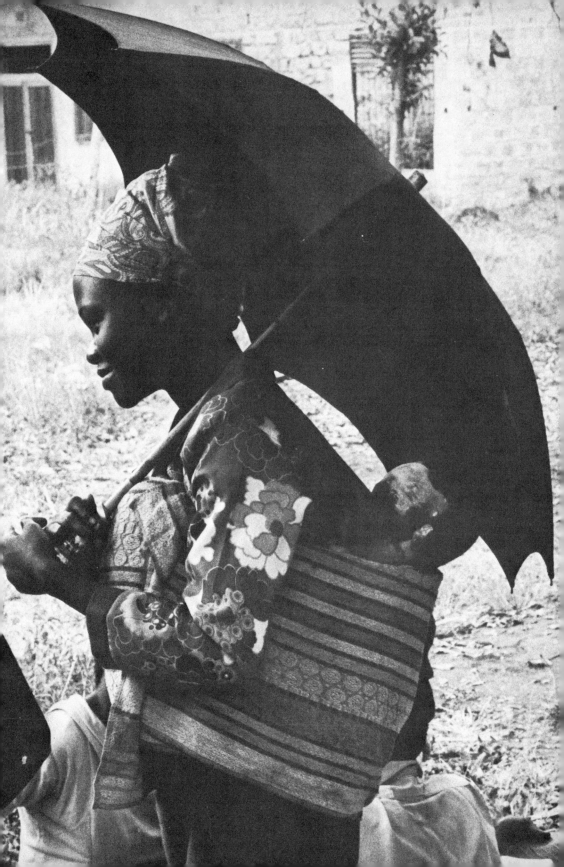

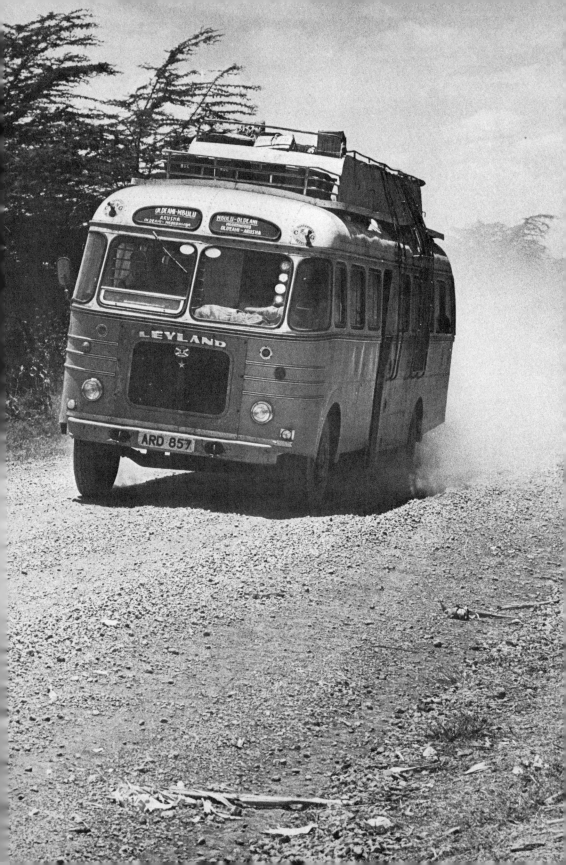

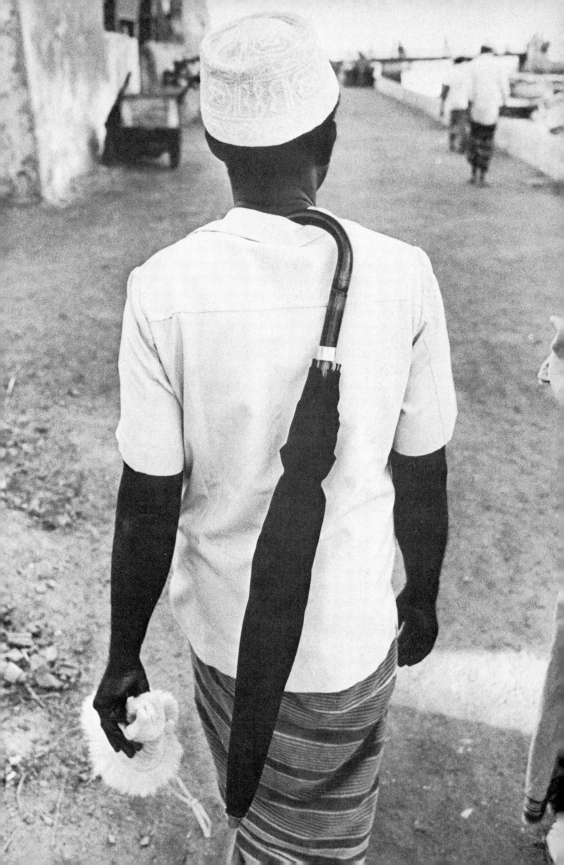

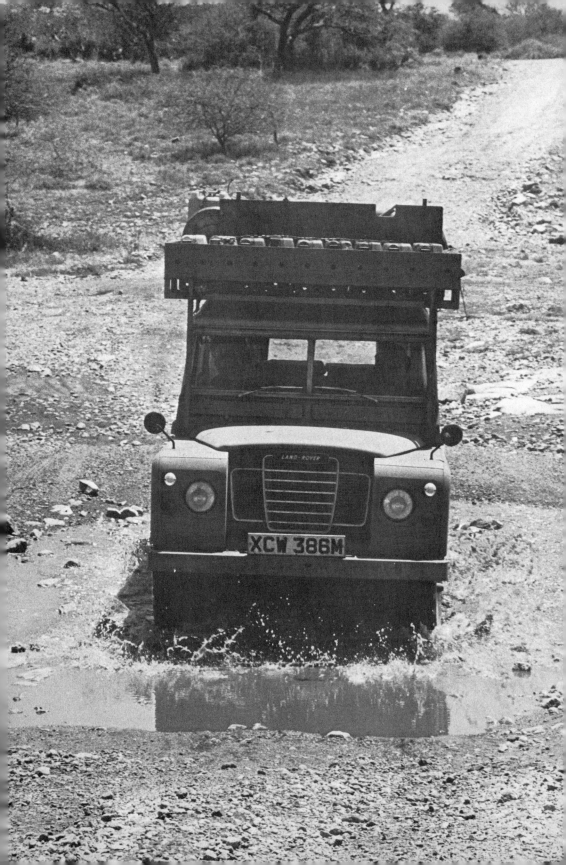

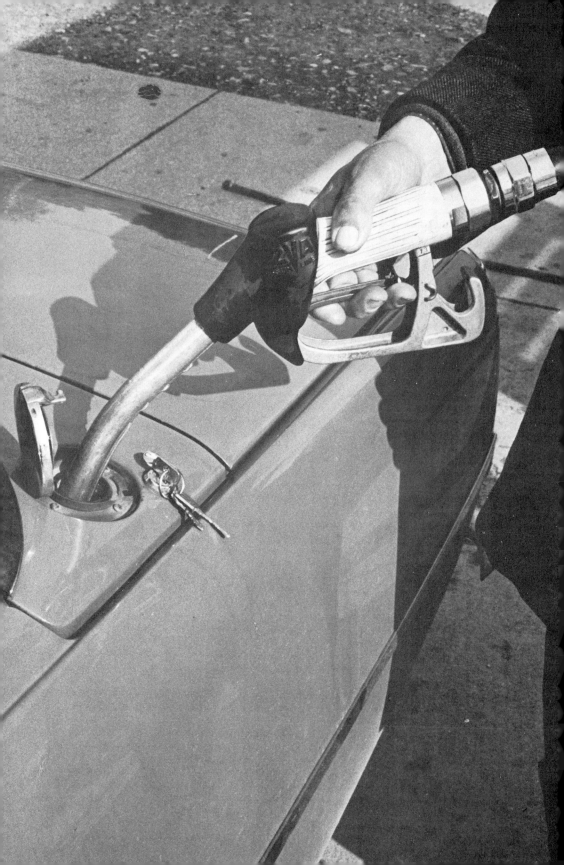

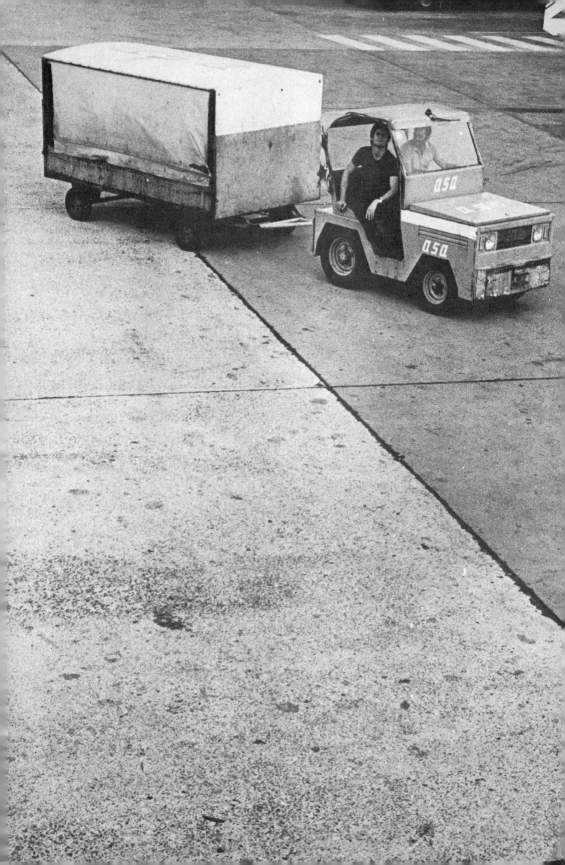

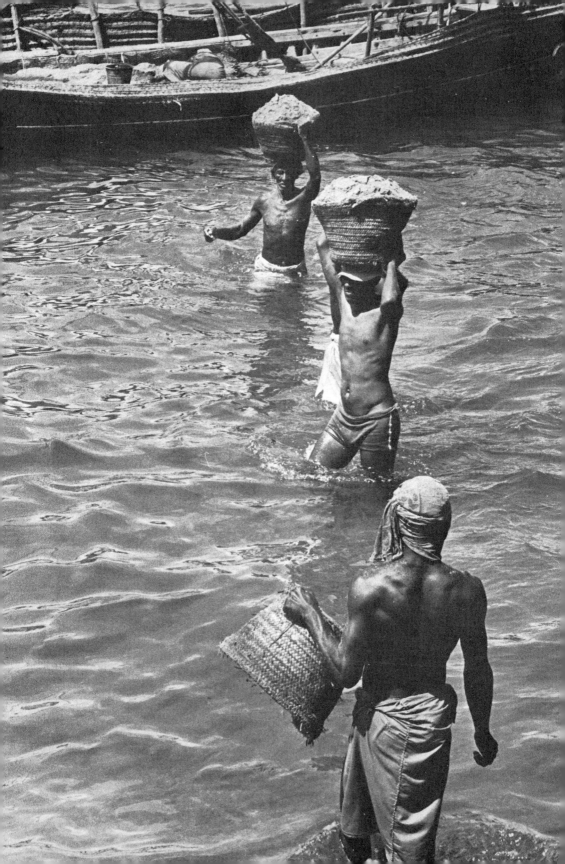

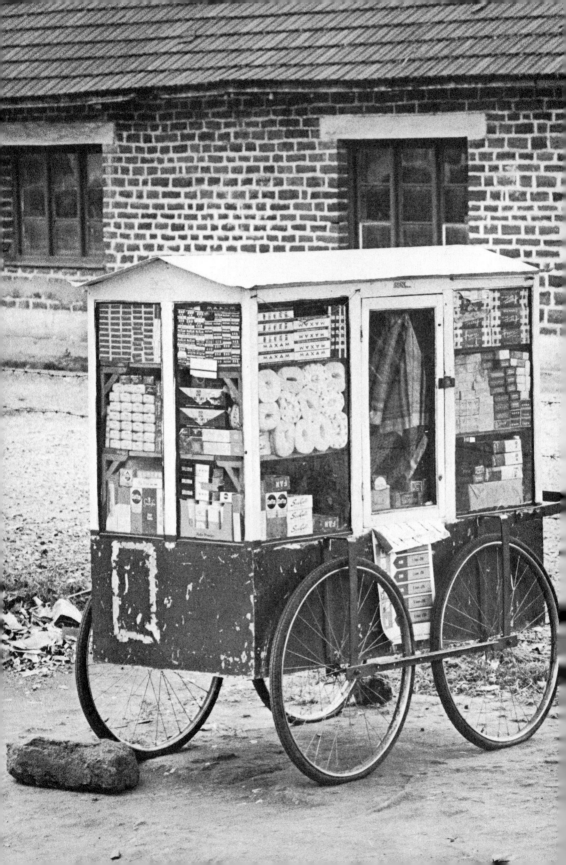

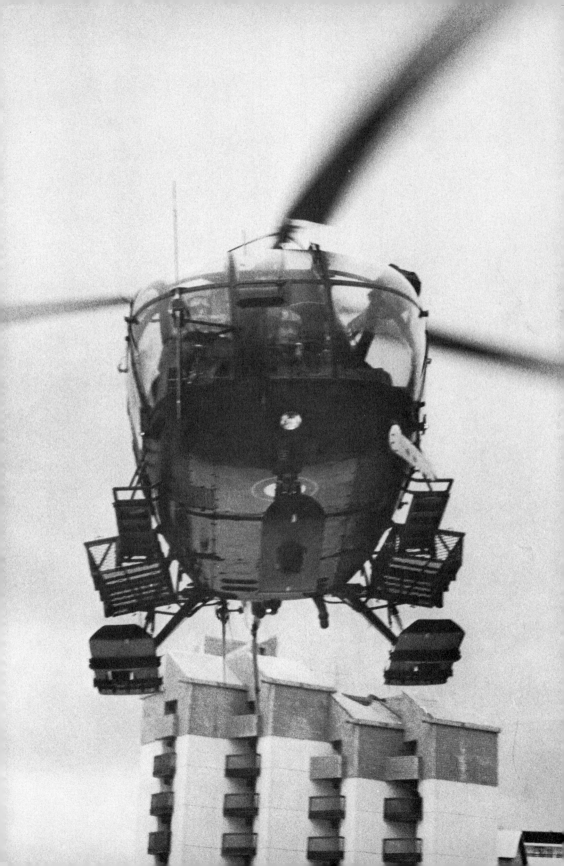

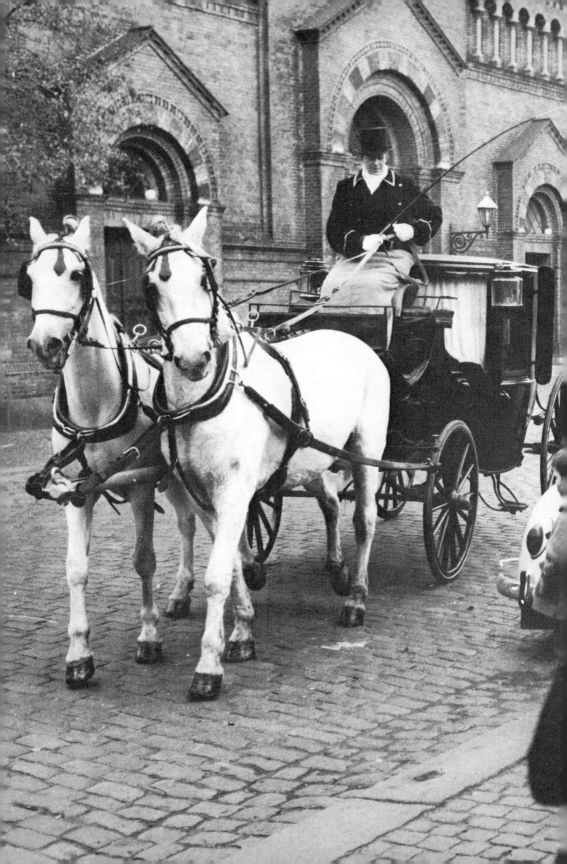

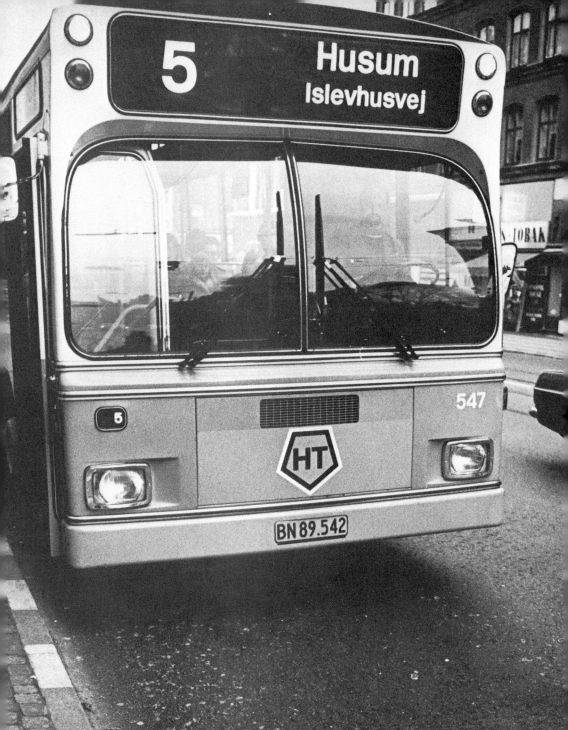

140 260-1

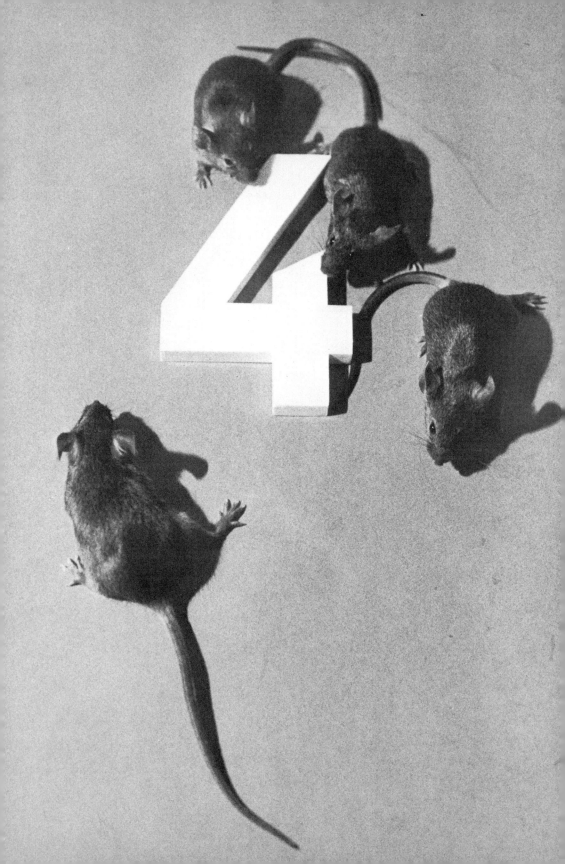

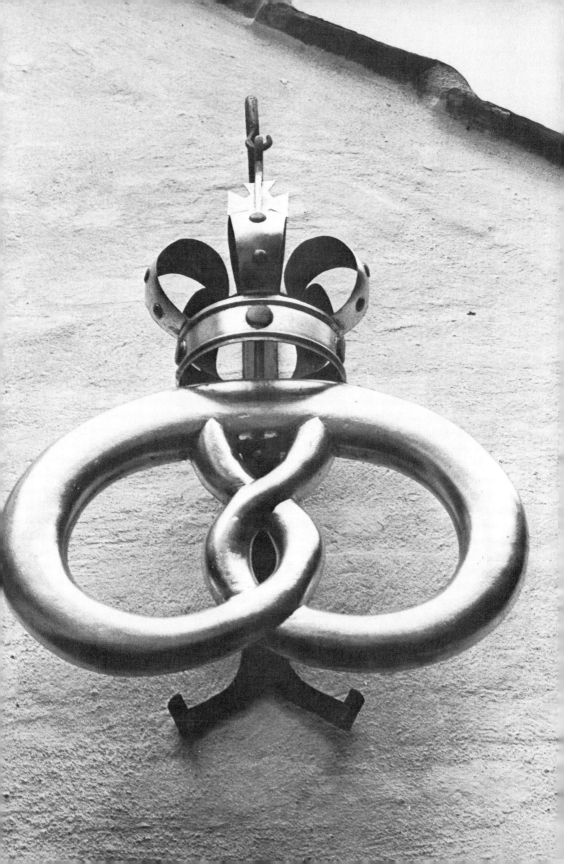

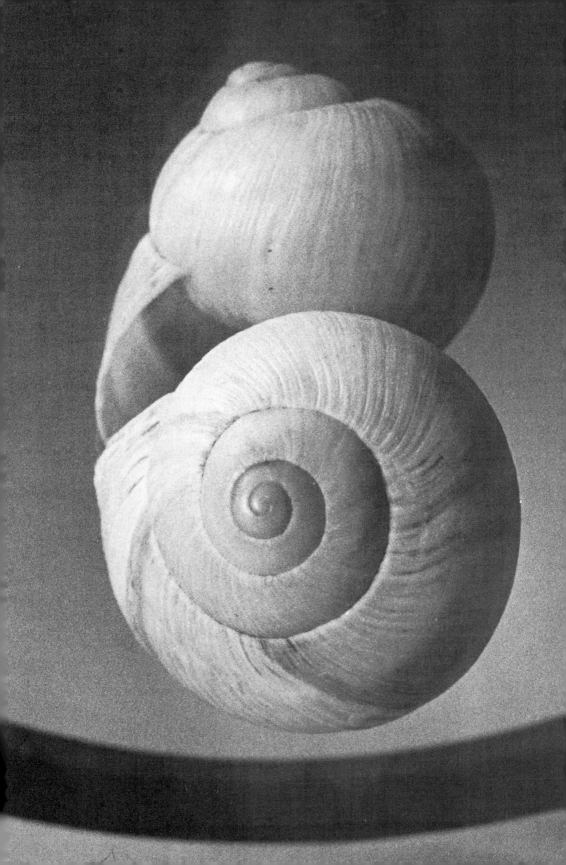

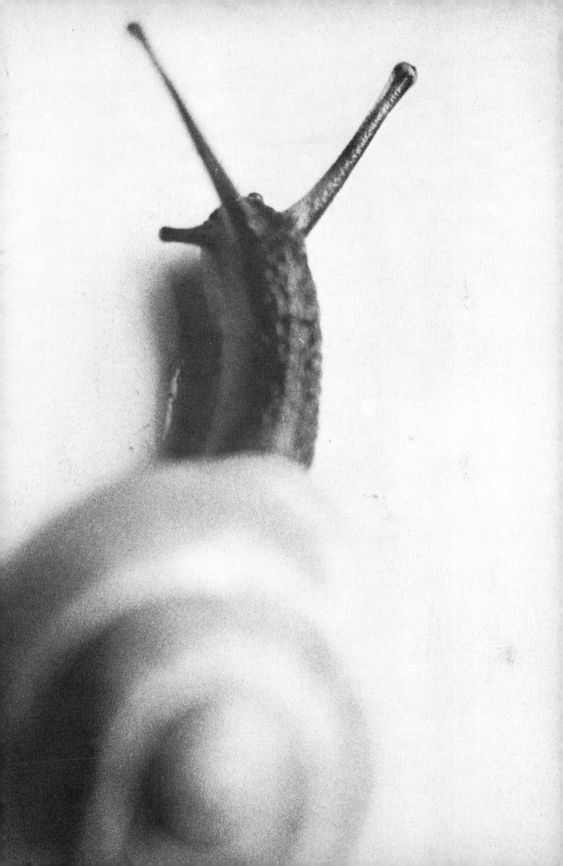

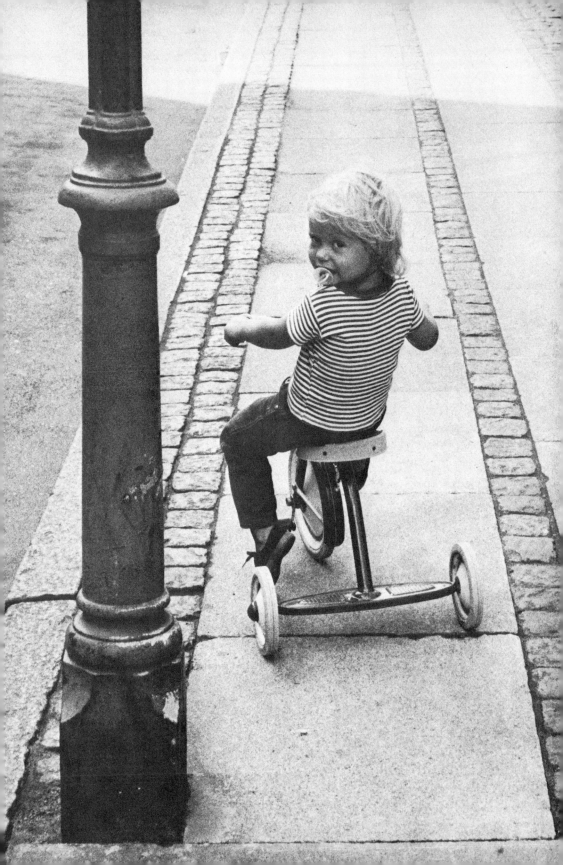

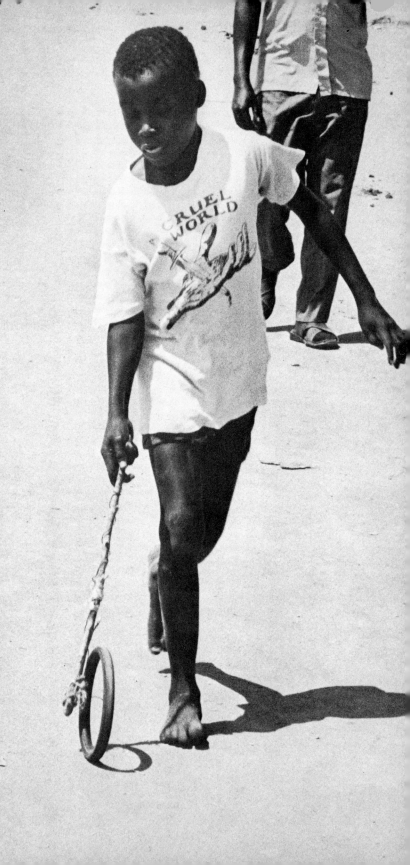

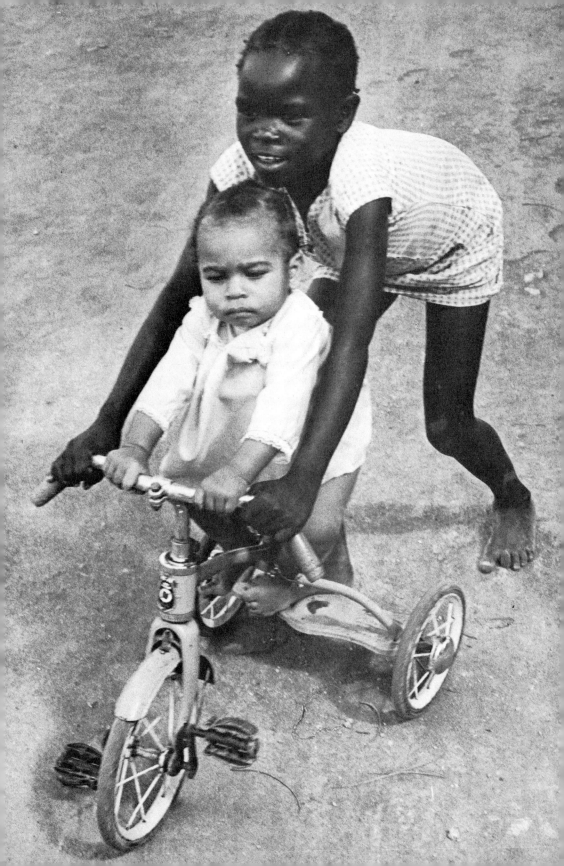

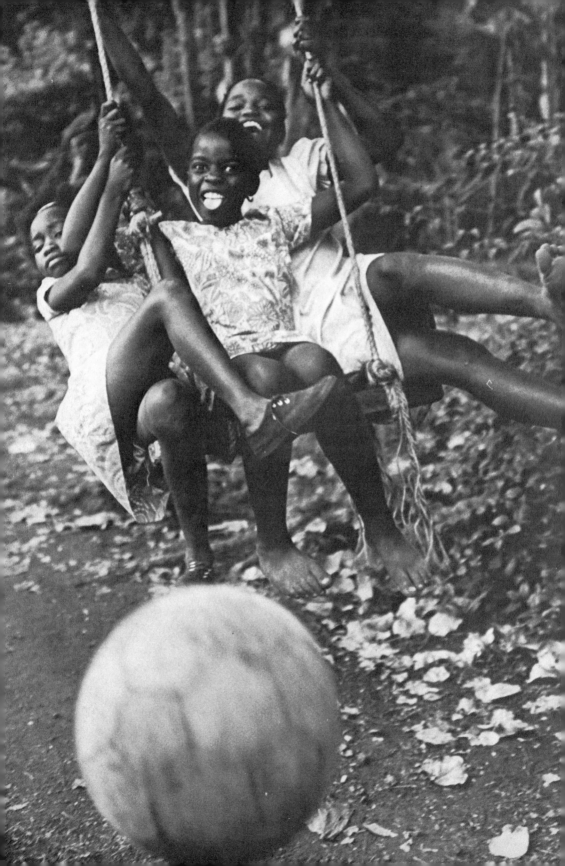

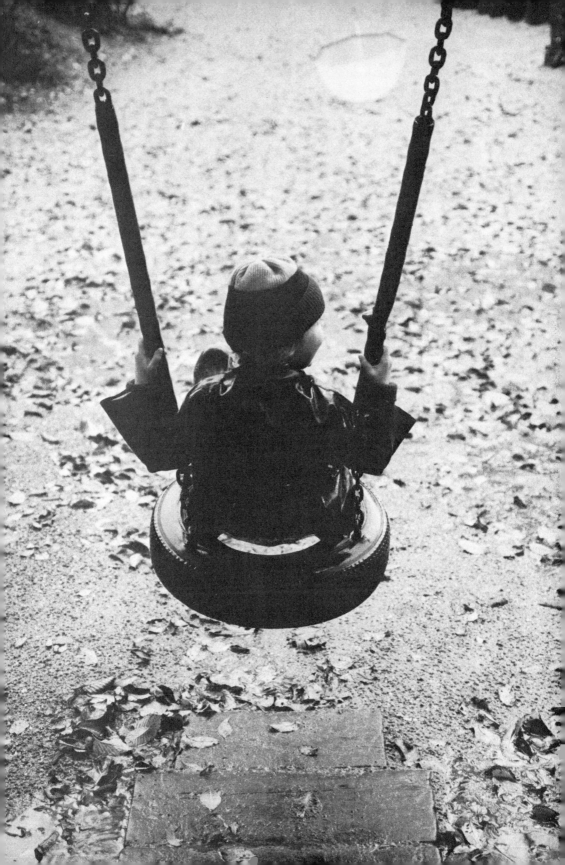

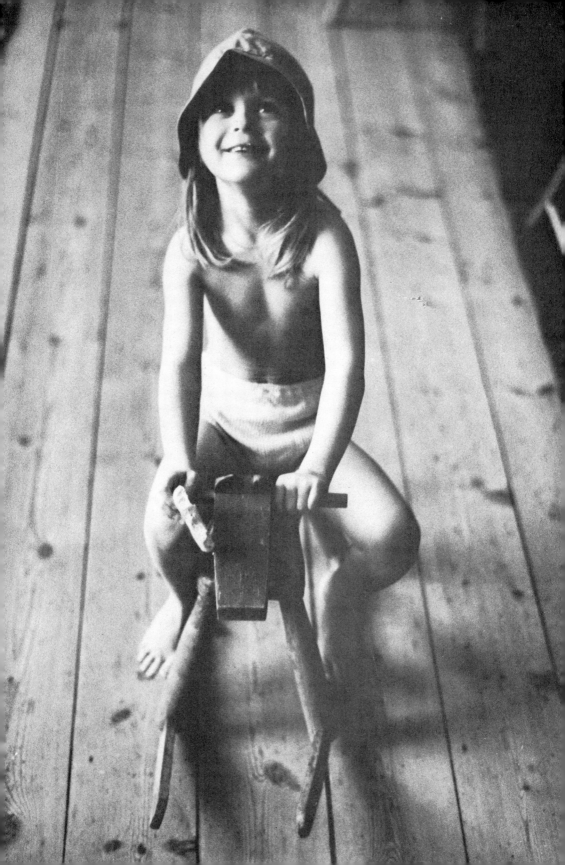

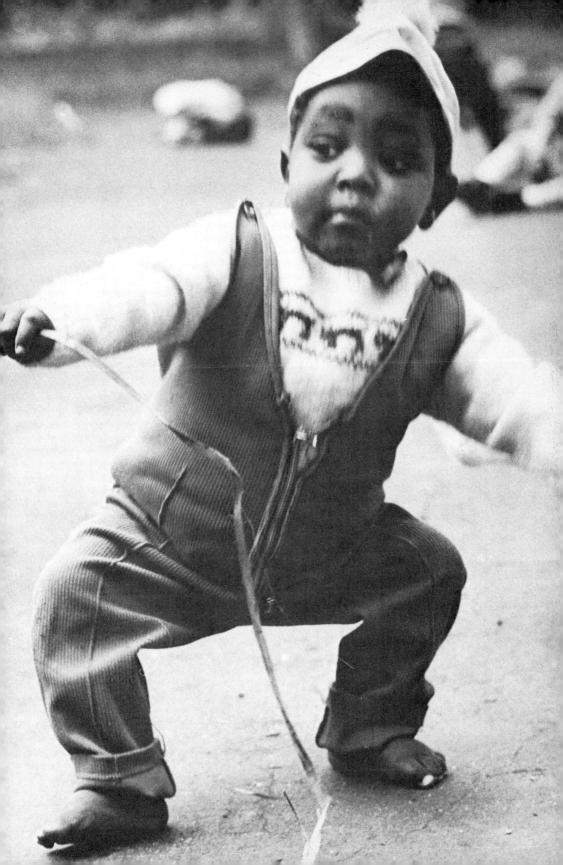

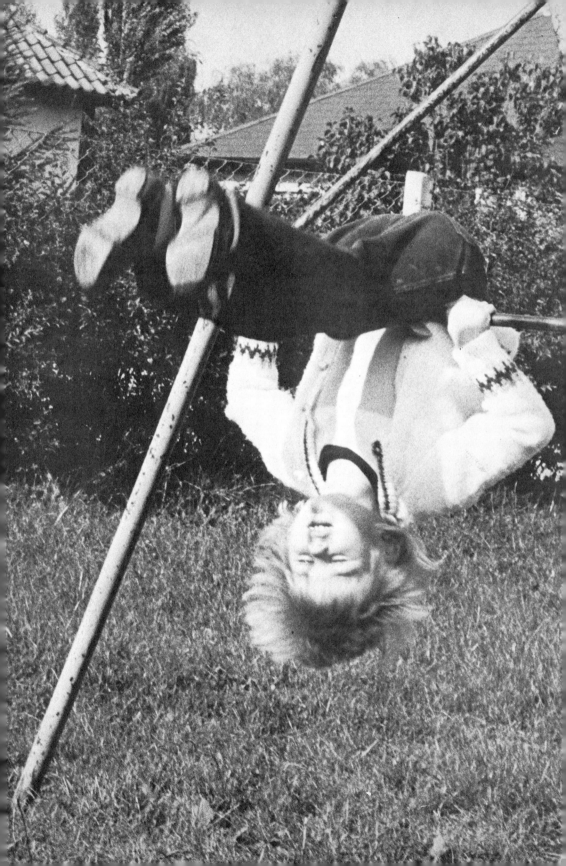

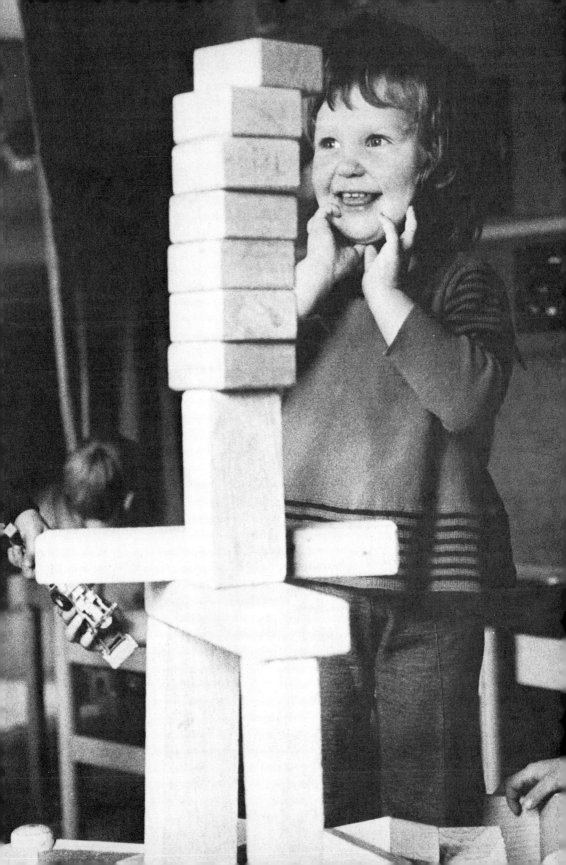

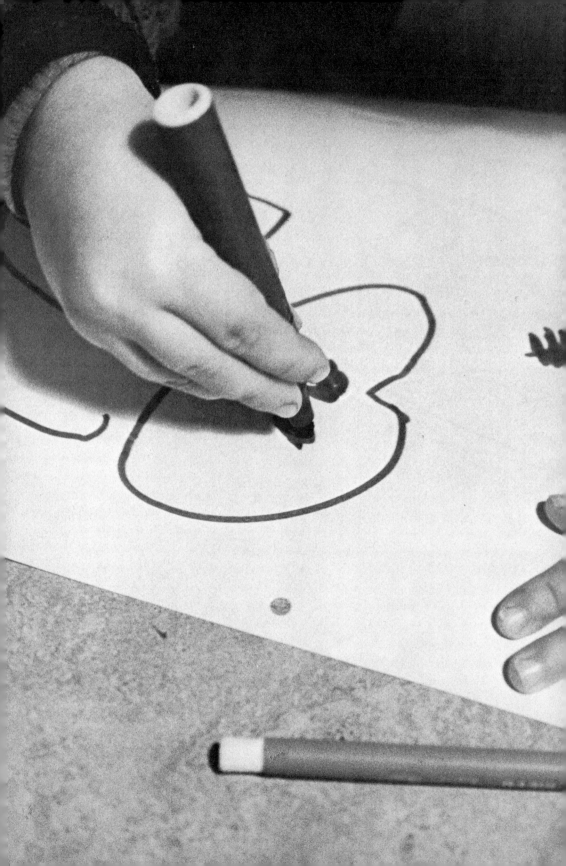

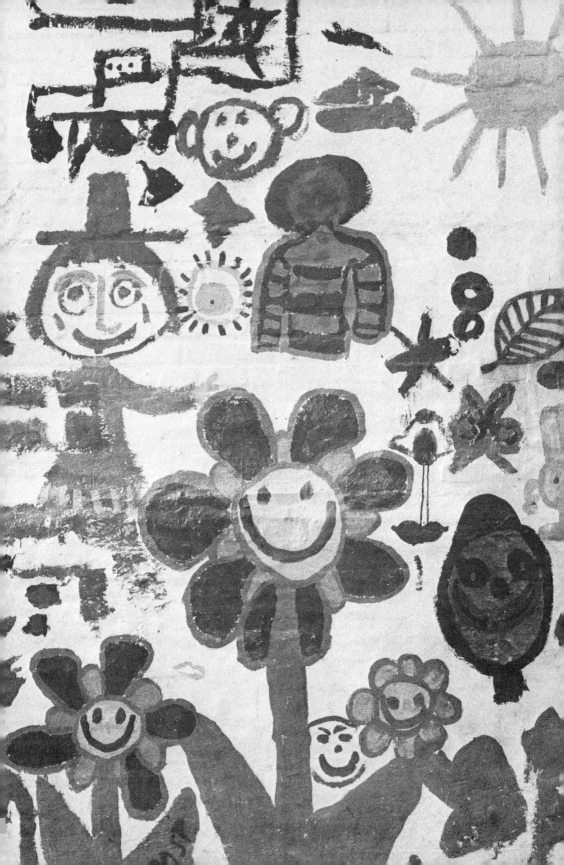

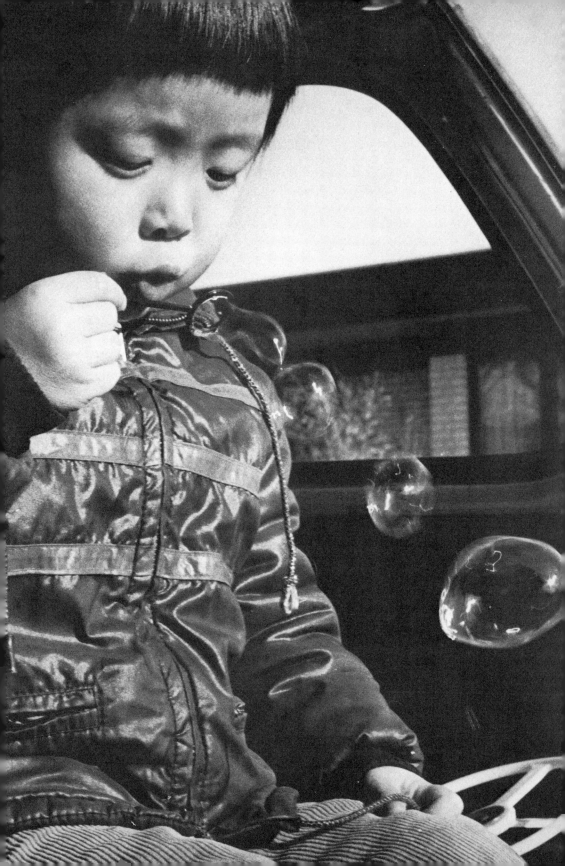

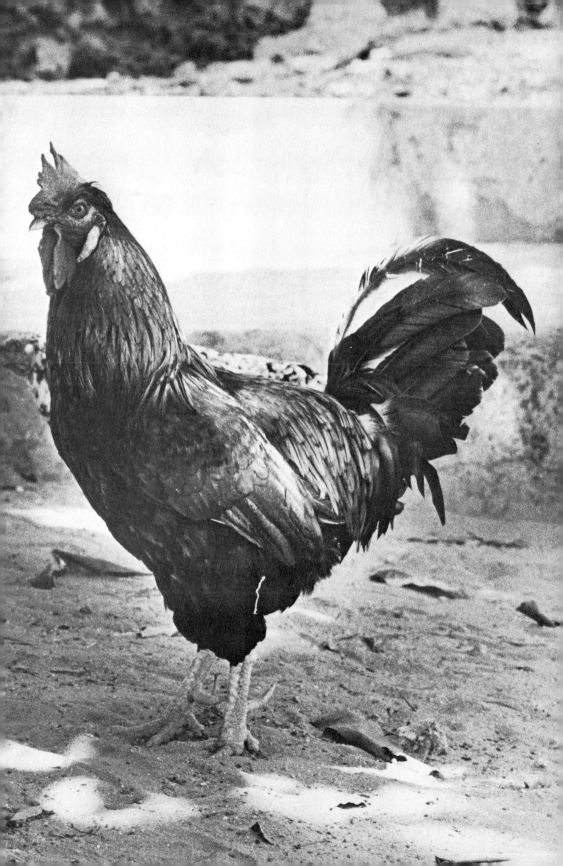

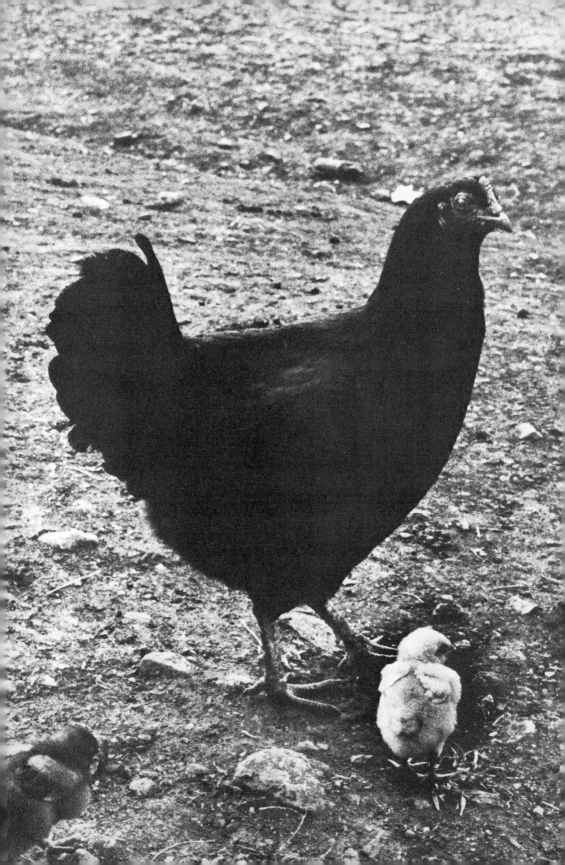

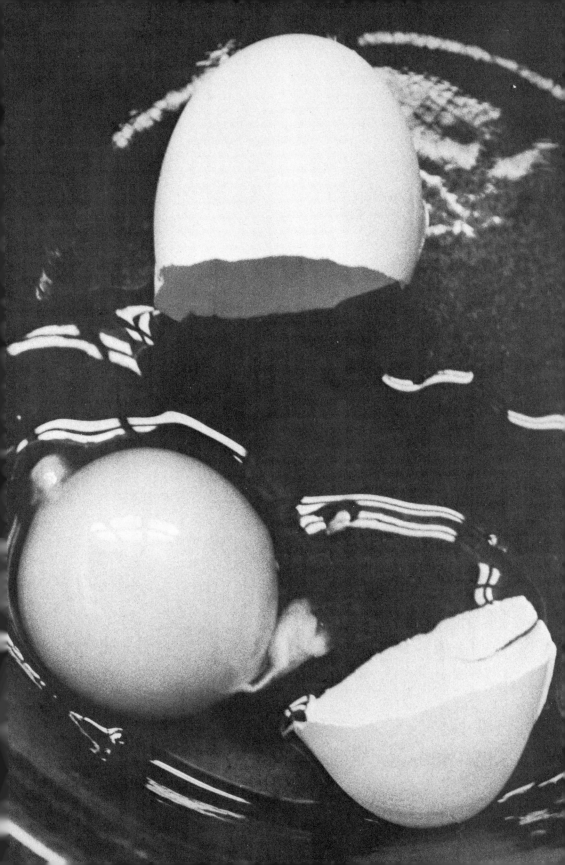

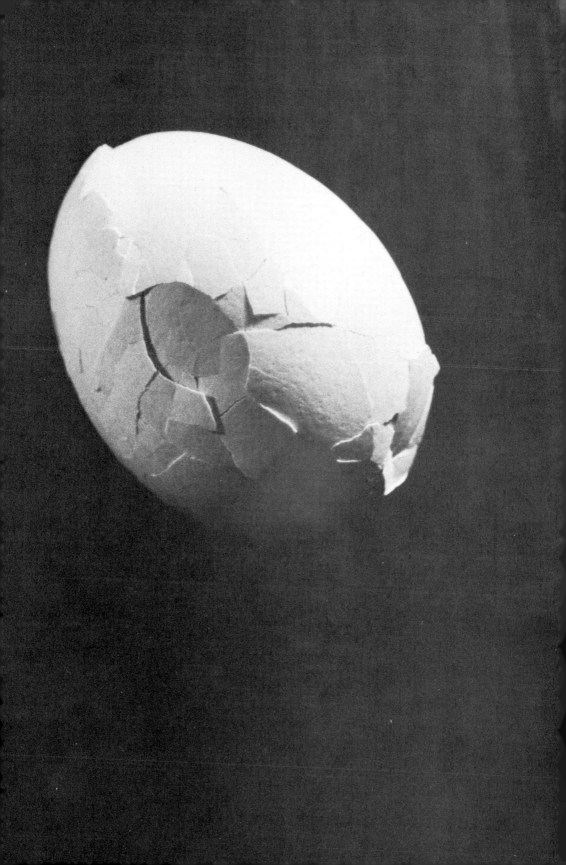

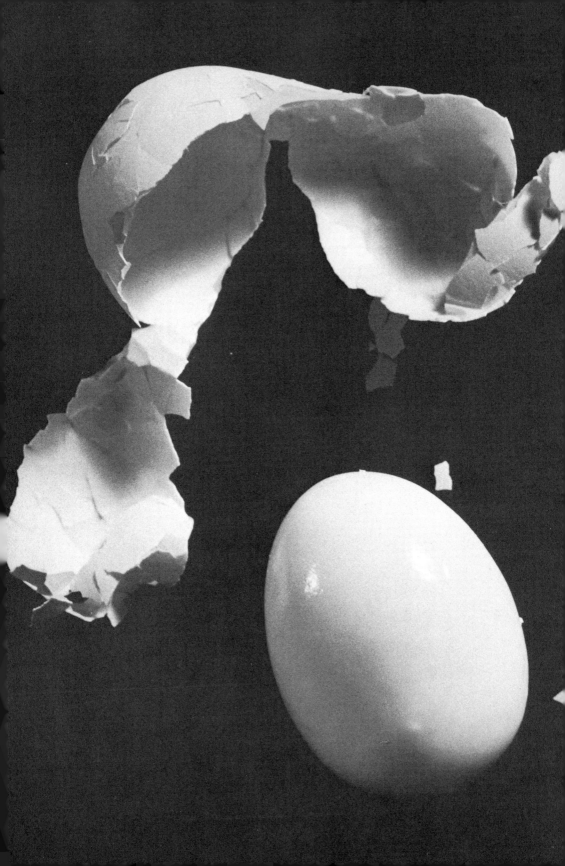

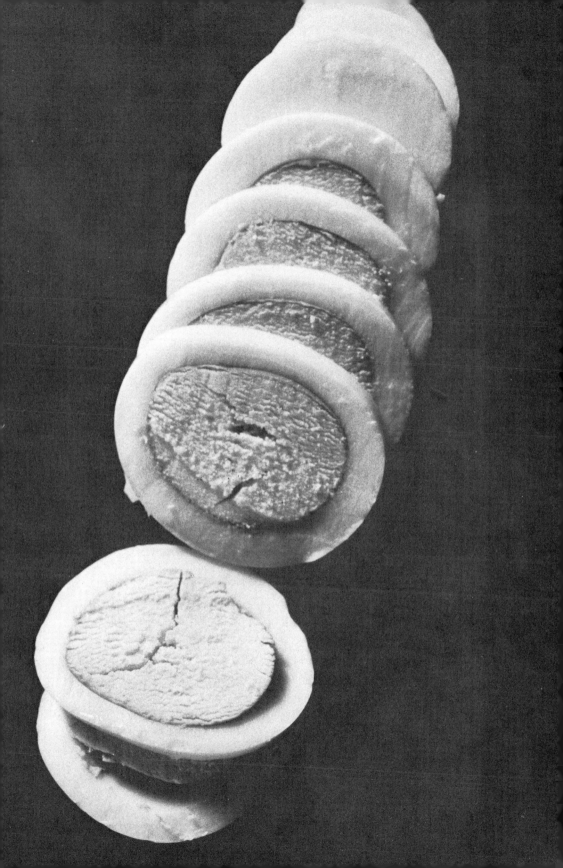

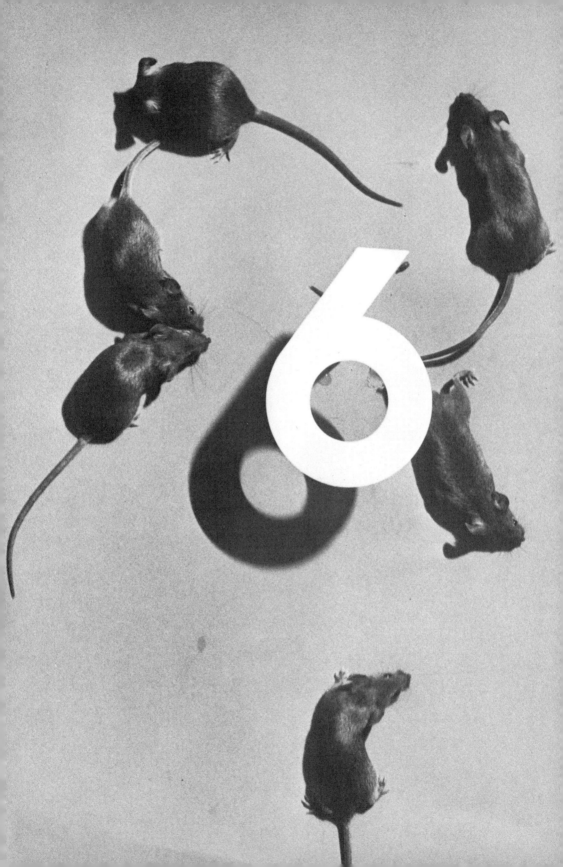

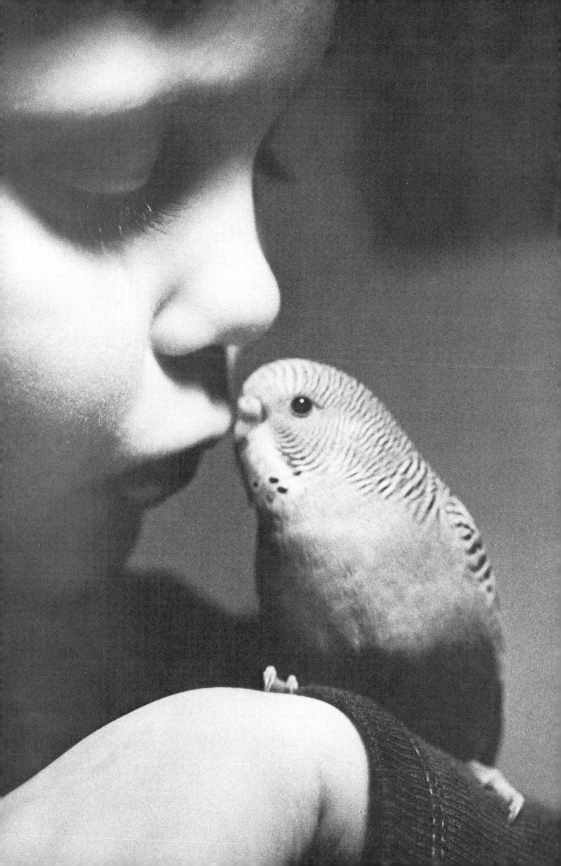

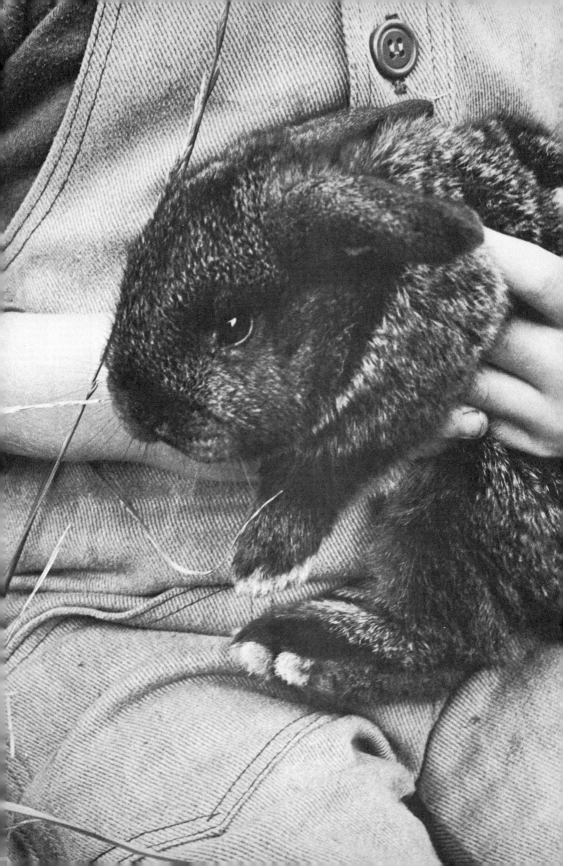

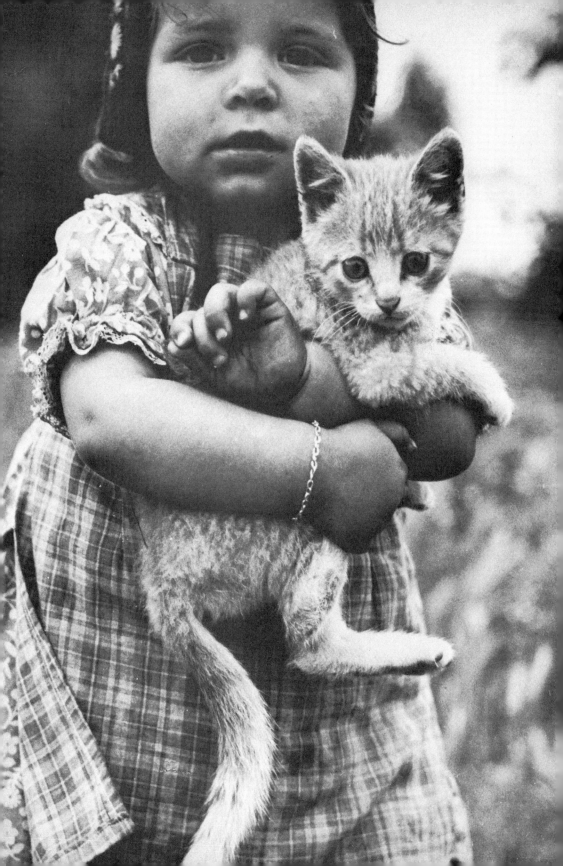

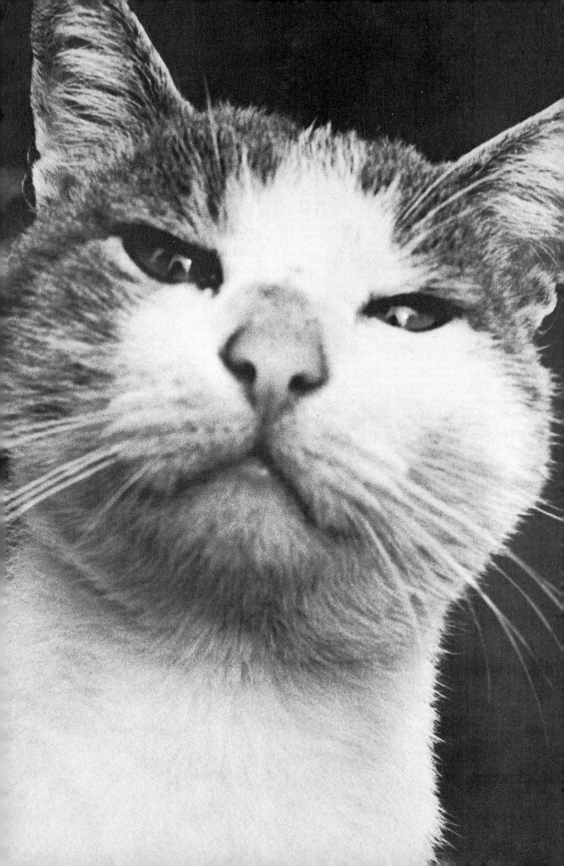

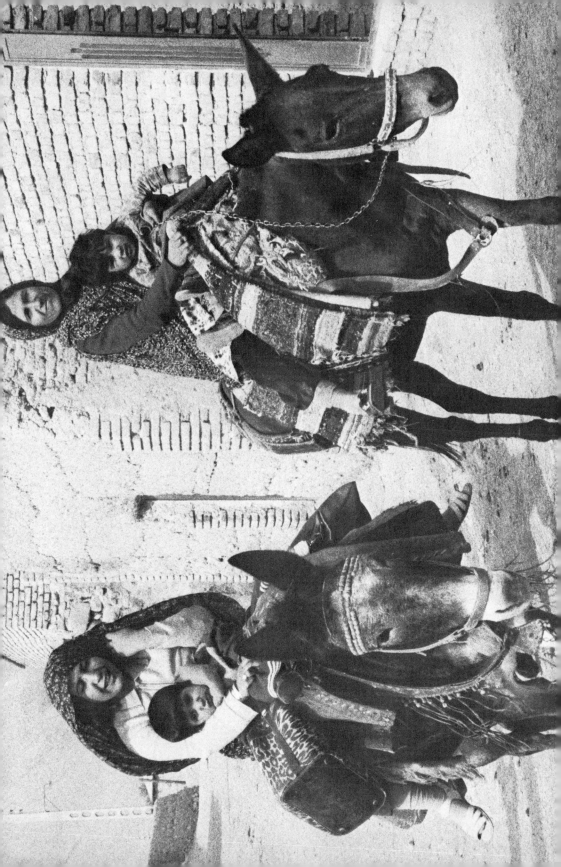

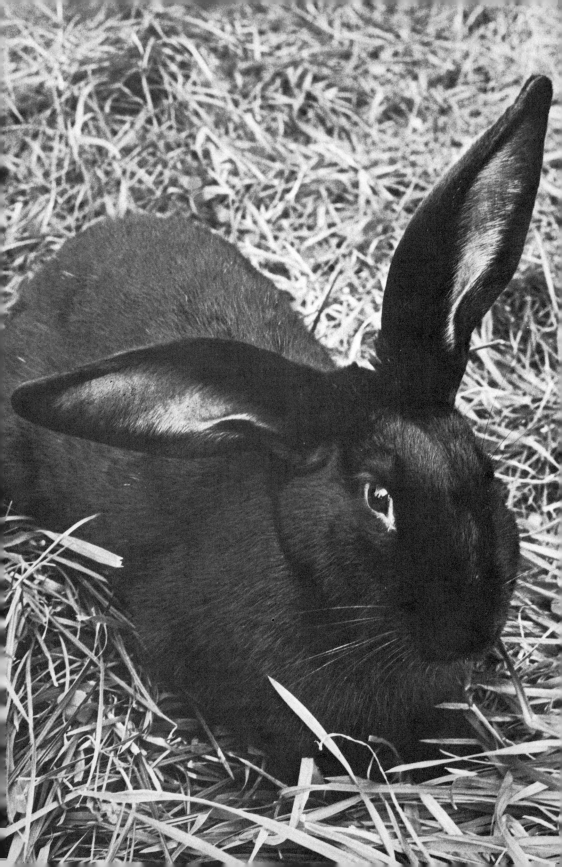

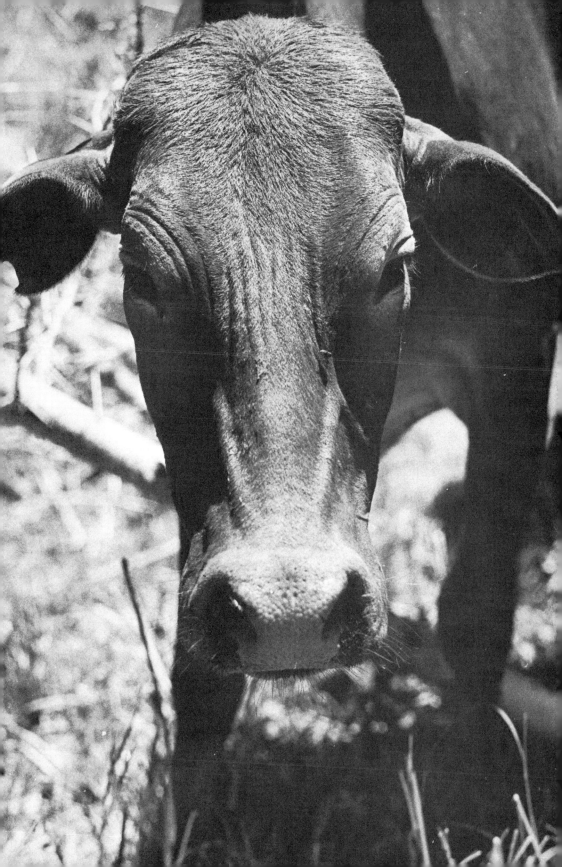

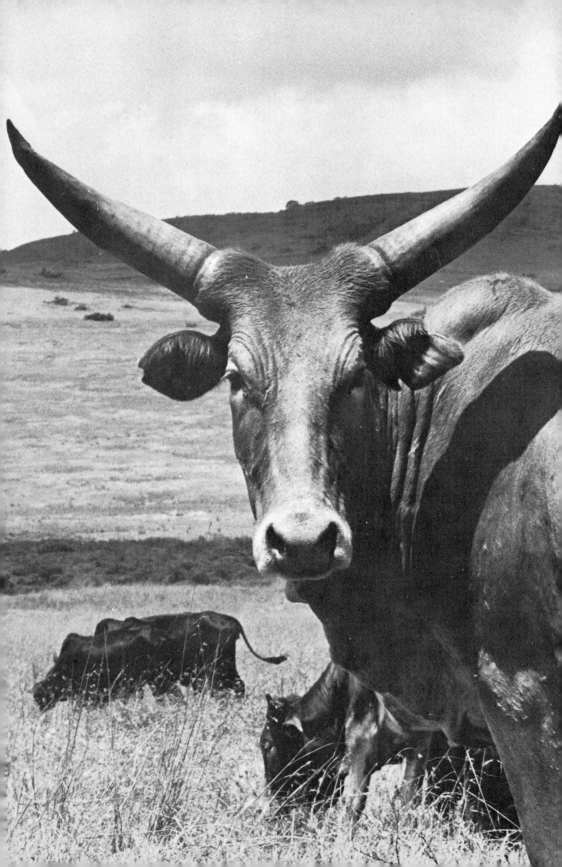

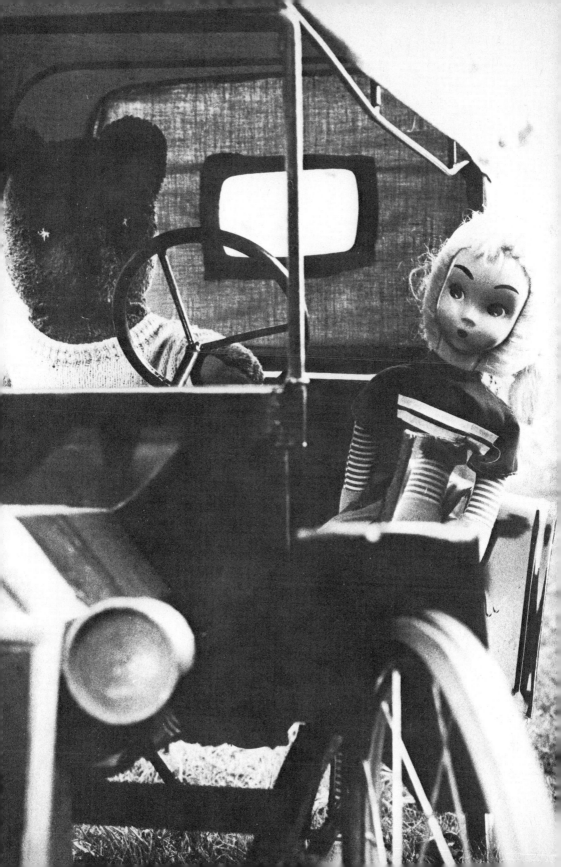

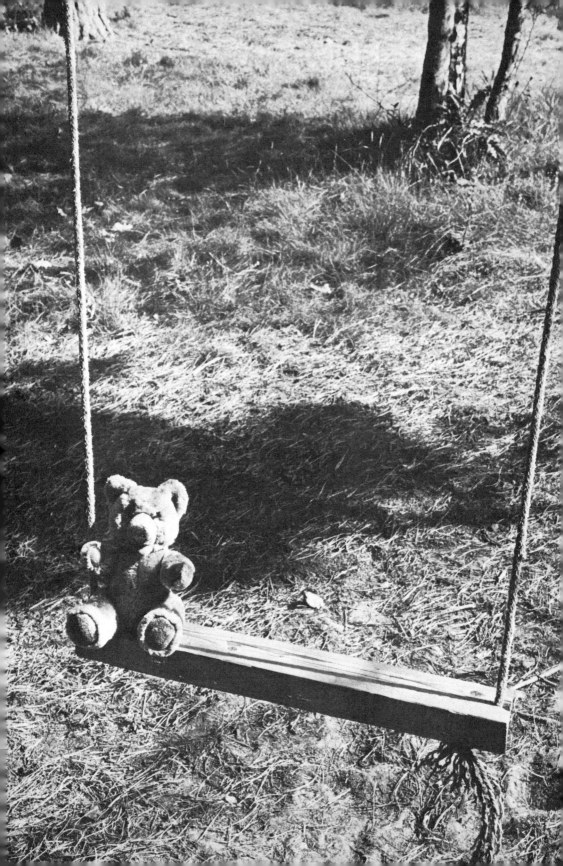

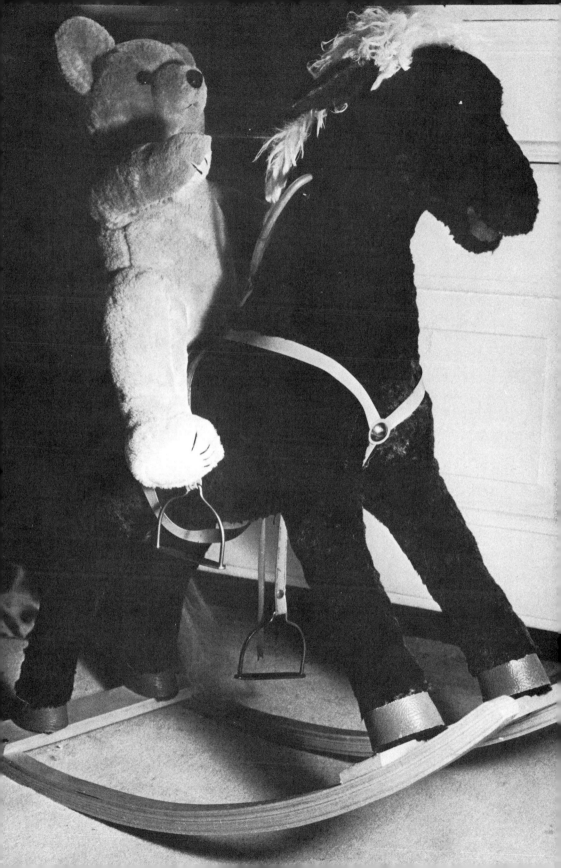

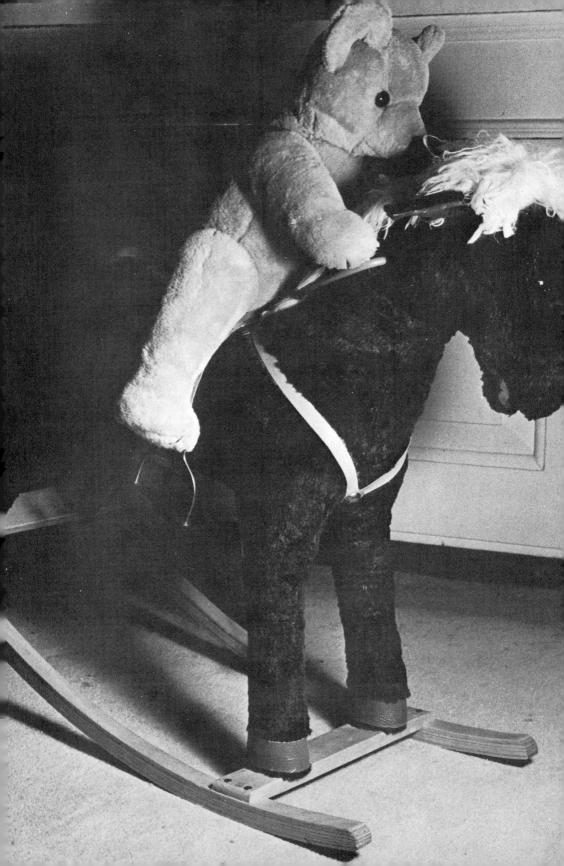

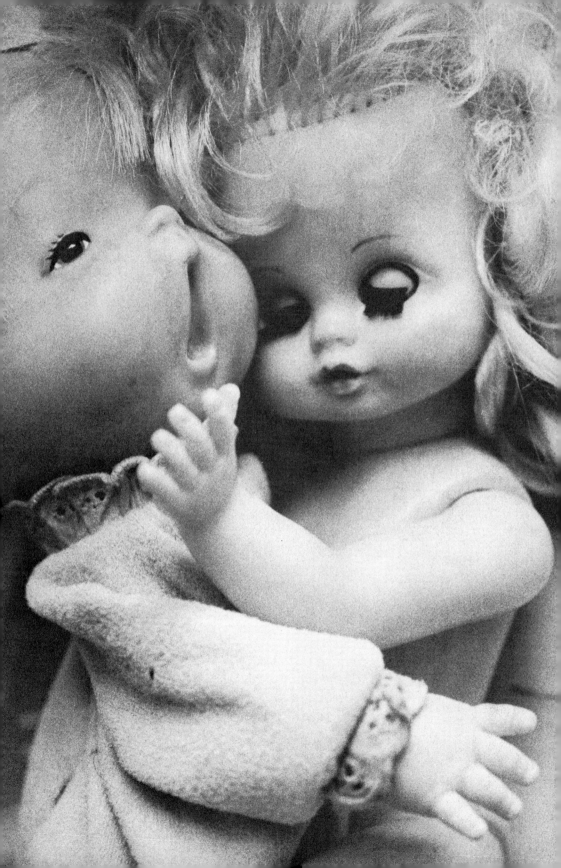

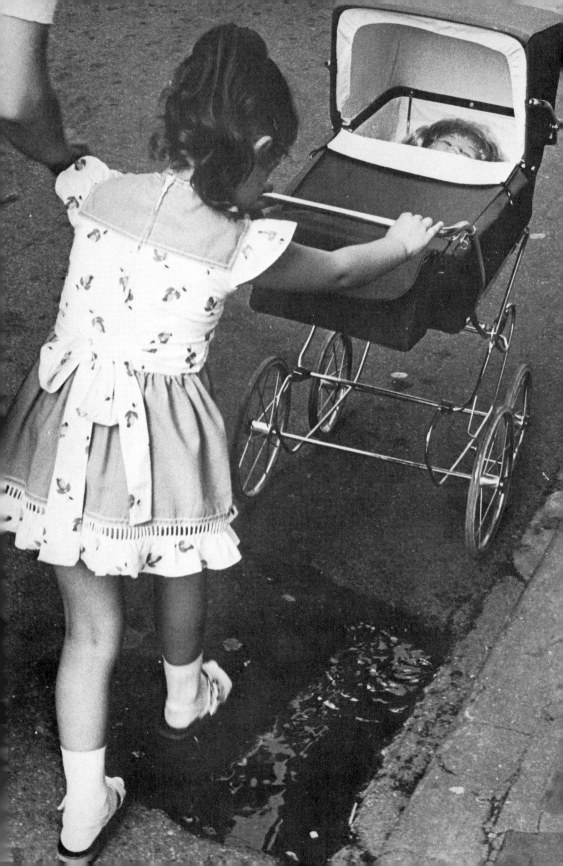

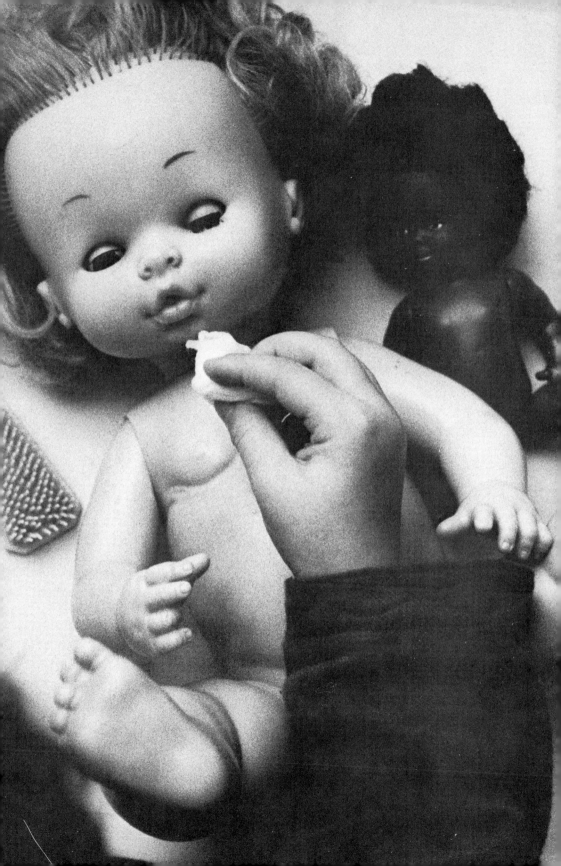

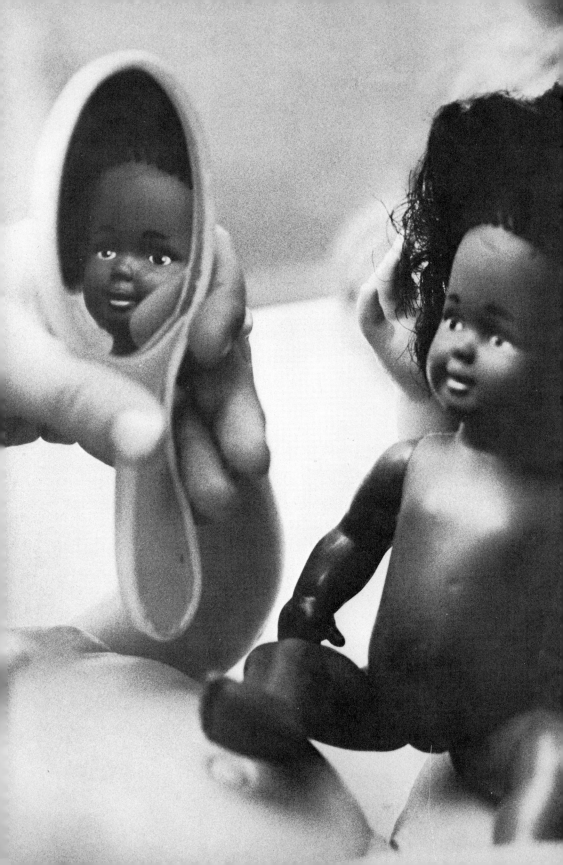

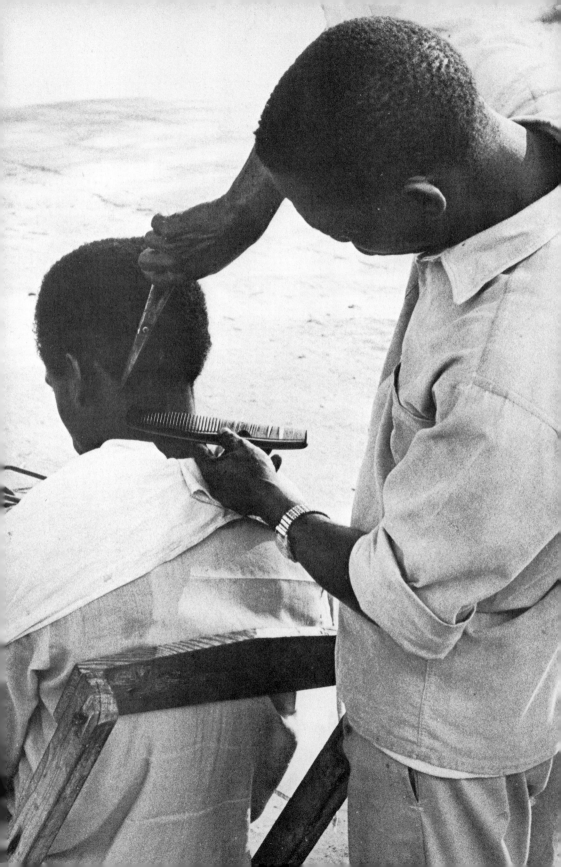

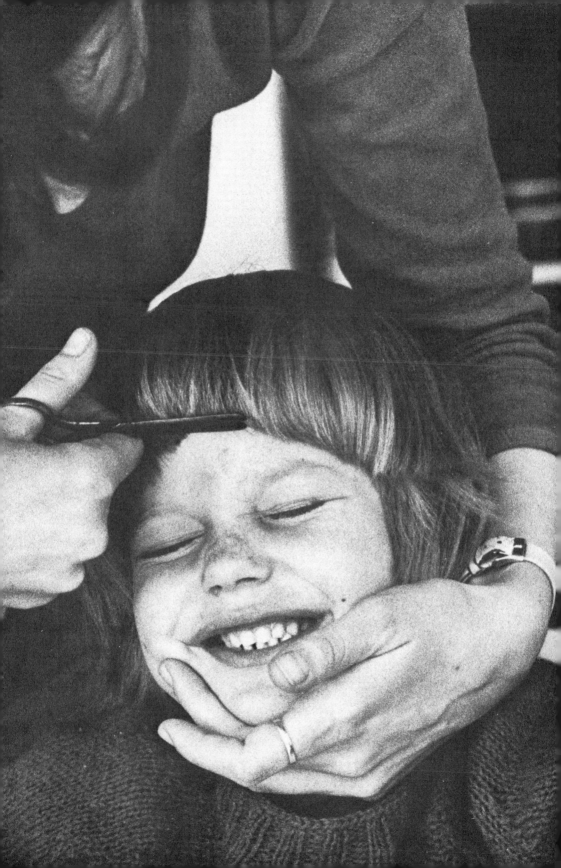

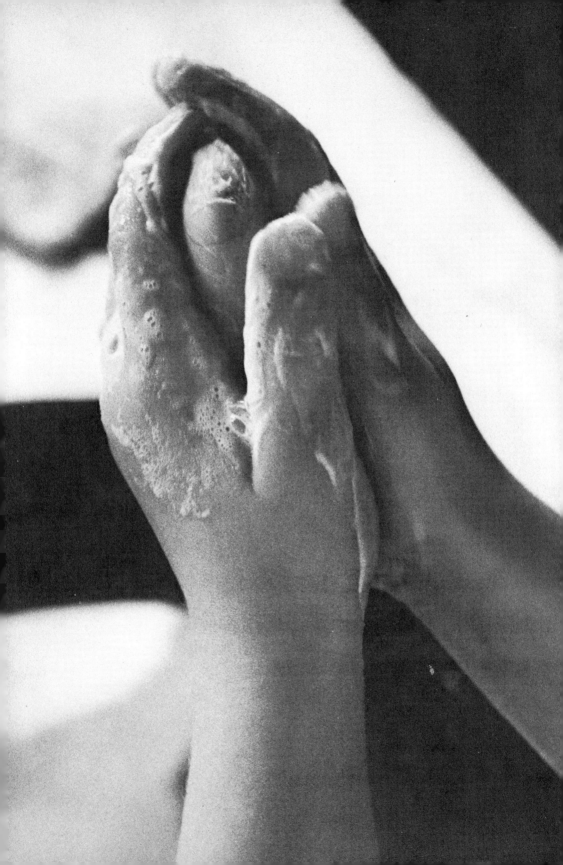

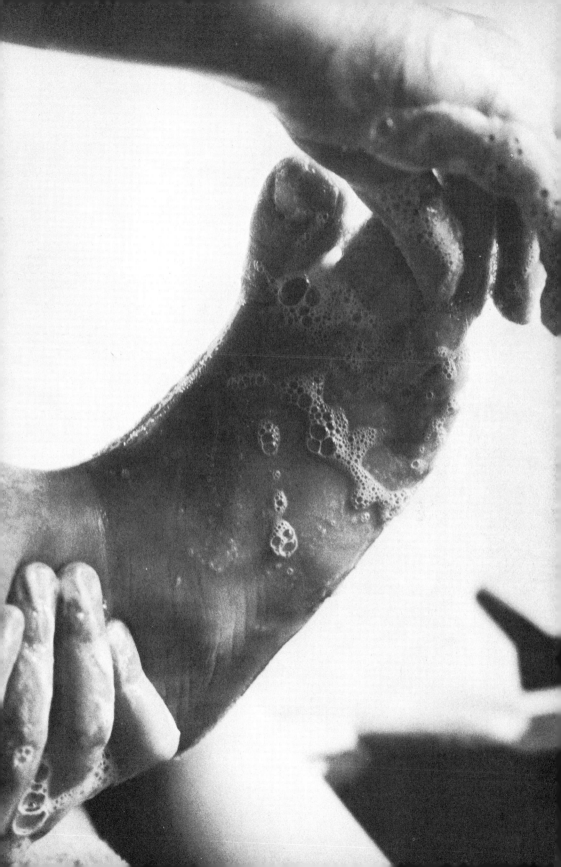

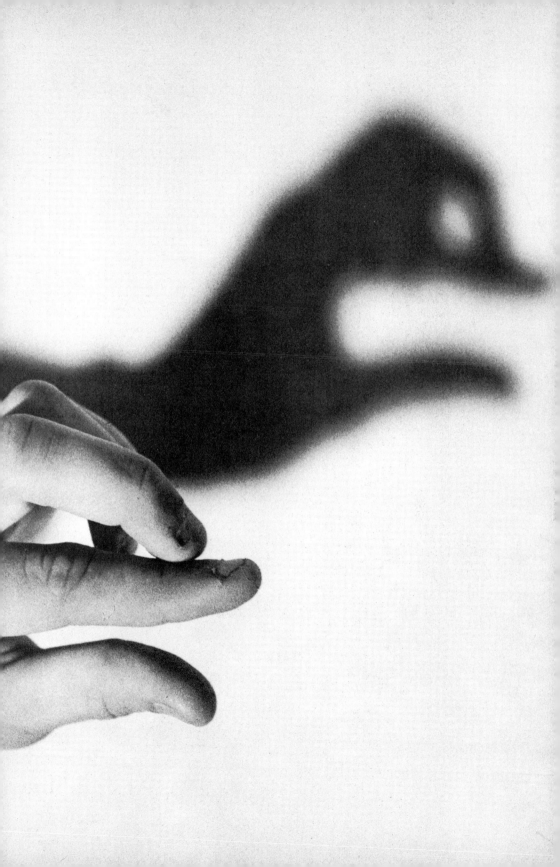

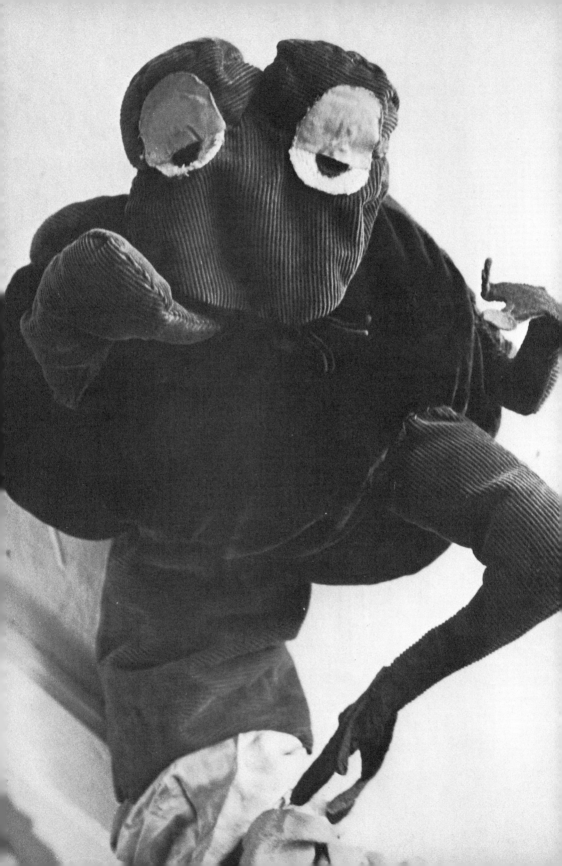

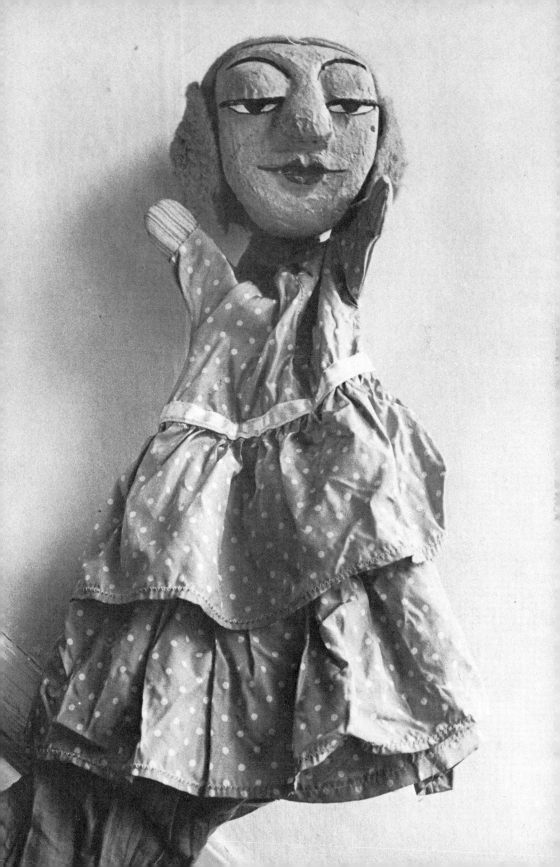

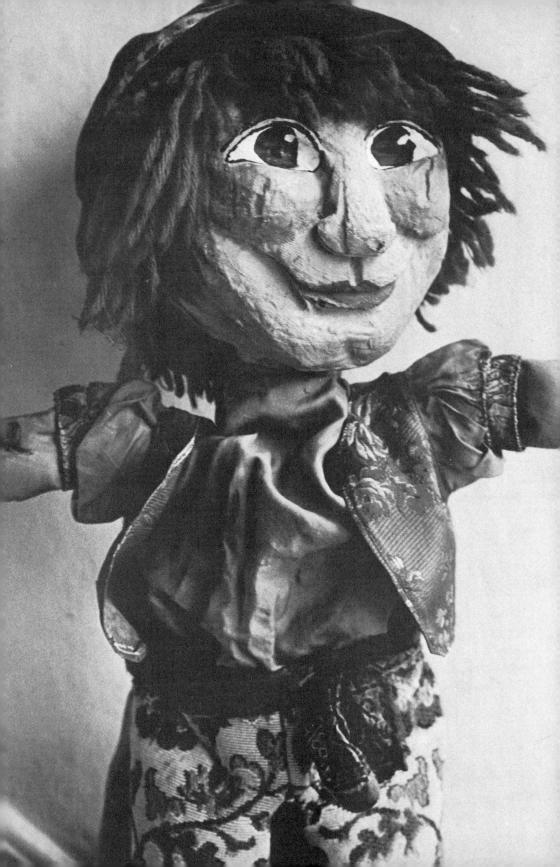

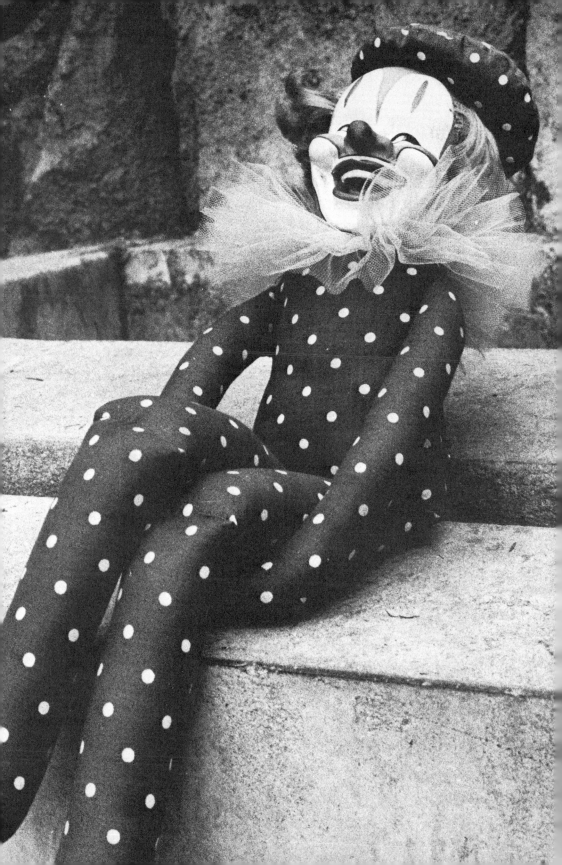

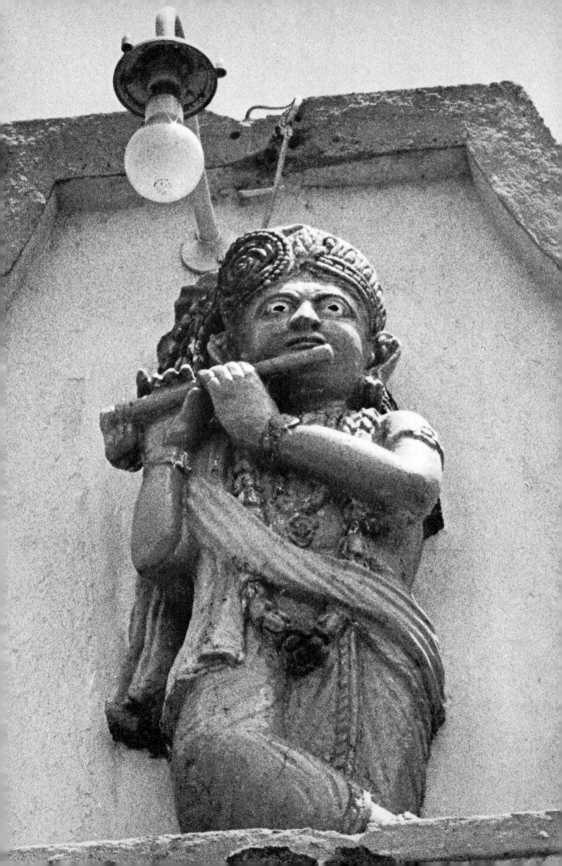

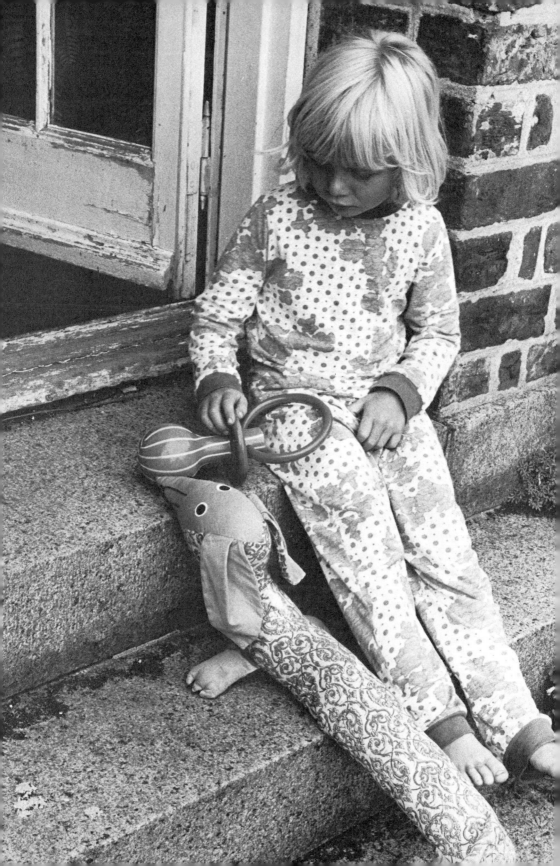

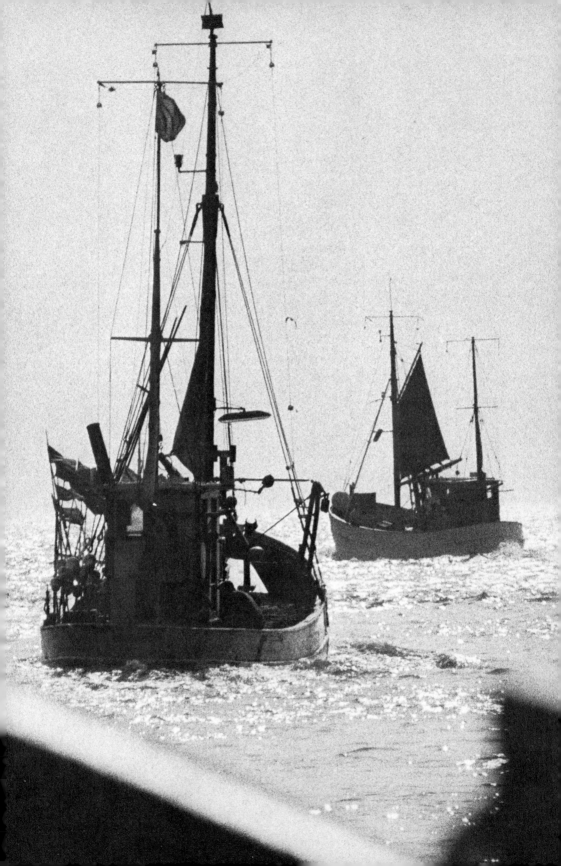

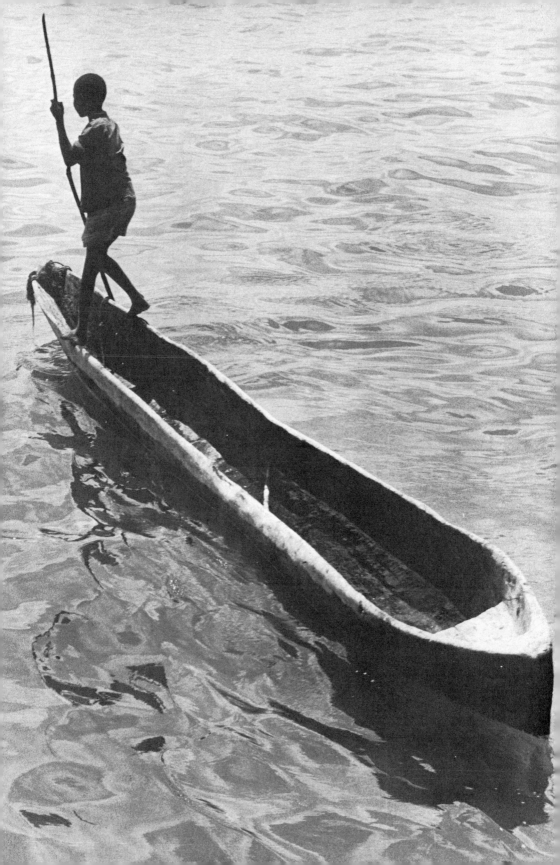

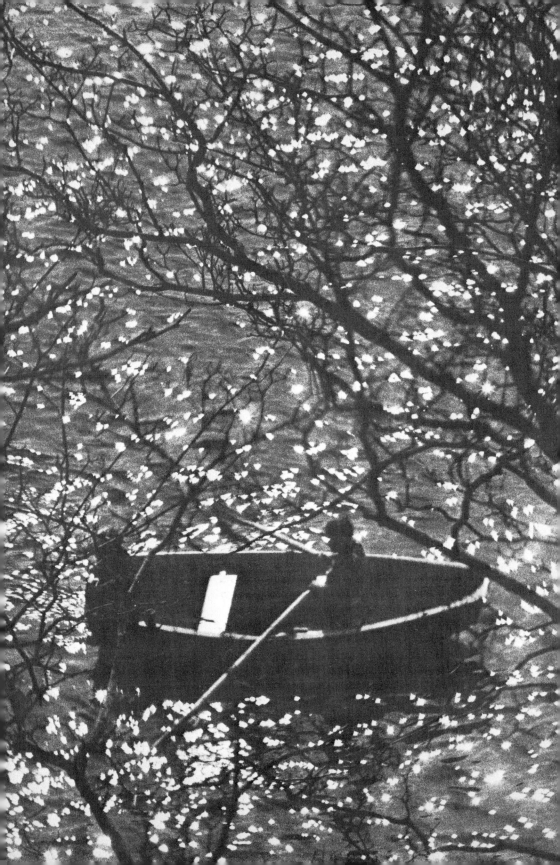

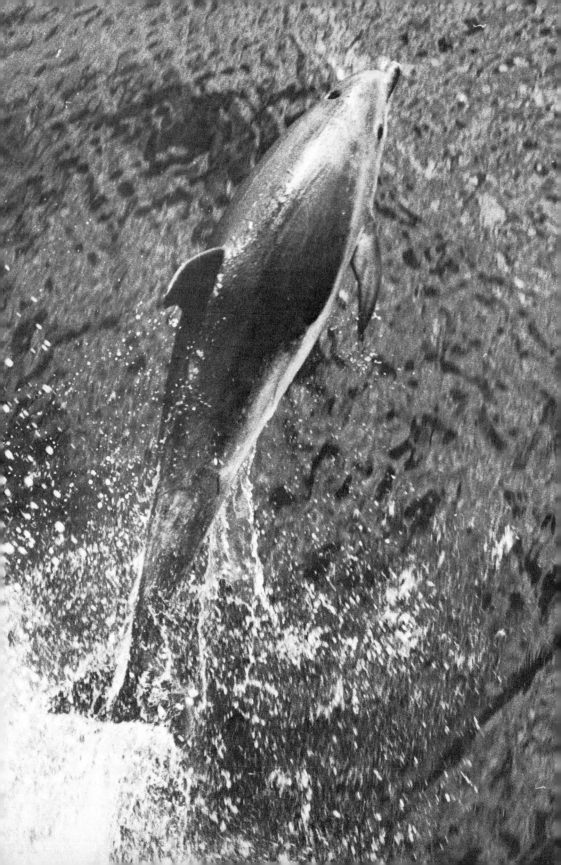

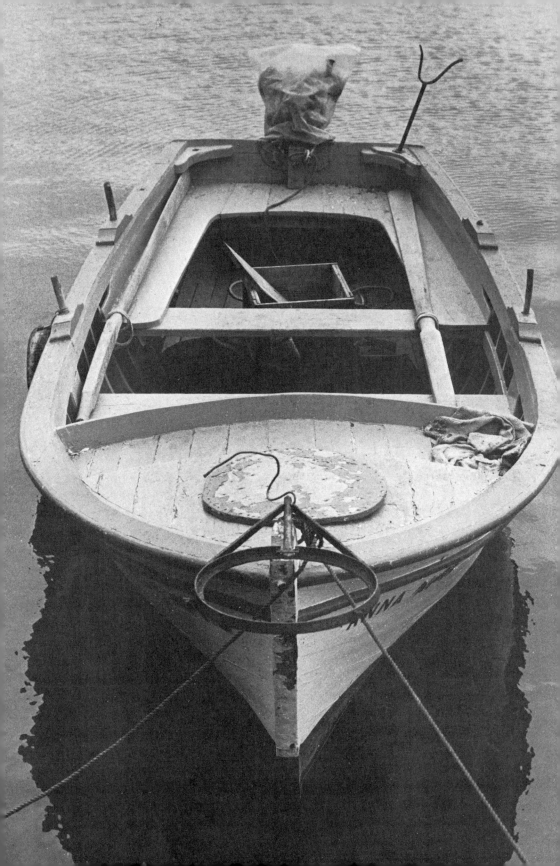

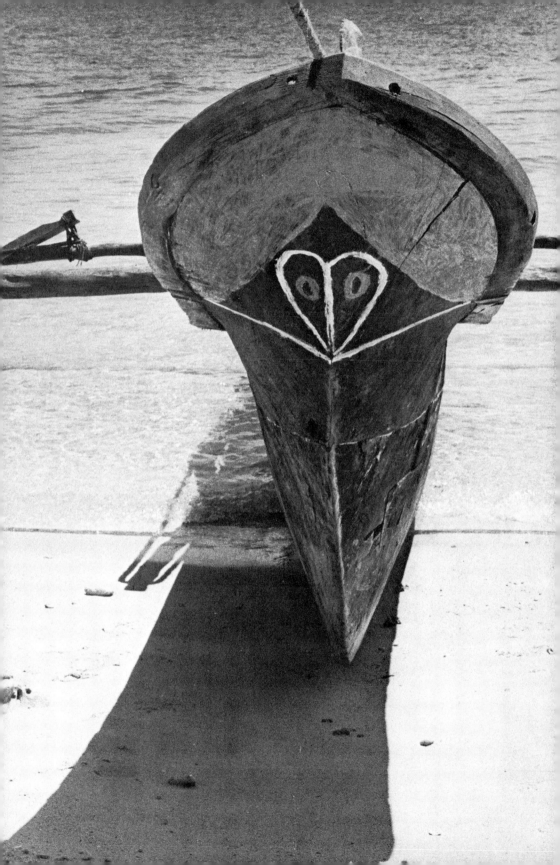

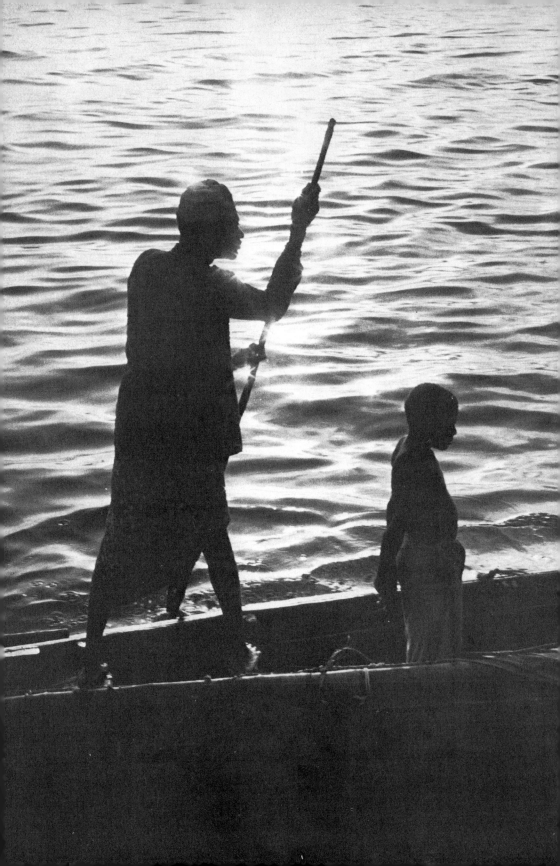

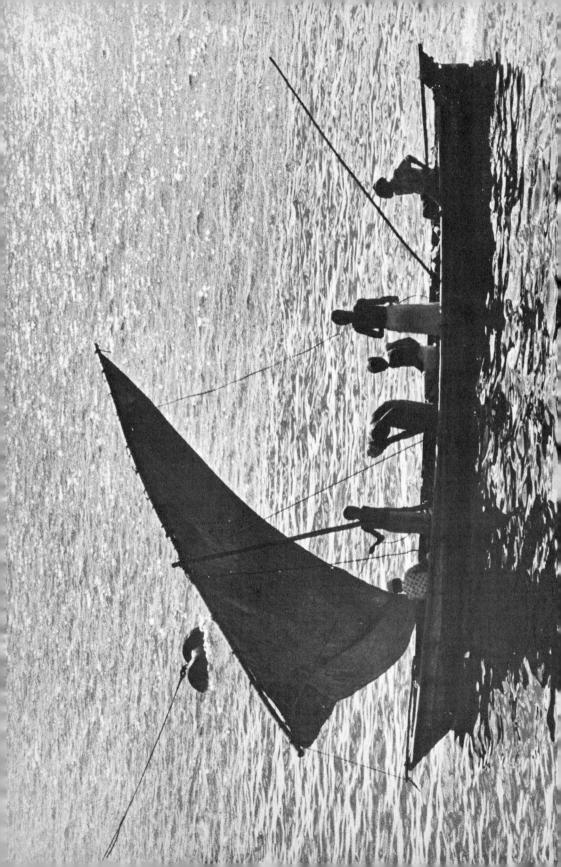

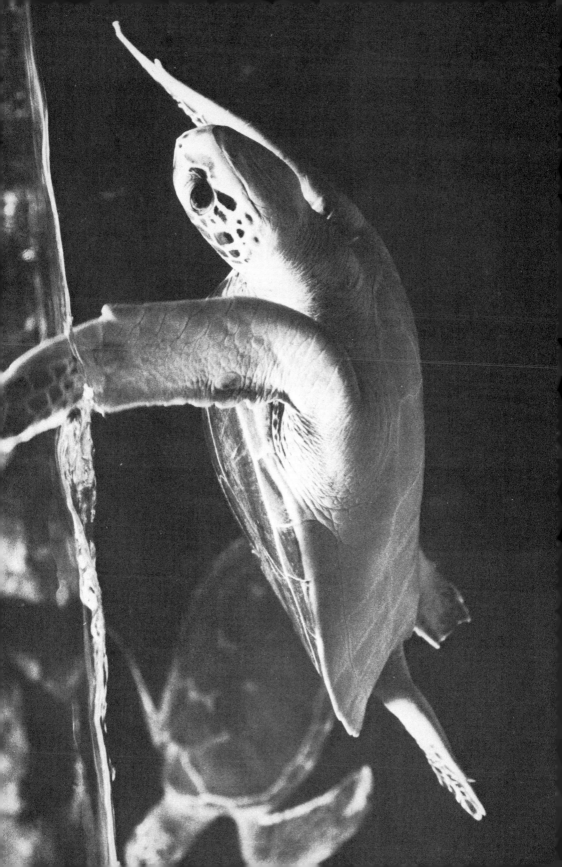

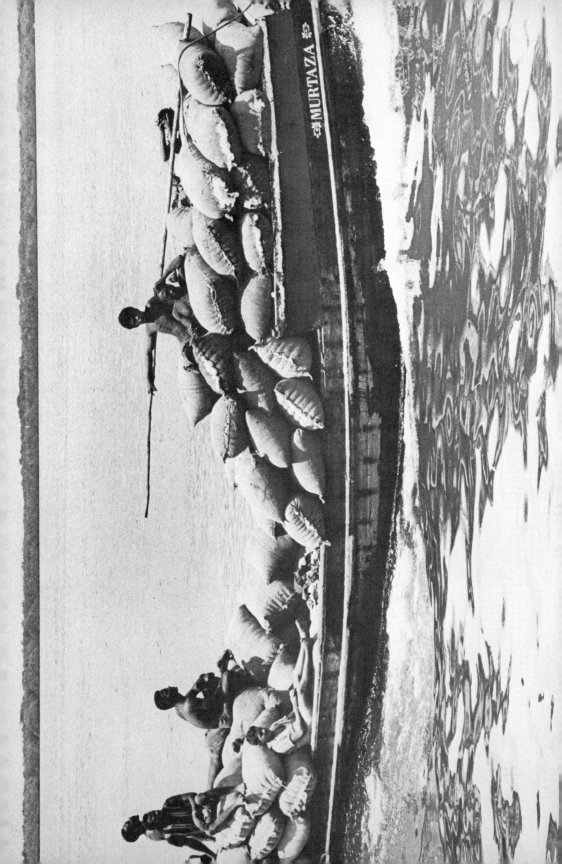

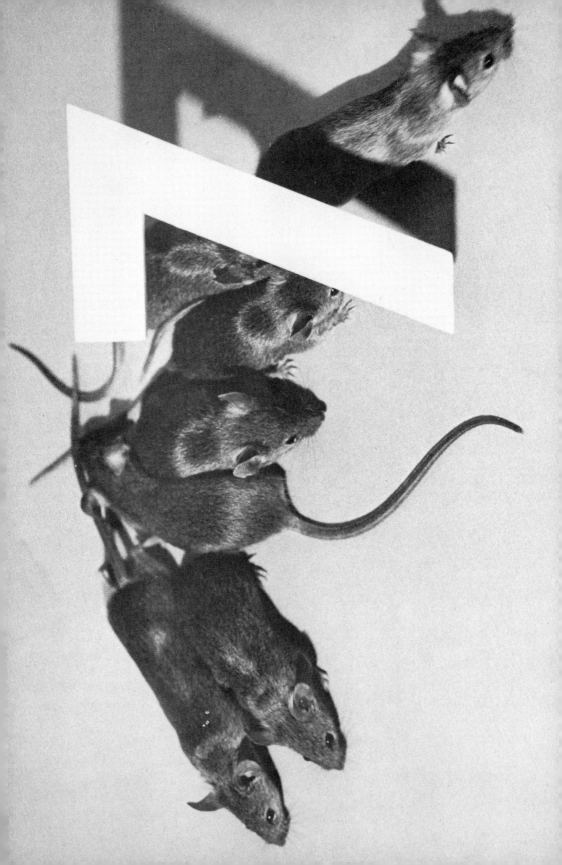

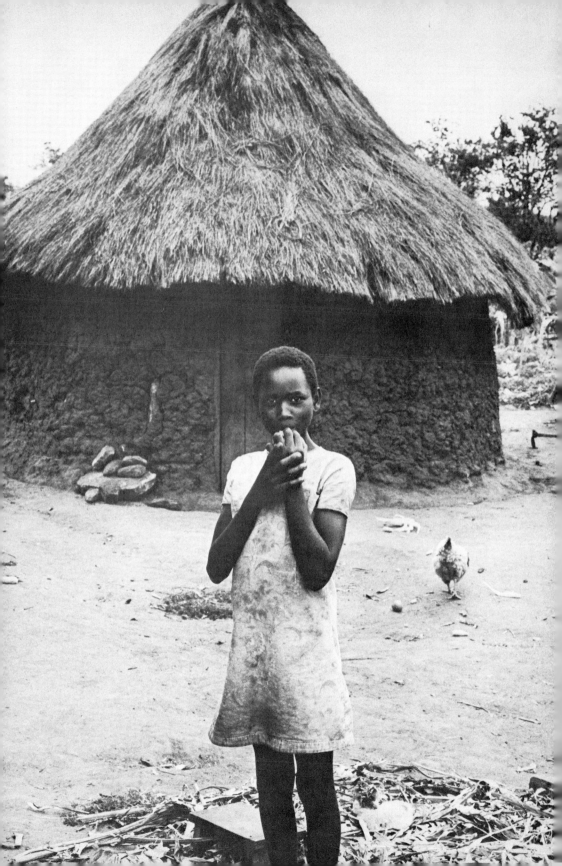

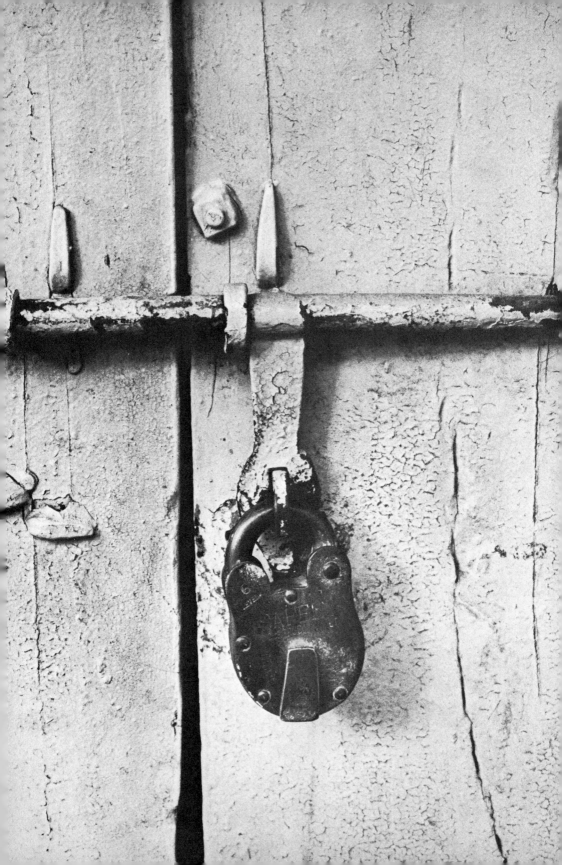

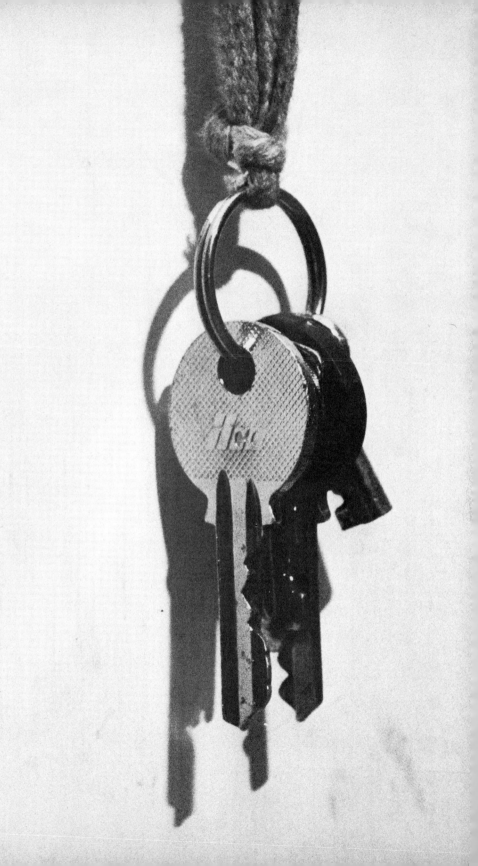

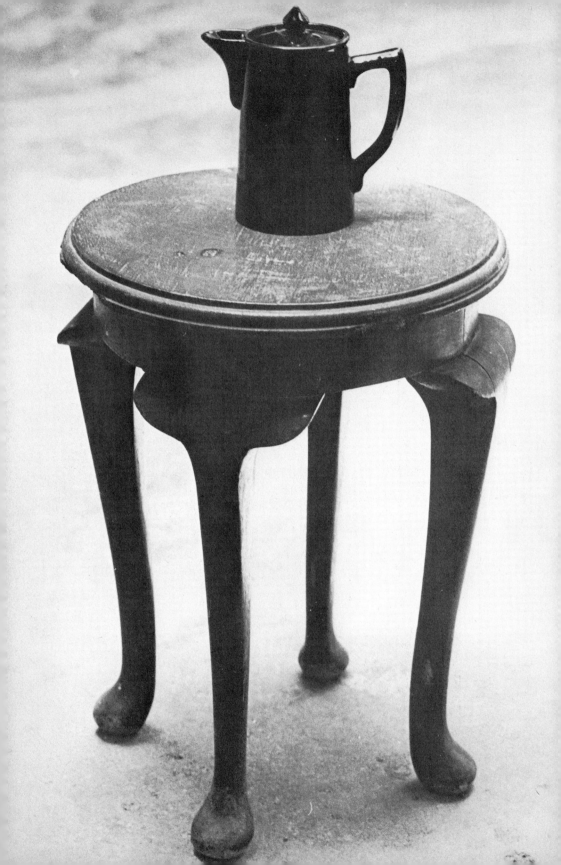

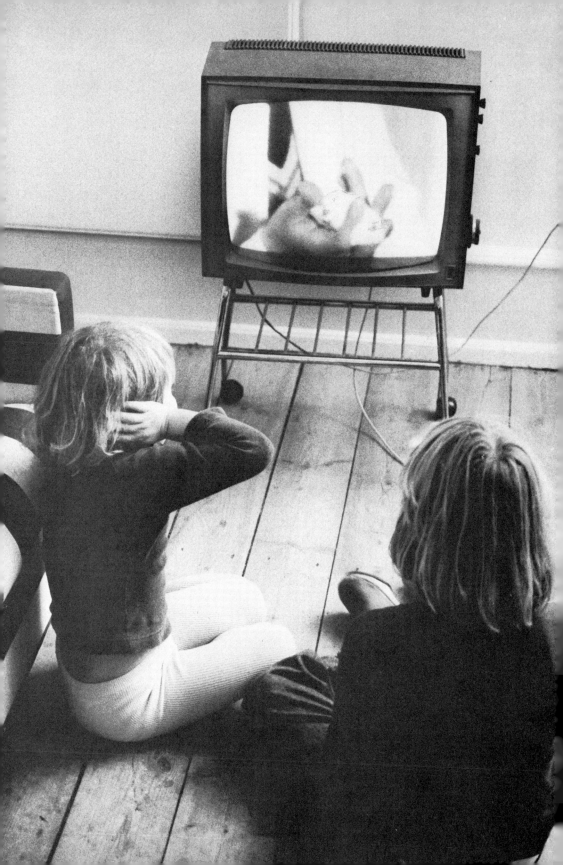

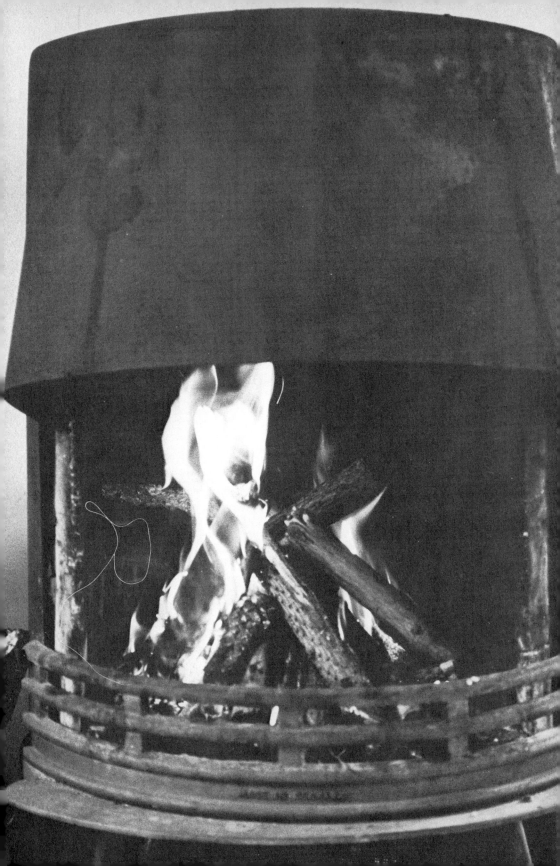

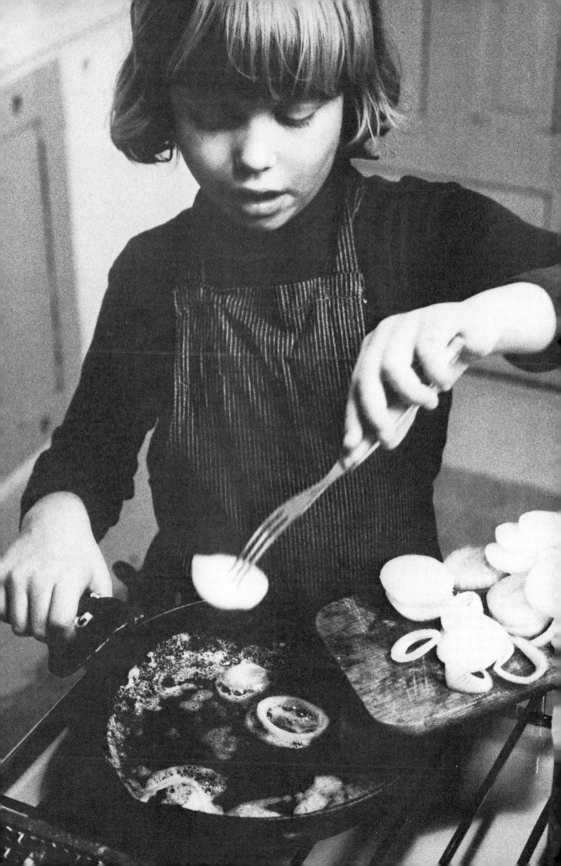

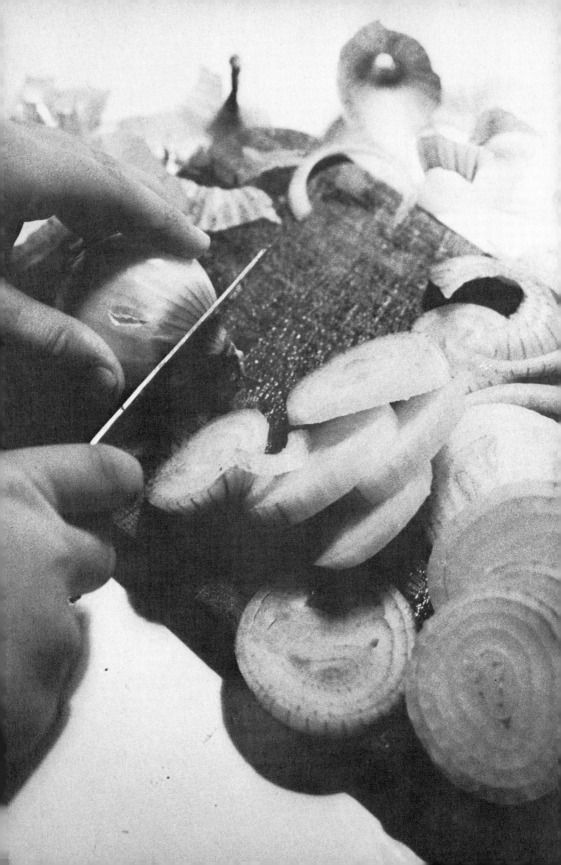

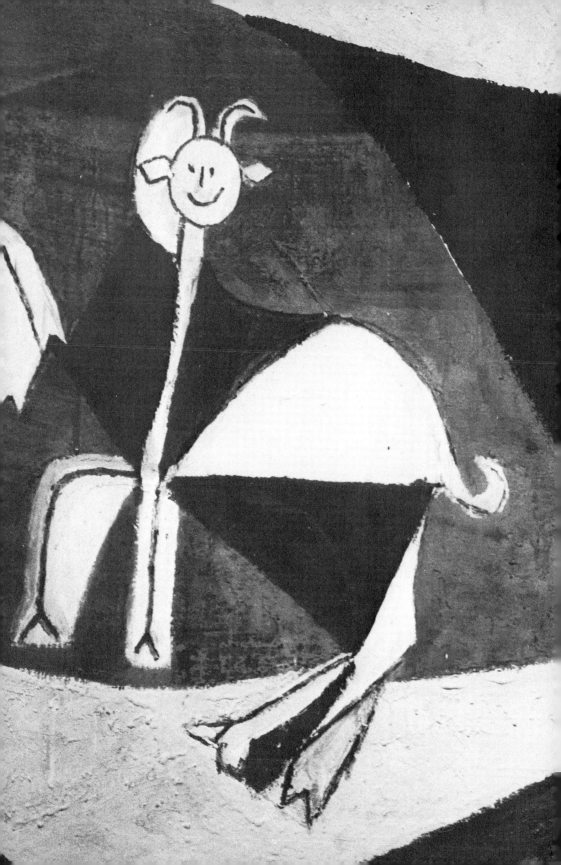

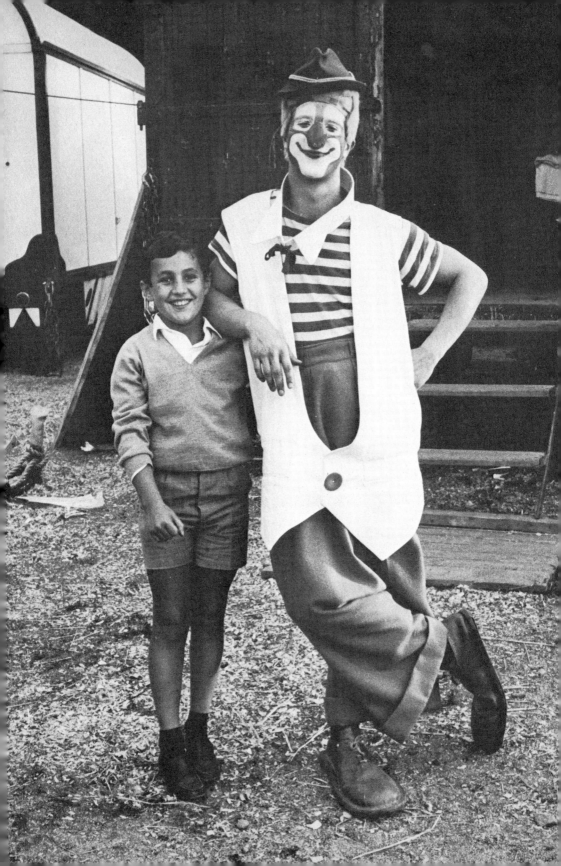

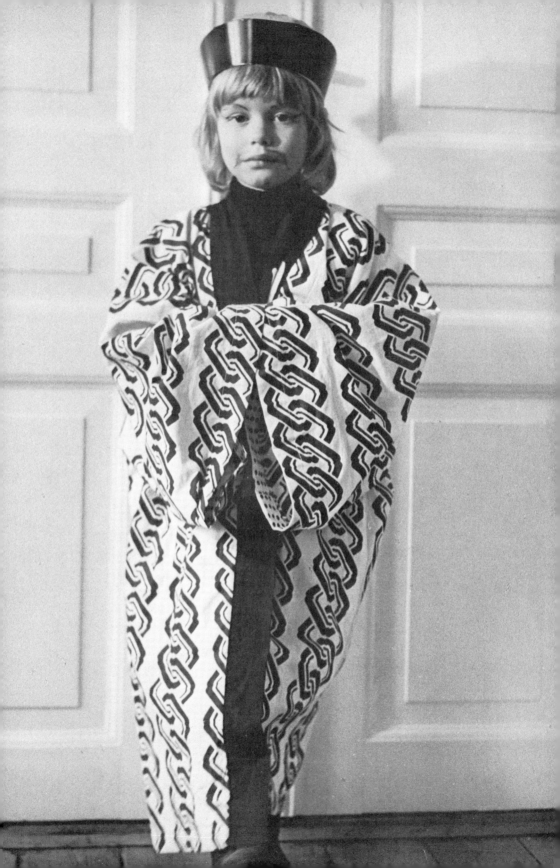

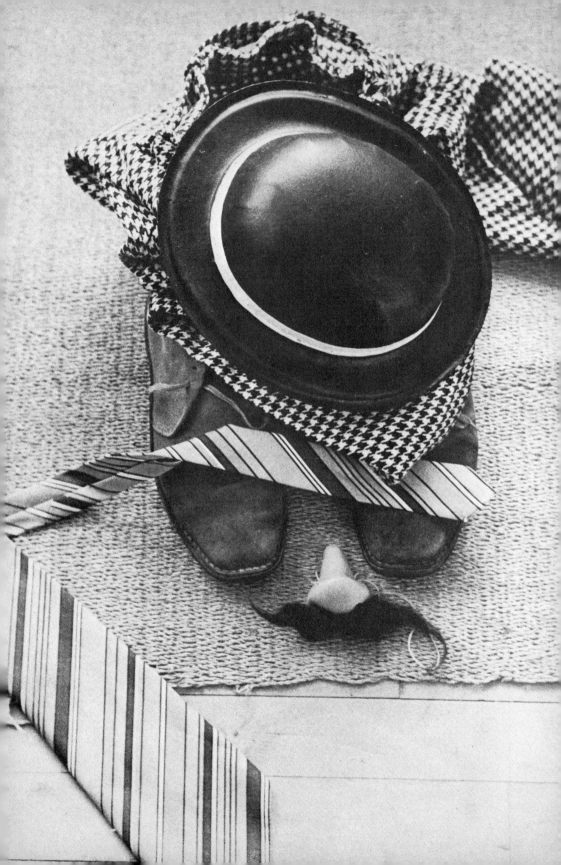

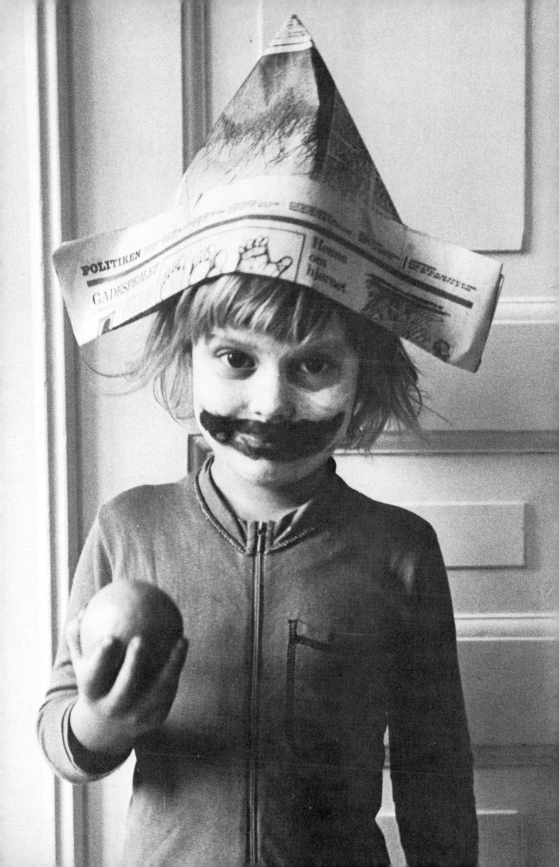

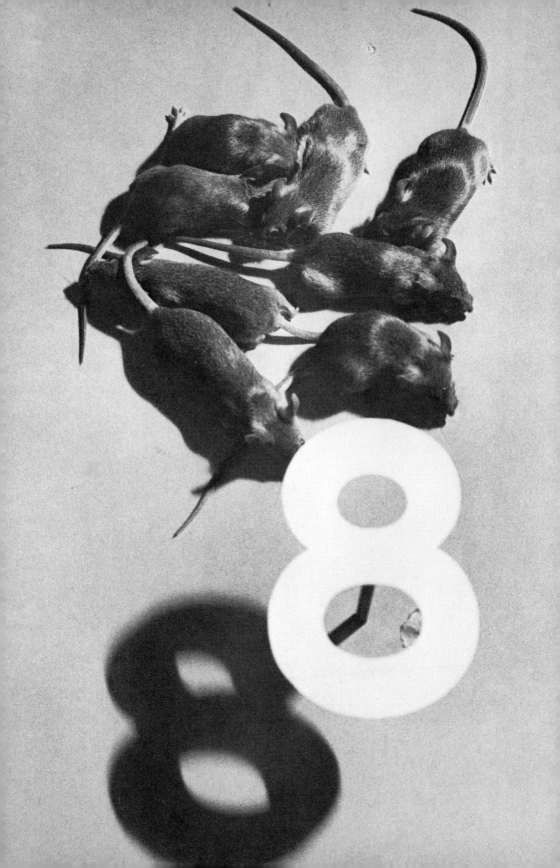

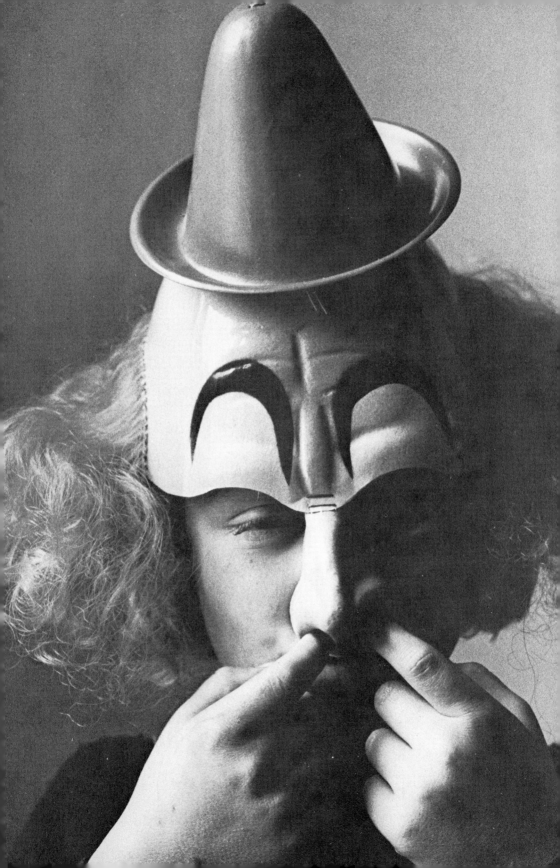

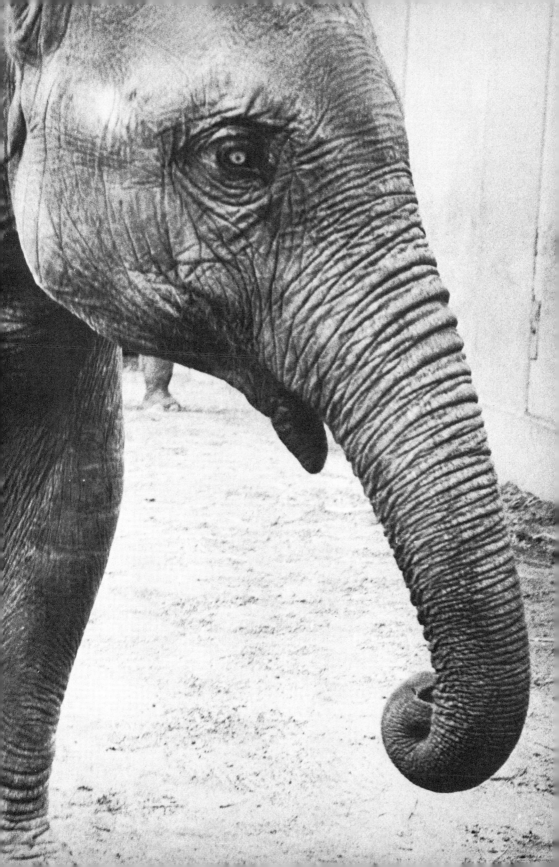

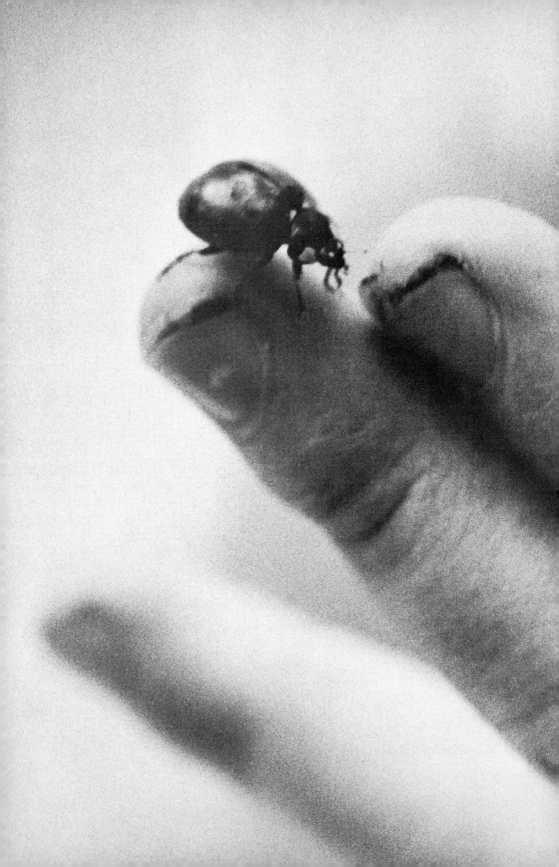

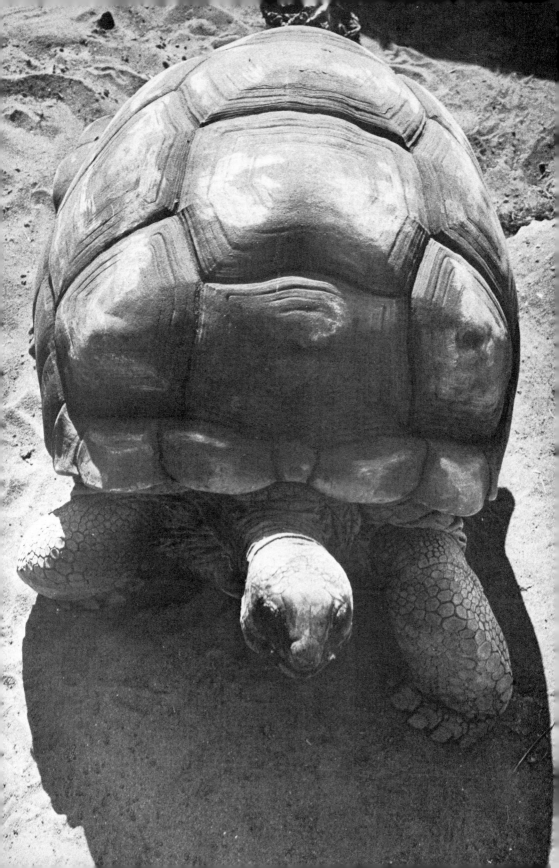

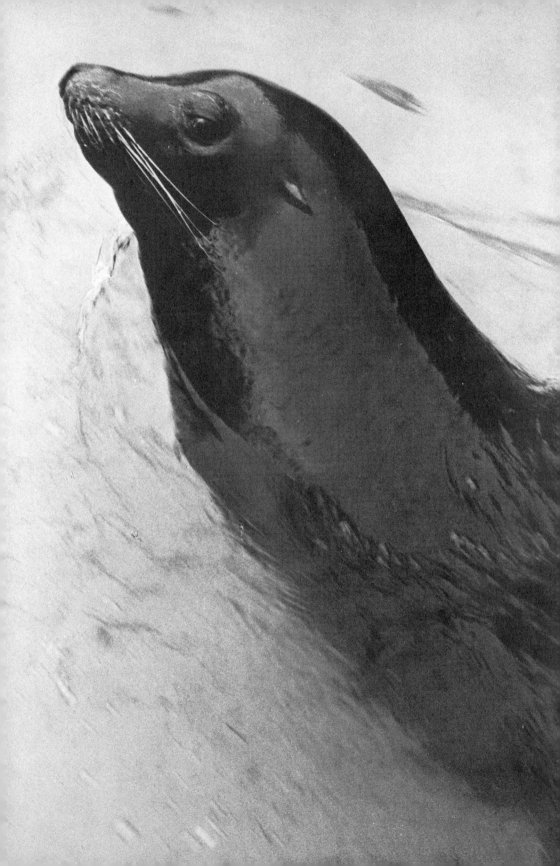

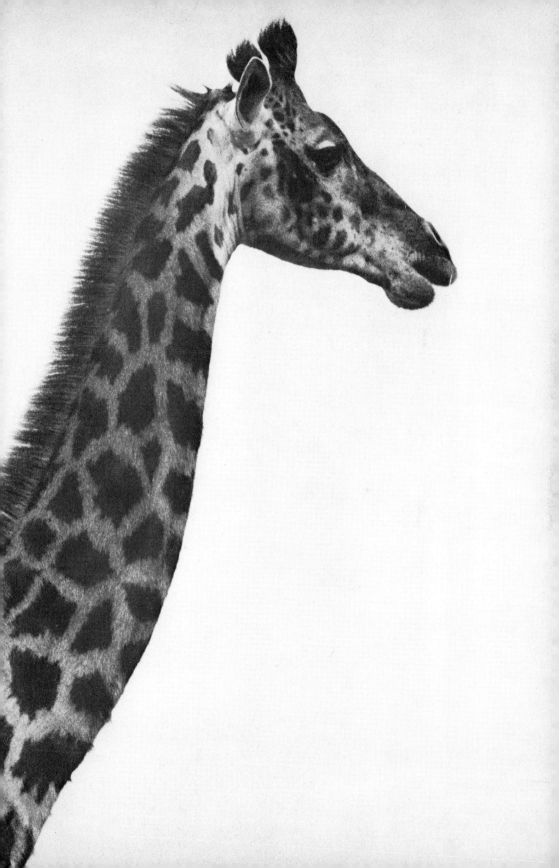

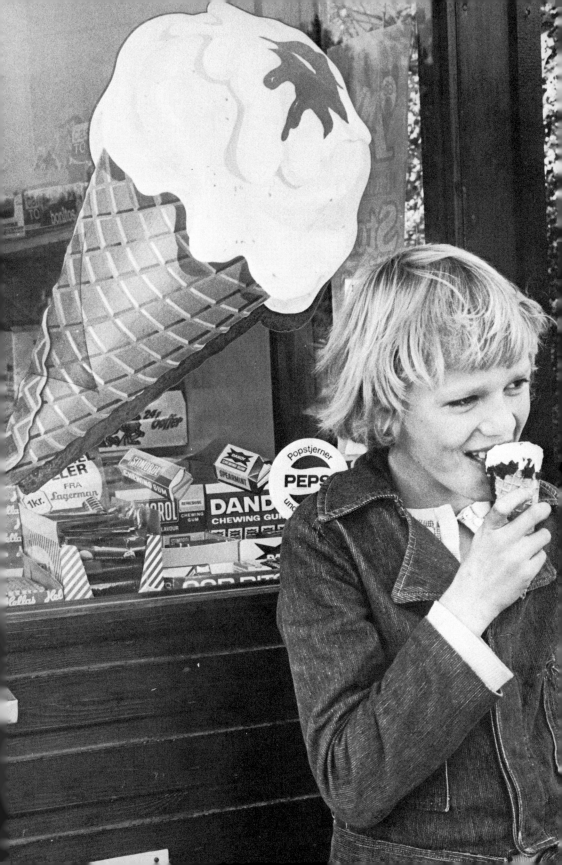

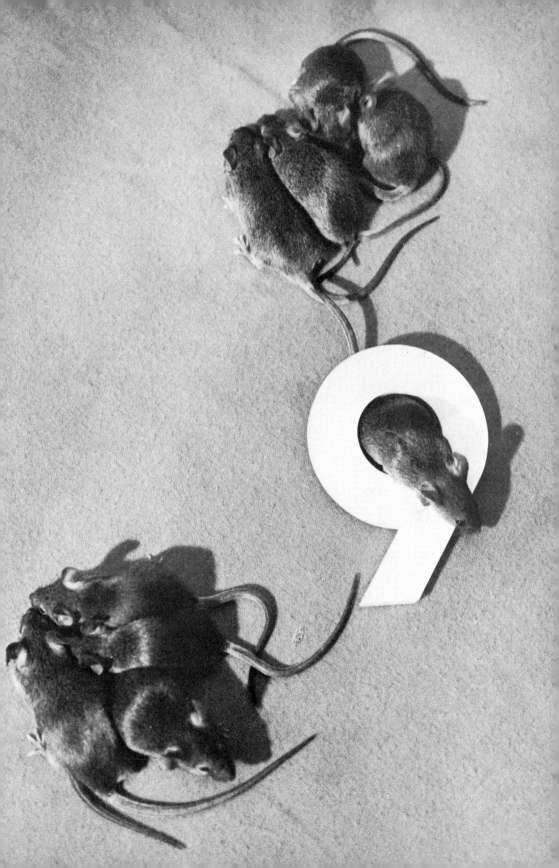

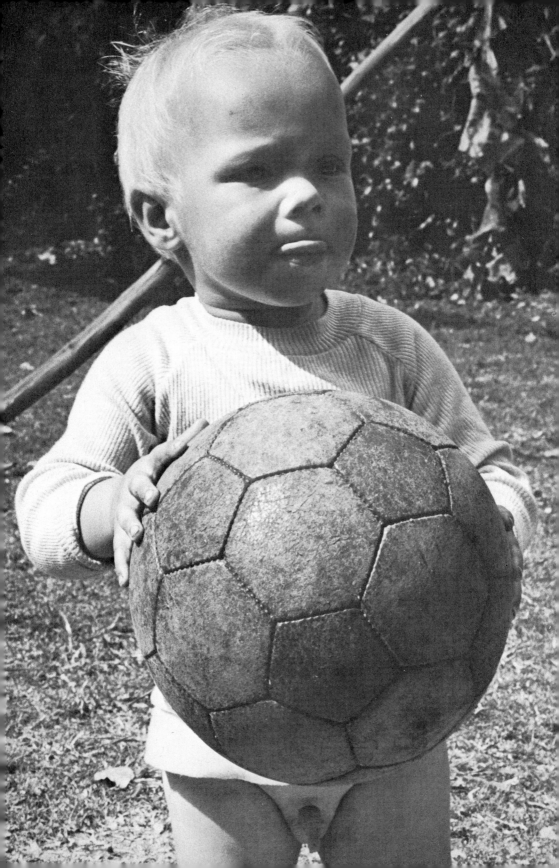

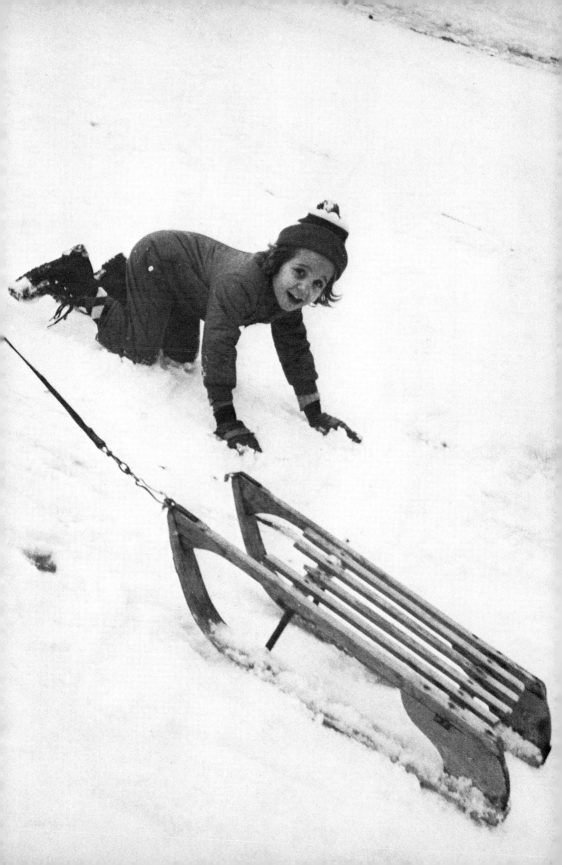

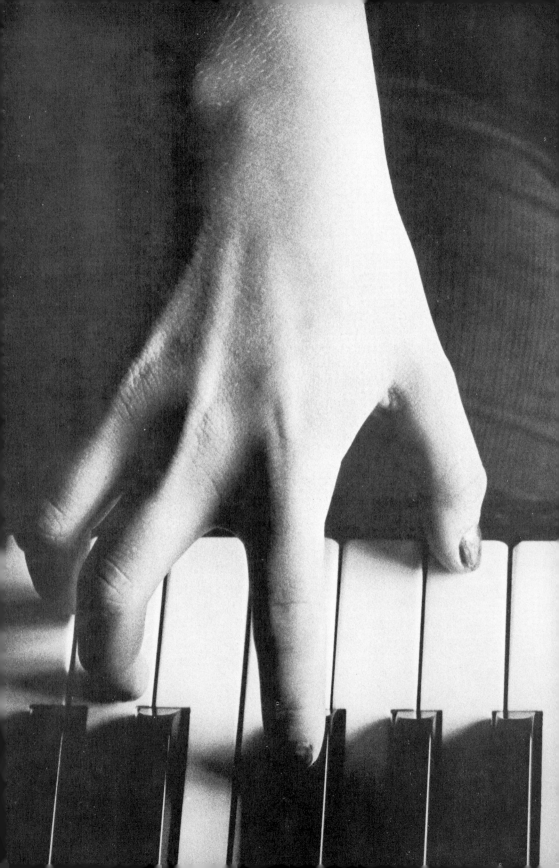

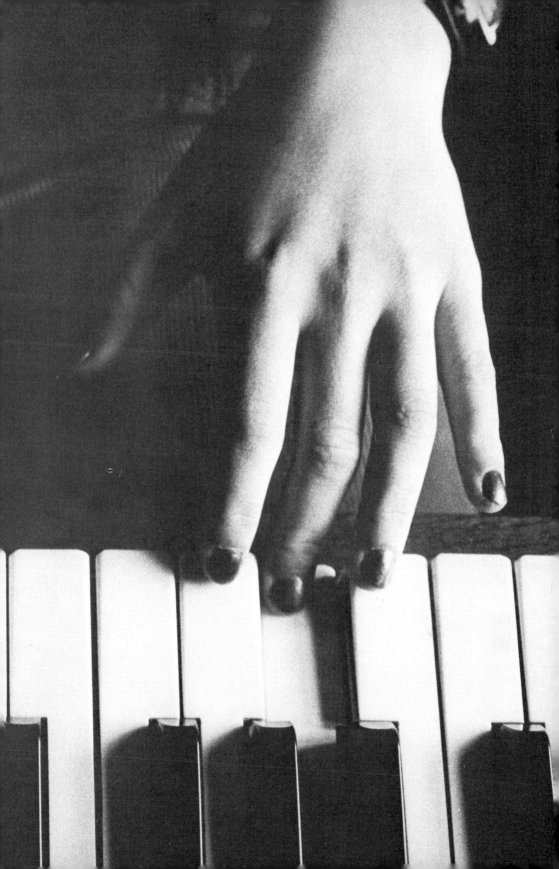

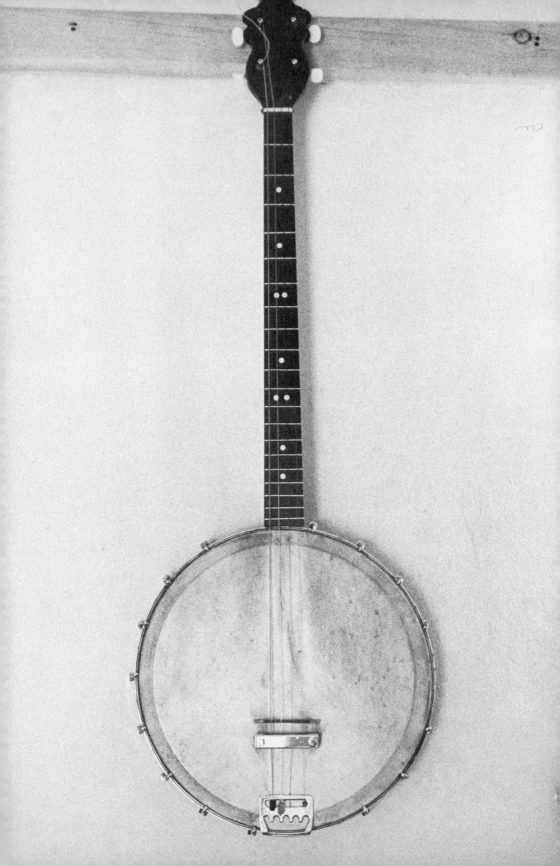

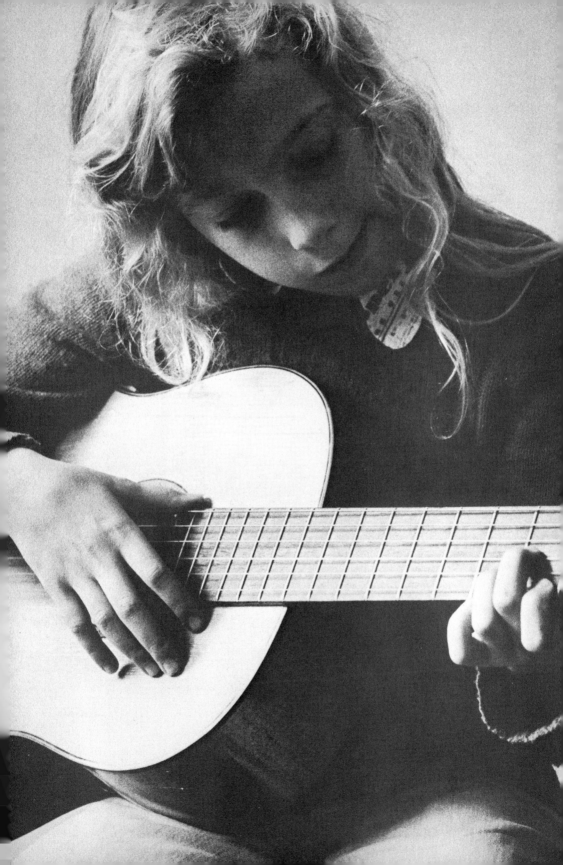

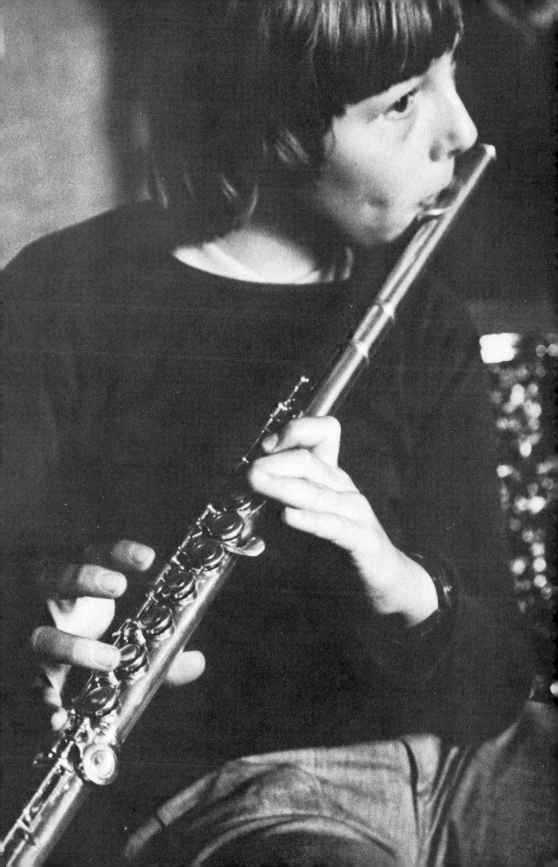

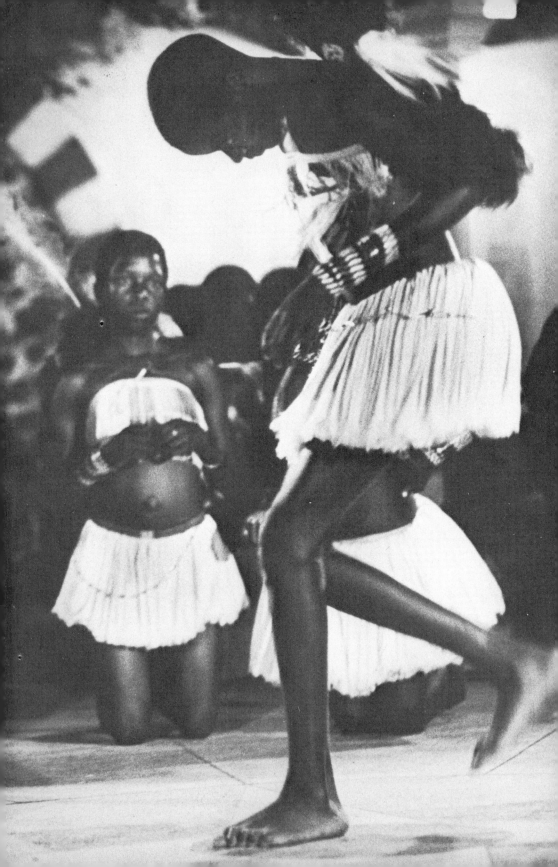

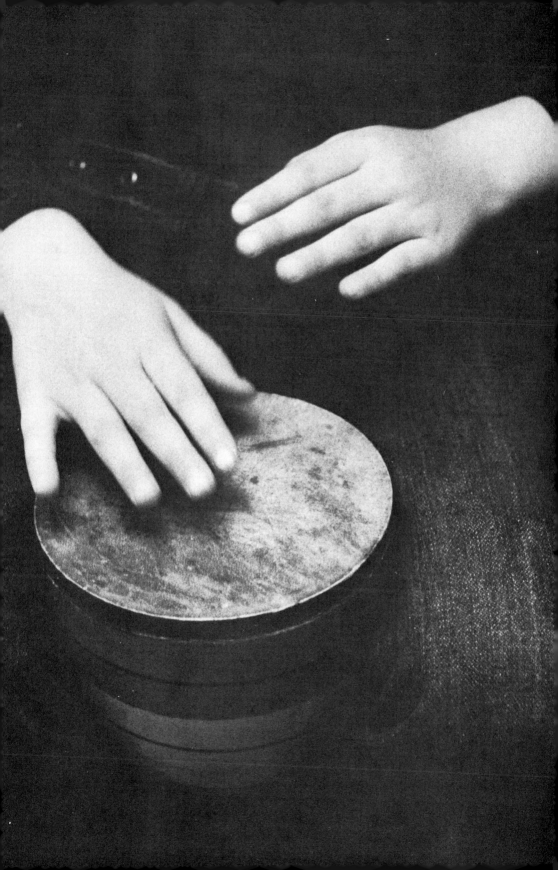

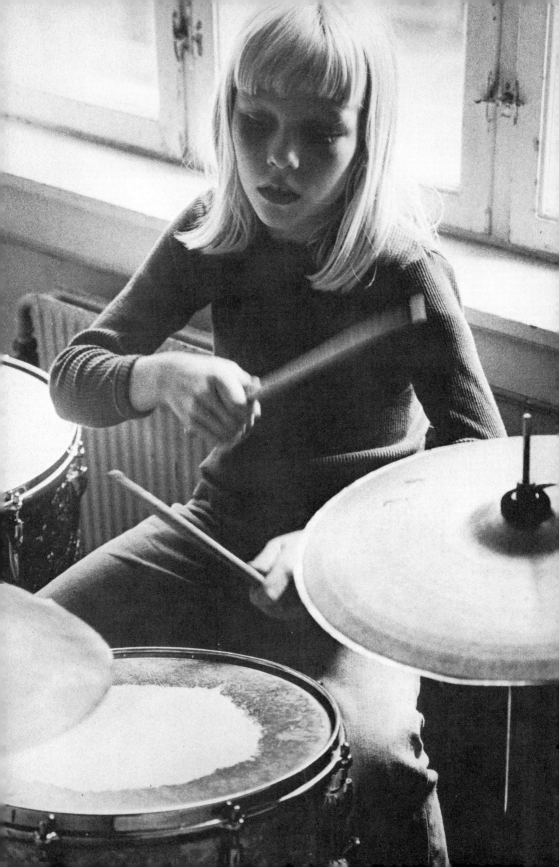

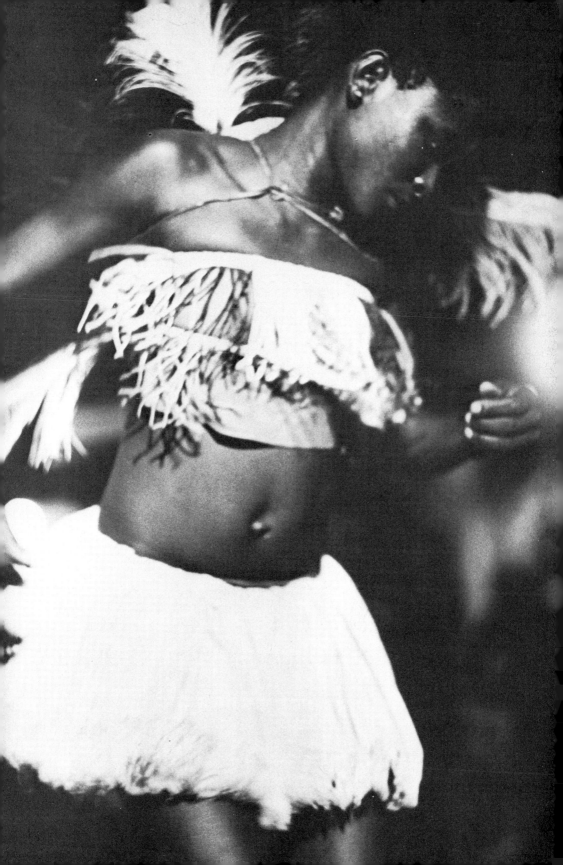

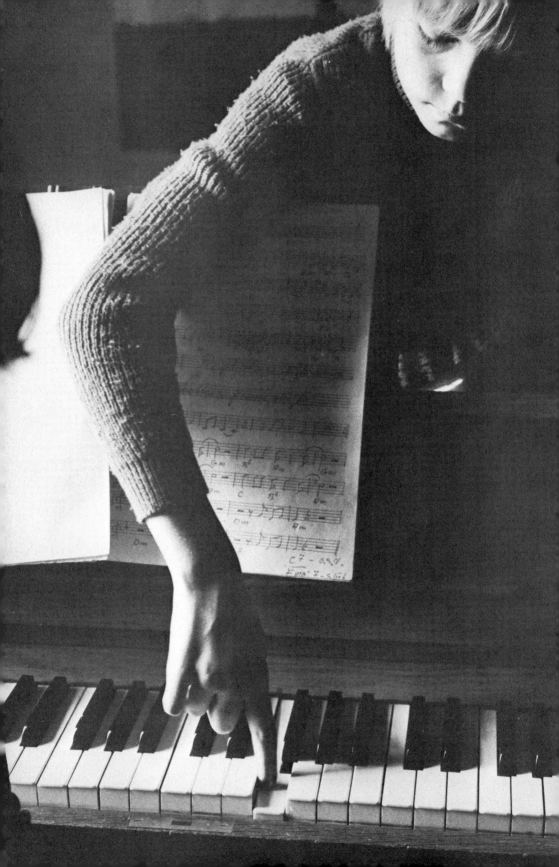

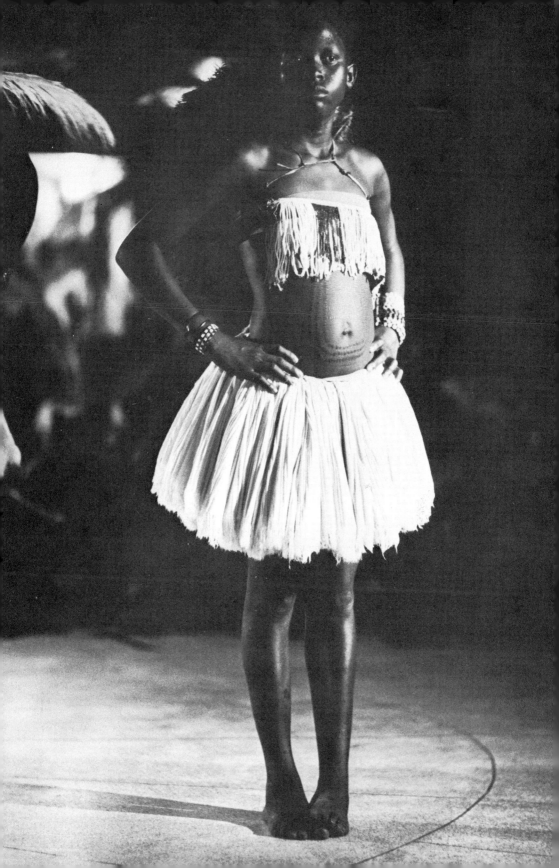

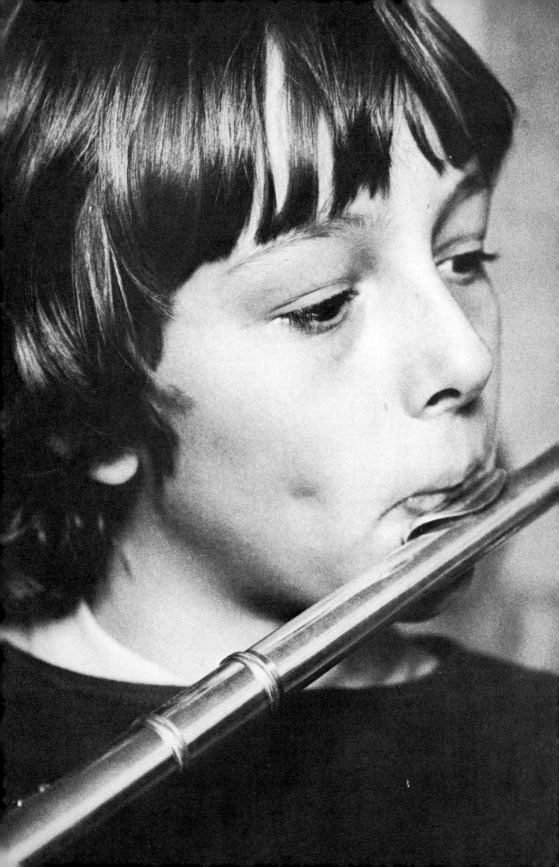

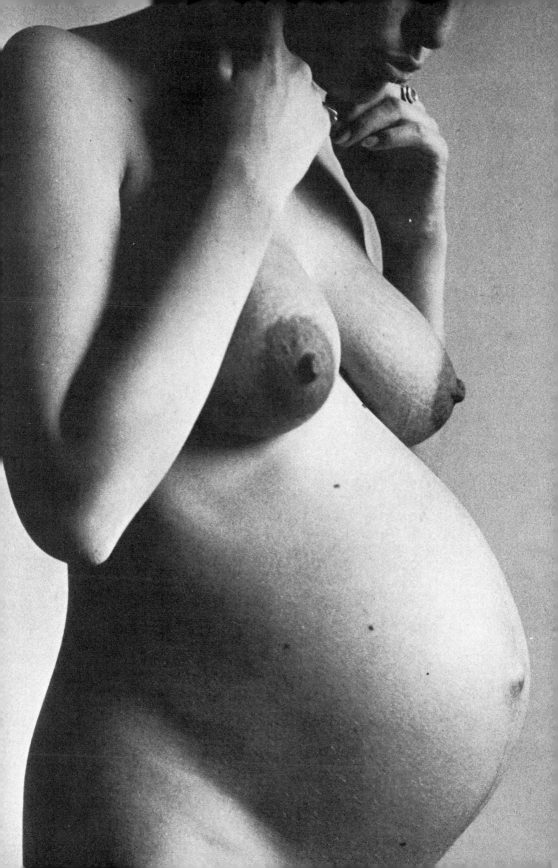

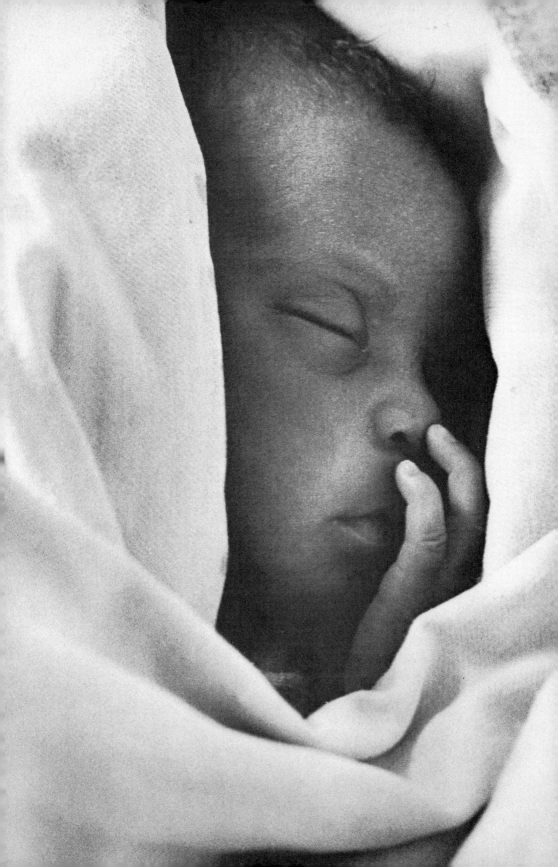

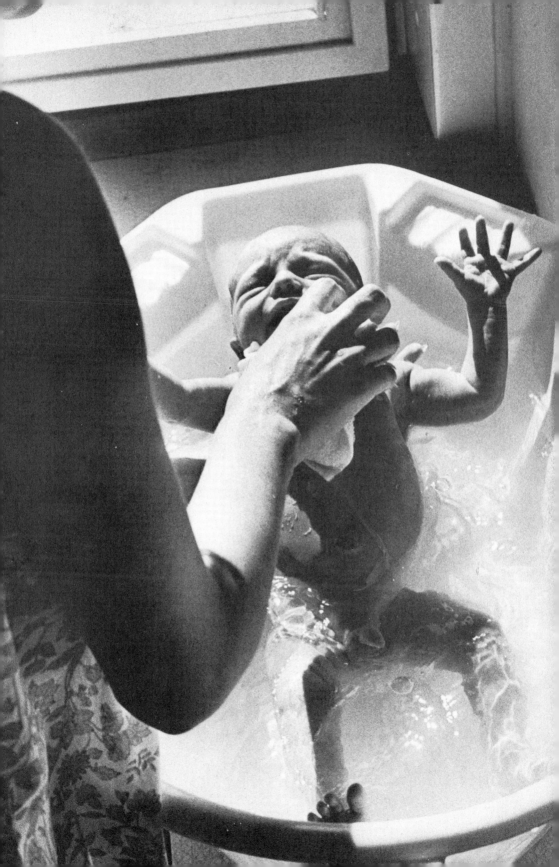

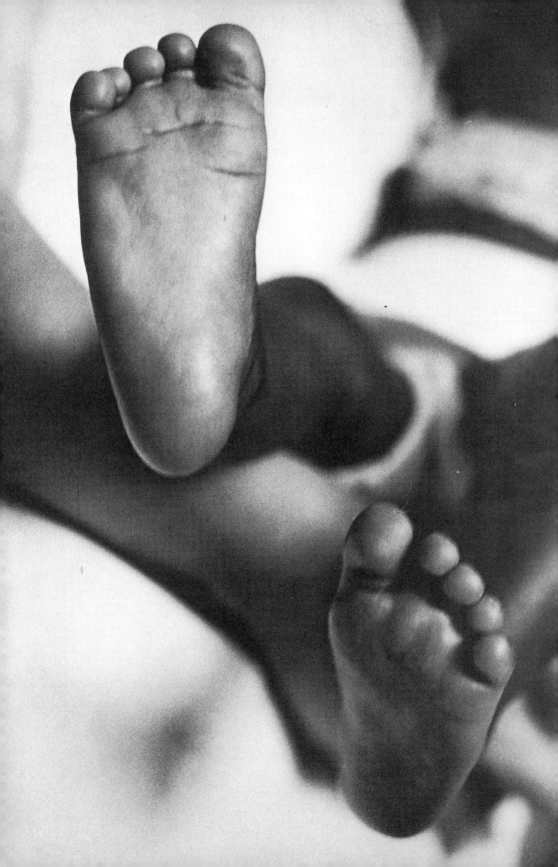

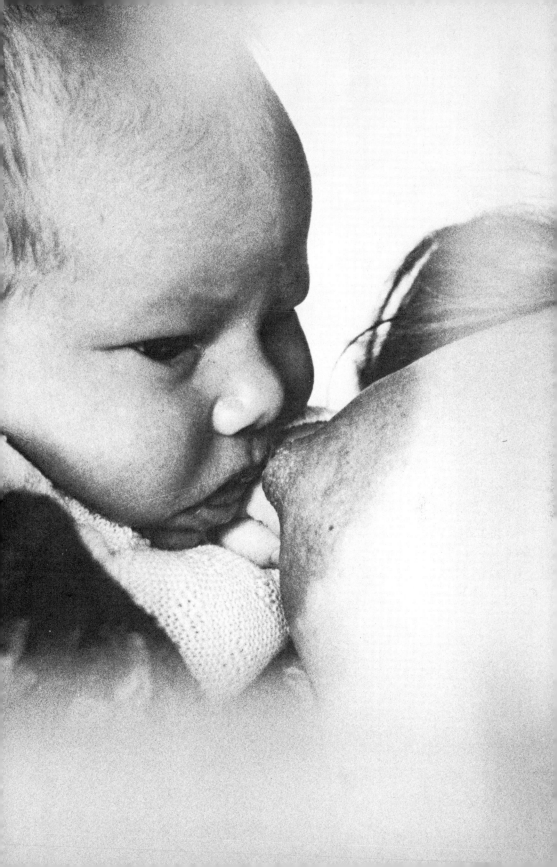

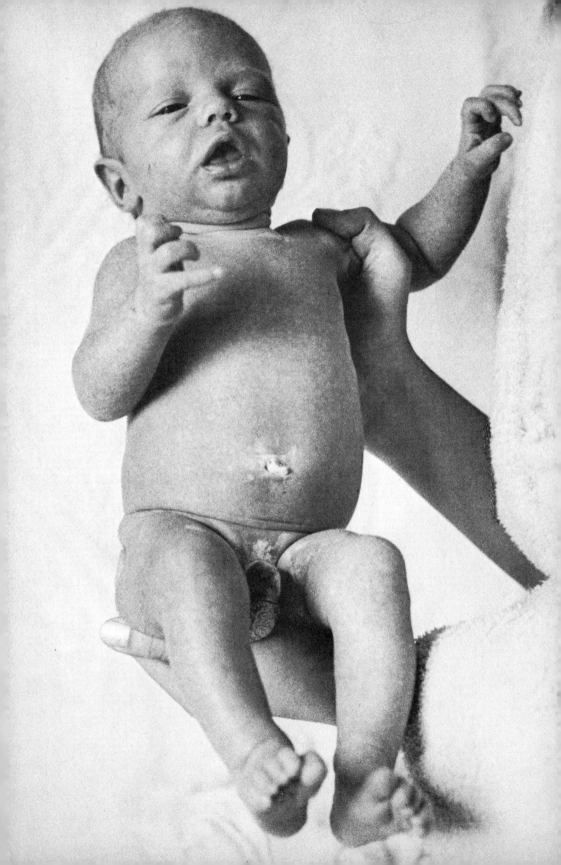

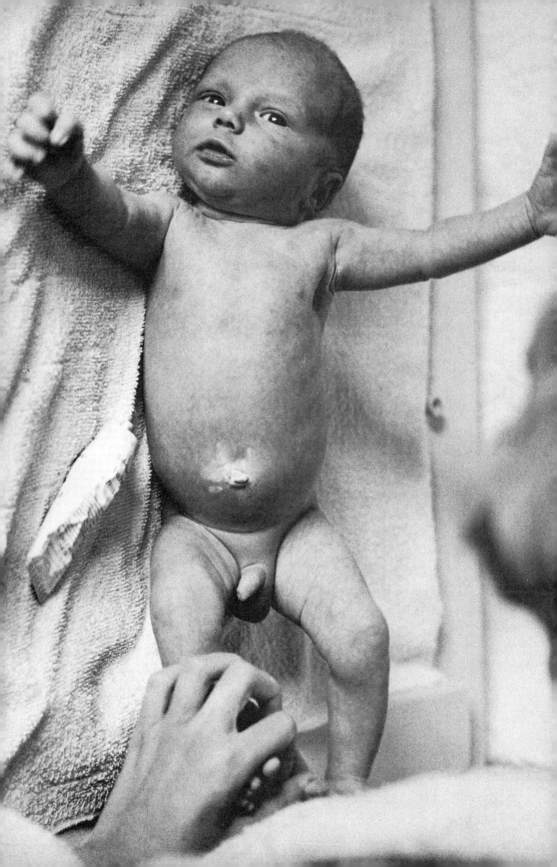

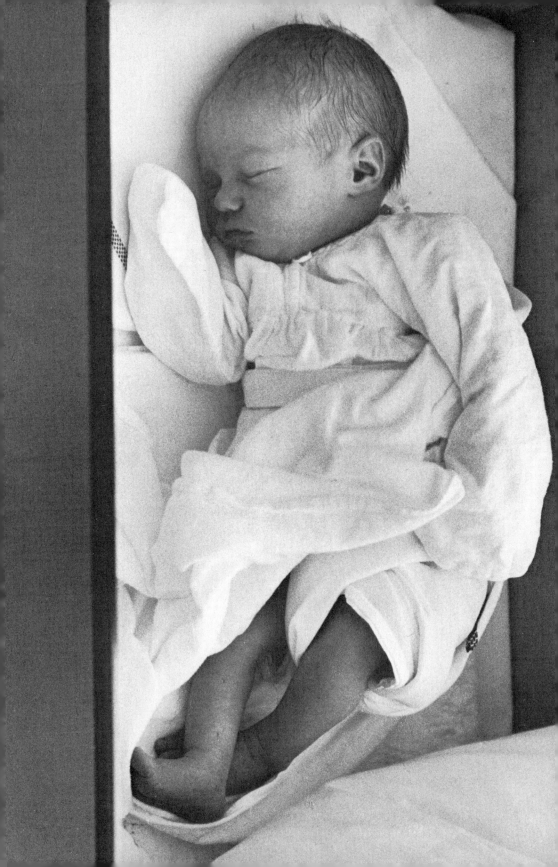

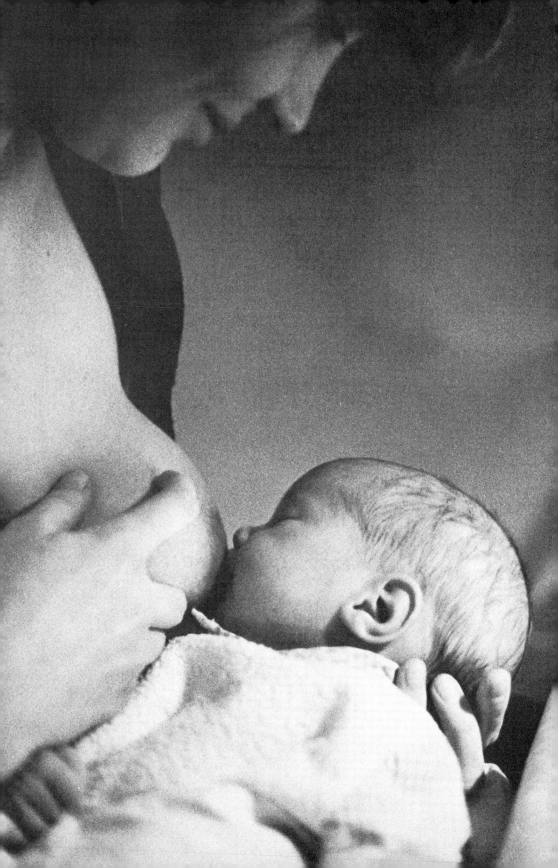

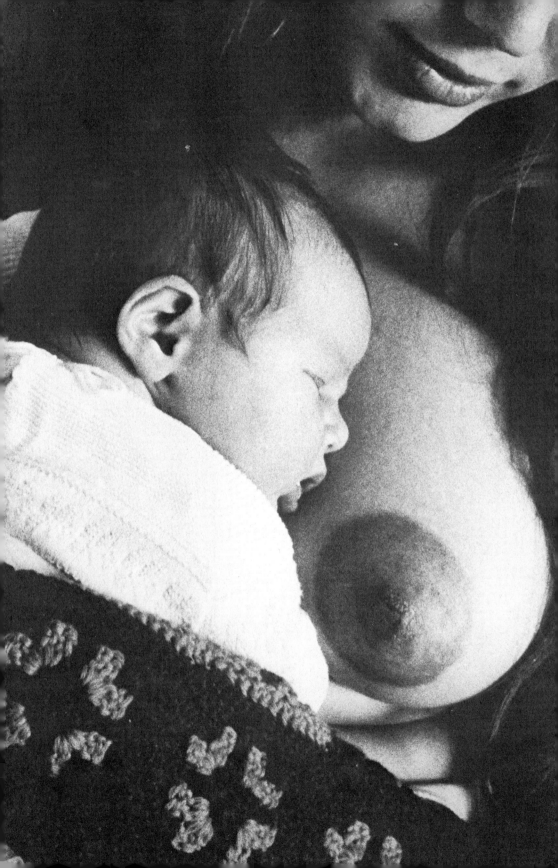

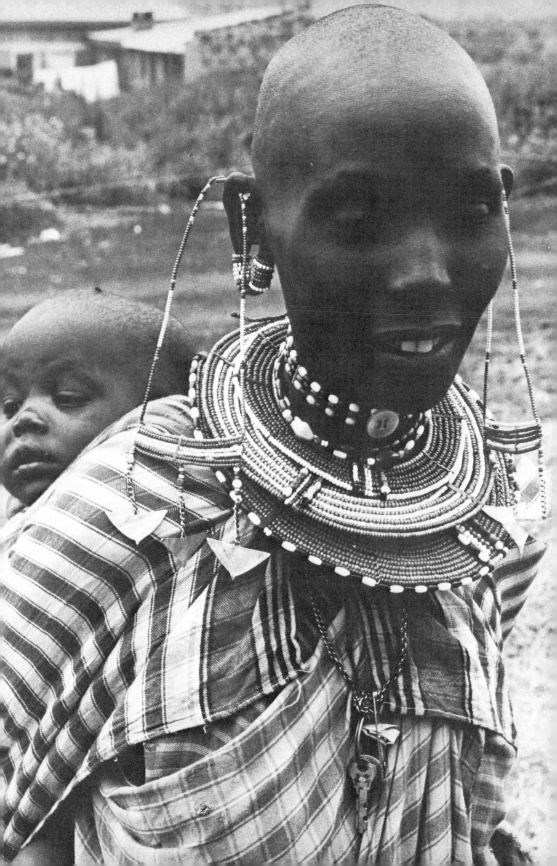

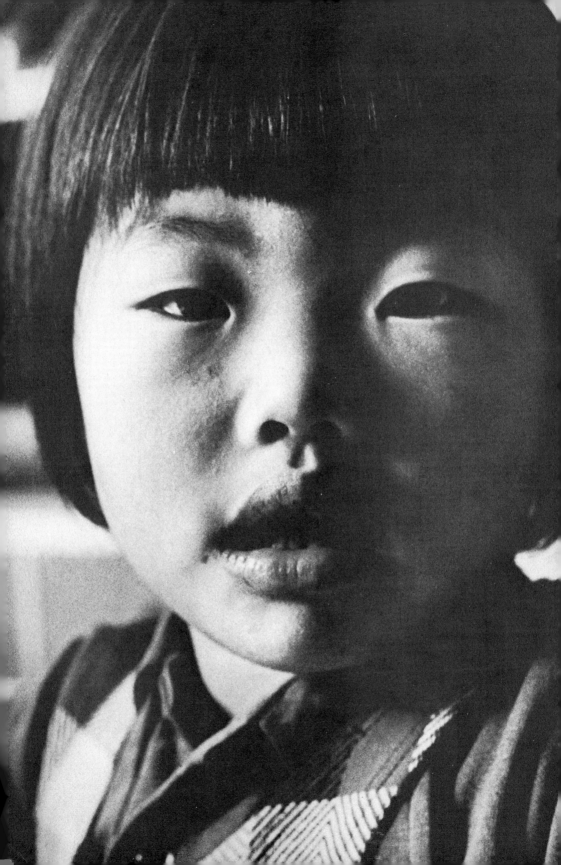

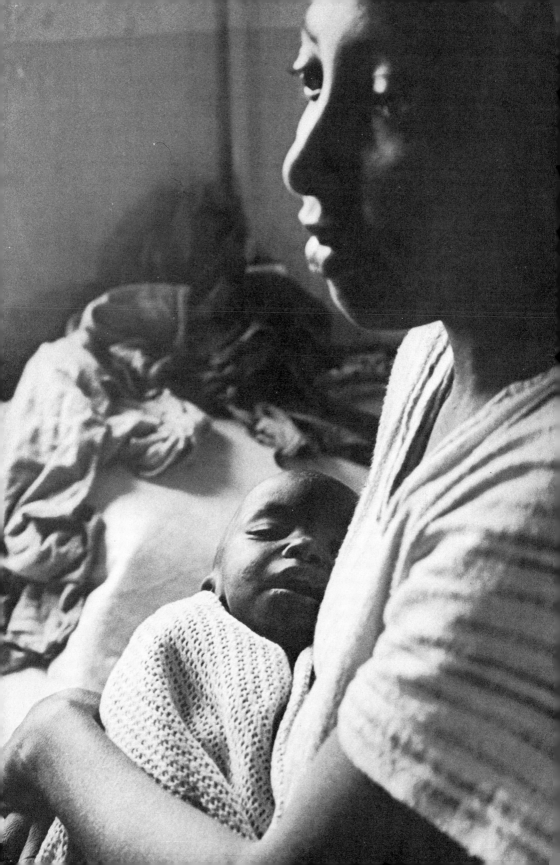

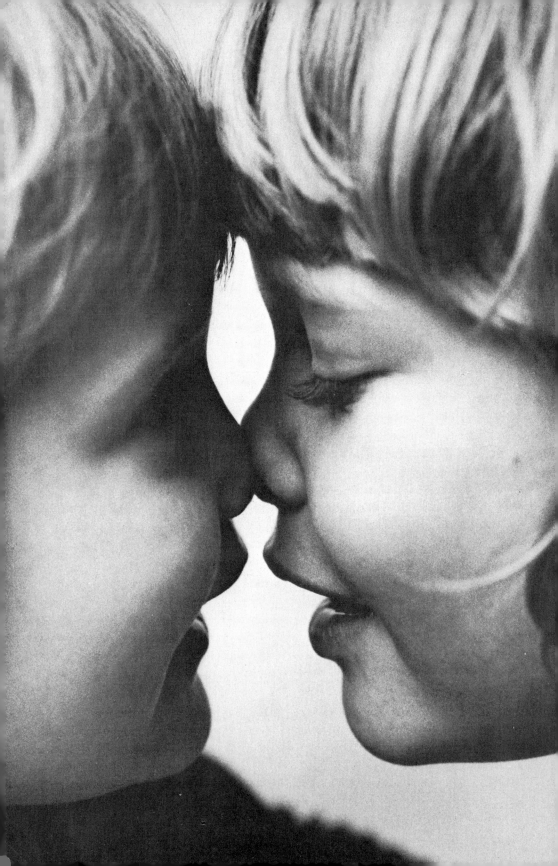

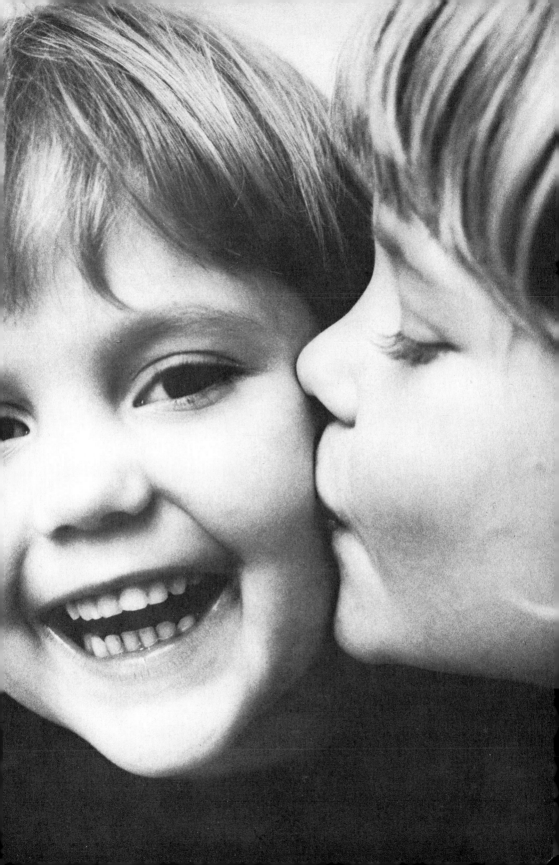

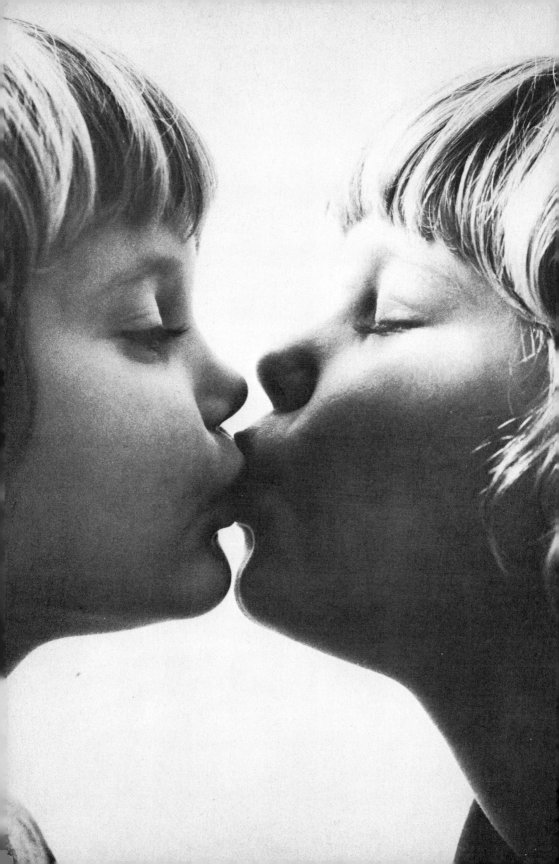

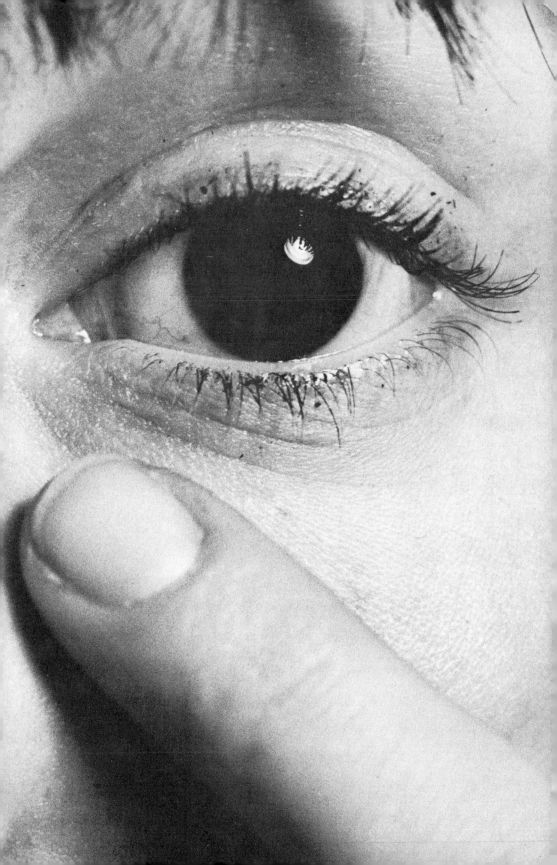

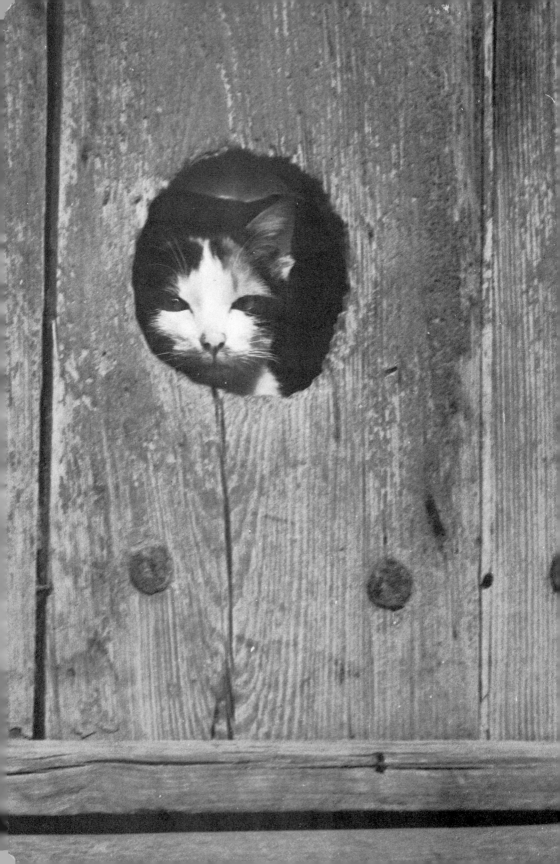